GREAT MUSEUMS OF THE WORLD

BRERA
MILAN

Paul Hamlyn LONDON·NEW YORK·SYDNEY·TORONTO

GREAT MUSEUMS OF THE WORLD

Editorial Director: Carlo Ludovico Ragghianti
Assistant: Giuliana Nannicini
Translation and Editing: Editors of Art News

Texts of this volume by Roberto P. Ciardi, Gigetta
Dalli Regoli, Gian Lorenzo Mellini, Licia Ragghianti
Collobi, Ranieri Varese
Design by Fiorenzo Giorgi

£1·75

Originally published in Italian by
Arnoldo Mondadori Editore, Milan
© 1970 Arnoldo Mondadori Editore–CEAM–Milan
© 1970 Photographs copyright by Kodansha Ltd.–Tokyo
This edition copyright © 1971 the Hamlyn Publishing Group Limited,
Feltham, Middlesex, England
All rights reserved
Printed and bound by Officine Grafiche Arnoldo Mondadori, Verona
ISBN 0 600 79314 1

BRERA
MILAN

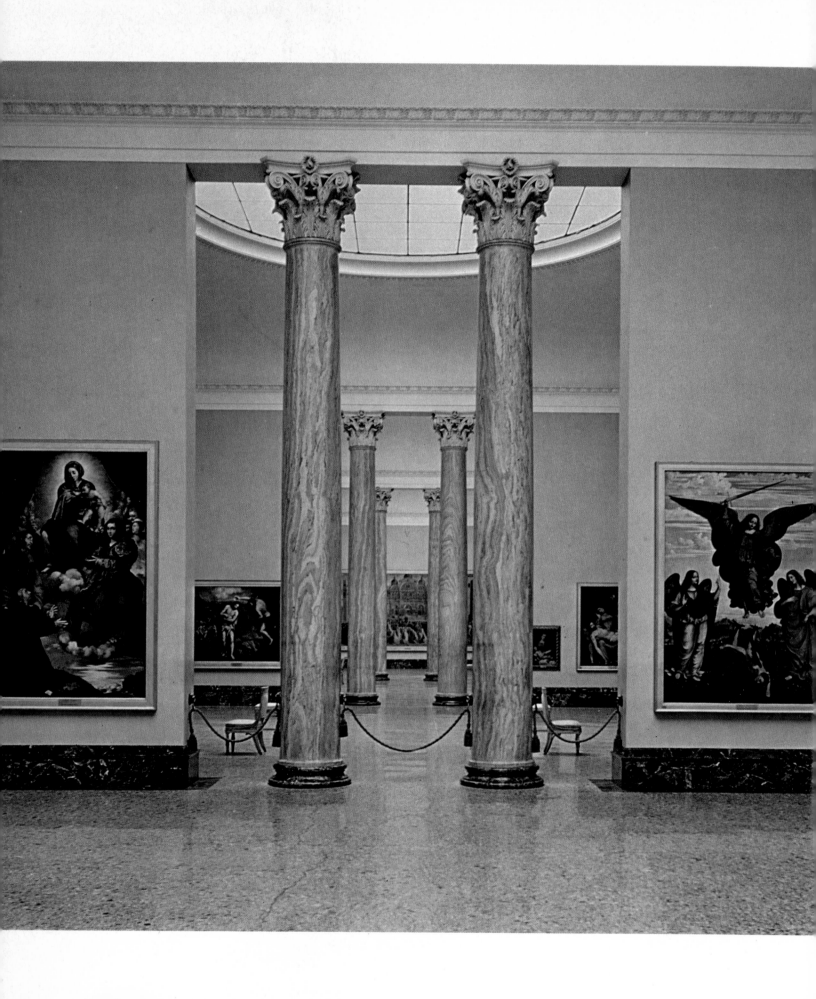

INTRODUCTION

FRANCO RUSSOLI
Director, Brera Gallery

The term "museum," even when limited to the field of art, is highly ambiguous and subject to various interpretations. There is the museum as a temple and shrine, as a laboratory, archive and school, the museum as a place of glamour and prestige, and the museum as a center for experimentation and challenge. A museum may spread cultural influences or it may be an avid amasser of treasures and documents. In today's consumer society a museum reflects the different degrees of awareness and the social and political ideologies of its staff and its public. It may be an instrument of stubborn or passive reaction, or of evolution and even revolution. Beyond its purpose of conserving, protecting and passing on examples of creative art, it must assume the responsibility for suggesting an interpretation of these examples in terms of philosophical principles and ideas.

The term "art gallery," which specifies the contents of a museum such as the Brera, seems to indicate a narrower range of possibilities. A showcase meant only for paintings would seem to be a place for such quiet activities as conservation, arrangement, classification, restoration, study, contemplation and meditation. The art gallery, however, also has the responsibility to present its material not merely as objects of specialized study and admiration, but as the bearers of a stimulating message. This should be the aim, in my opinion, of the curator of an art gallery. Aside from insuring the safety of the gallery's possessions, he should see that the different art works, representing various visions of the world, make up a dialectic of critical and cultural opinion that is relevant to the problems of the present time. The gallery protects the paintings but should not cut them off from contemporary reality. Indeed, it should provide a means of relating them to current life.

This does not mean that the pictures necessarily should be rearranged each time new interpretations of their meaning and relationships are

proposed. In some cases the museum itself and its installations can be culturally significant documents that are worth preserving in themselves for their historical value. If the presentation of the works reflects the ideas and intentions of a given historical period or personality, then it is not only the esthetic and functional values of the collection that should be respected, but also the cultural significance of the architecture, the setting and the concept behind the arrangement. But even in such cases, a collection should not be maintained in mummified form merely as a passive continuation of its original arrangement. Instead there should be a whole range of activities aimed at bringing out the values and the historical meaning of the works, and involving them in the contemporary culture. This does not prevent the enrichment of collections, the improvement of facilities for their conservation and the rearrangement of the works. It does prevent the destruction of the historical identity of a collection, where its quality and importance are an original expression of a specific trend of thought.

Such is the case with the Brera Gallery. The Gallery was rebuilt and rearranged, after being badly damaged in World War II, so as to retain as much as possible of its original form. The reasons for this reconstruction lie in the realization that the Gallery was a highly important document of a revolutionary period in Italian history and of a new theory of museology. Its restoration was not merely a sentimental gesture but a means of establishing continuity between the past and the present. The Neoclassical building and its didactic inner arrangement were to be the basis for a contemporary critical exposition corresponding to the specific features of the Brera's heritage.

It would be opportune to recall some aspects of the history of the Gallery in order to explain the importance of its original arrangement as a document not so much of taste as of ideology and cultural policy.

Many picture galleries have been formed by the accumulation of private collections, acquisitions and donations, each accession reflecting the characteristics of its own time and the taste of different individuals and environments. The Brera, however, was a single creation, established as part of a specific cultural program aimed at providing a means of public education. It brought together the highest examples in painting of "the progress of the human spirit," as manifested in the course of the history of Italy. Thus it corresponded to the principles of the Enlightenment, which were present in Maria Theresa's political thinking and found application in Napoleon's cultural policies. In Milan between the end of the eighteenth century and 1809, accordingly, a gallery of painting and drawing was established as an educational adjunct to the National Academy of Fine Arts.

Out of its original function as a specialized and scholarly institution, the museum-gallery developed into an independent depository of national treasures, at the service of the new Italian citizens. Art was thus used as a means of making the people aware of their own tradition and dignity as a nation. Its values were utilized to stimulate further production of the national genius. At the same time, in keeping with the conceptions of abstract reason, the centers of local culture were destroyed. Convents, churches, palaces and regional seats of private and public power were plundered. The organic fabric of historical Italian art centers, as it had developed over the centuries, was torn up, and the network of regional interrelationships was broken. Paintings, sculptures and other works of art were removed from their original contexts and arranged in the privileged setting of the museum. This painful and violent sacking operation led not only to the formation of the Brera but also to the creation of a shrine to the new Caesar, the Musée Napoléon in Paris, and of other collections of treasures to show the new nations the genius of Napoleon.

Torn from their native settings, the works of art would lose any "reactionary" power of suggestion as mythical symbols of independence and of traditions of power, culture, religion and economics that might hinder the formation of a unitary and national spirit. In the new ideal and artificial environment of the museum, these masterpieces would be stripped of any memory of their original commemorative or religious purpose. Their subdivision and arrangement by chronological periods and geographical schools in the museum would carry them beyond the chance circumstances of their birth in order to represent an Italian cultural unity.

To collect paintings of outstanding artistic and documentary value for this new institution, the connective tissue between the works of art and their original environments was broken. In keeping with this principle, an appropriate and "functional" building for such an ideological and didactic museum had to be found. Between 1807 and 1809, an architectural monument of extraordinary historical importance and beauty was destroyed for this purpose: the Gothic church of S. Maria di Brera degli Umiliati, a masterpiece by Giovanni di Balduccio and one of the most notable examples of Milanese art of the time of the Visconti. "Cut down in its elevation," the church produced a series of halls in the Neoclassical style for the museum. This structure, based on symmetry and functionalism, underscored the character of the Brera and gave it historical definition.

The preservation of the Brera as an explicit document of a revolutionary moment in the development of thought, taste and social policy in Italy has imposed conditions and sacrifices in modern museum management, and has meant foregoing enlargements and a more dialectical arrangement of the collection. All the same, it has stimulated activities that have made the museum a lively place associated with the problems of

contemporary art and culture. It has meant finding technical solutions for conserving and presenting the art works, that is, following and sometimes anticipating concepts of museum organization suited to new cultural needs. It has also called for a study of the forms best suited to making the pictures "act" in the modern social and cultural context, under the conditions imposed. The Brera has not remained ossified, like a monument or an archaeological site. It has changed and adapted itself to successive historical periods while still retaining the stamp of its original character. The eighteenth-century rationalism of its architecture and its chronological and geographical arrangement "by schools" has, in fact, permitted flexible internal rearrangements.

As Gian Alberto Dell'Acqua has put it, the Gallery was conceived originally as a non-religious museum, owing its existence directly to the State, yet composed mainly of church and altar paintings. Subsequently, however, when new critical approaches and new cultural needs made themselves felt, it was enriched with easel paintings of profane subjects. To the original nucleus, formed by plundering religious institutions of their art works in Napoleonic times, a number of paintings from art collections which have been added by purchase or donation, have notably — if not substantially — changed the appearance of the Gallery. In the Brera's early years Andrea Appiani, the famous painter who was close to Napoleon and who was Commissioner of the Academy, had chosen large altarpieces and other religious masterpieces for the Gallery. He sent small paintings of secular subjects to the apartments of the Viceroy who was, as Giulio Carotti put it, "fed up with saints and Madonnas." The impressiveness of the religious paintings was well suited to the solemn and official character of the National (later called Imperial) Museum at the Brera, while the "intimate" and precious works continued to provide aristocratic decoration and display for the newly rich and the newly powerful of the Napoleonic regime. Even the

13

exchange of paintings with the Louvre, ordered by Napoleon in 1812–13, brought in primarily large-sized works by Rubens, Jordaens and Van Dyck. The one small picture by a great foreign artist was the little portrait by Rembrandt. Successive and not always judicious exchanges revealed new directions in critical taste and the first signs of a change in the conception of the Gallery from a solemn sanctuary of imposing "monuments" to a more varied collection of fine paintings, including cabinet pictures. Small landscapes, genre scenes and other such compositions by Flemish and Dutch masters were sought and obtained. The Gallery was broadening its interests, becoming less pompous and more a gathering place for every kind of "pictorial genius." In the course of the nineteenth and the present centuries, the acquisitions of easel paintings originally made for private collectors were important and frequent. The original collection of altarpieces and frescoes was enhanced by small profane portraits, landscapes, genre scenes, fantasies and even the works of modern artists. In addition to the vast Venetian canvases of the Renaissance, the altarpieces from Ferrara, the Marches, Bologna and Lombardy, and the large Baroque and Counter-Reformation pictures, room had to be found for the little gold-ground panels and the exquisite little canvases of the realistic and classicizing masters.

In this way, successive revisions in the arrangement of the Gallery took place, each following the original principle of subdivision by school. At the same time, Romanticism, historical eclecticism and scholarly specialization successively altered the appearance of the Brera. The focal points of the Gallery, the places of honor for the works that were considered of major importance, changed from time to time. Admiration for Raphael, Mantegna, Bellini, Titian, Veronese, Tintoretto, Luini, Bramante and a few others remained unshakable. However, the works of Piero della Francesca, Ercole de' Roberti, Vincenzo Foppa,

Gentile da Fabriano, Lorenzo Lotto, Caravaggio and Piazzetta also emerged as their esthetic and historic values gained recognition. This is a process of adjusting critical sights that is still going on today, and will certainly lead to new changes and substitutions. The Brera is still typified, however, by the magnificent scenic church paintings of Savoldo, Gaudenzio Ferrari, Bellini, Crivelli, Ercole de' Roberti, Foppa, Bergognone, Veronese, Tintoretto, Michele da Verona, Cima da Conegliano, Bassano, Moroni and the Master of the Sforza Altarpiece. These, like the works of Crespi, Cerano and Tiepolo, strike the spiritual and visual keynote of the Gallery no less than the masterpieces of Piero della Francesca, Stefano da Zevio, Ambrogio Lorenzetti, Bonifacio Bembo, Signorelli, Caravaggio, Baschenis, Guercino, Guardi, Magnasco, Longhi, Canaletto, Ceruit, Fattori, Lega and Boccioni.

Spacious, airy, serene and solemn, the Gallery is democratic and imperial at the same time, including intimate areas where it is possible to have private colloquies with the works of art. Like a symphony, the Gallery ranges from the vast resonant passages of the altarpieces and frescoes to the lyric fugues and variations of the smaller pictures. Through this harmony between historic framework, educational arrangement and stimulation toward individual discovery, we are still attempting to keep faith with the principle of a "living museum" that is firmly rooted in its past.

Franco Russoli

ITALY

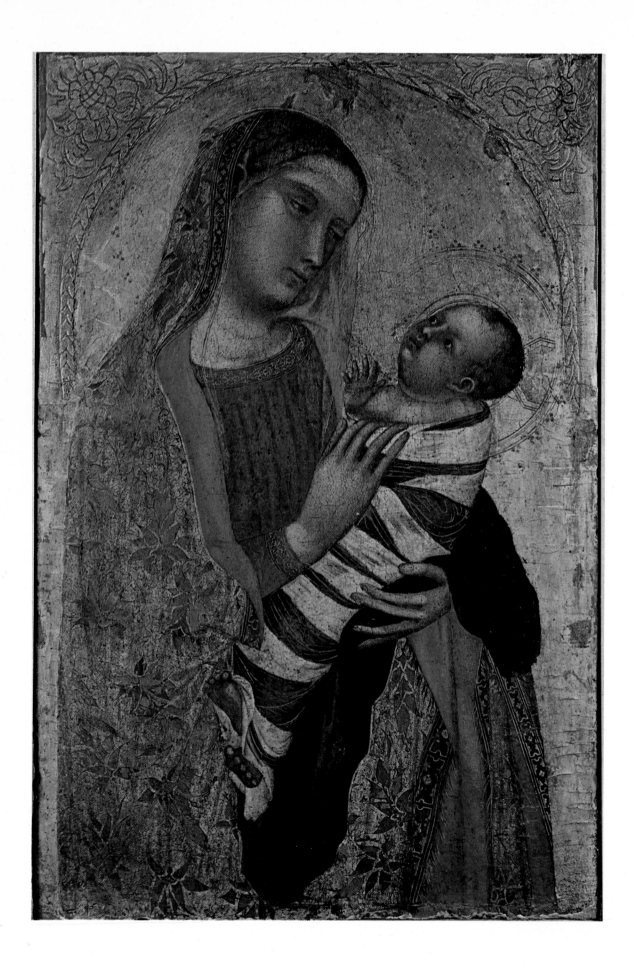

AMBROGIO LORENZETTI. *Madonna and Child.*

Ambrogio Lorenzetti and his brother Pietro were trained as artists in Siena, a busy, commercial city in which exotic imports, such as Byzantine and Persian miniatures, French ivories and Oriental and Flemish fabrics, were common. Their influence, as well as the powerful examples of Duccio, Nicola and Giovanni Pisano, were fundamental in the education of the Lorenzetti brothers. Ambrogio also found inspiration in the work of Simone Martini — who had brought the cosmopolitan novelties of the Angevin court at Naples to Siena — and later in Giotto's Florentine followers, Stefano and Maso.

Ambrogio discarded Giotto's rigorous construction and incisive modeling in favor of open spaces, broadly articulated volumes, fluid composition and a color range with many gradations. Contrary to Giotto's practice, he introduced subtle psychological effects. Note, in this painting, the intensity with which mother and child look at each other. The Virgin holds the Child with such delicacy that from a realistic point of view the support would be inadequate; the Child appears weightless. A lively detail is seen in the feet, escaping from the swaddling, which are not represented realistically but in terms of the linear cadences of the draperies.

Probably intended for private devotion, this panel is an example of highly refined taste and skillful technique. On the gold ground the two large halos are indicated by a fine, incised line; the rectangularity of the panel is modified by the braided arch motif and by the flowers in the upper corners. The two figures are related to each other in a system of undulating rhythms and spiral movements. They widen or narrow with slow waverings in depth. Not a wrinkle mars the compact ivory of the faces and the Virgin's long, seemingly boneless hands.

This lovely panel is almost contemporary with Ambrogio's extensive work in the Palazzo Pubblico between 1335 and 1345 for the Sienese government, which included the great frescoes of the *Allegories of Good and Bad Government,* a map of the world on canvas (now lost), and the 1344 panel of the *Annunciation* (now in the Pinacoteca of Siena), which is the artist's last signed and dated work.

AMBROGIO LORENZETTI
Siena circa 1290 — Siena 1348(?)
Madonna and Child (1340–45)
Tempera on panel; 33 1/2" × 22 1/2".
Presented by Guido Cagnola in 1947.

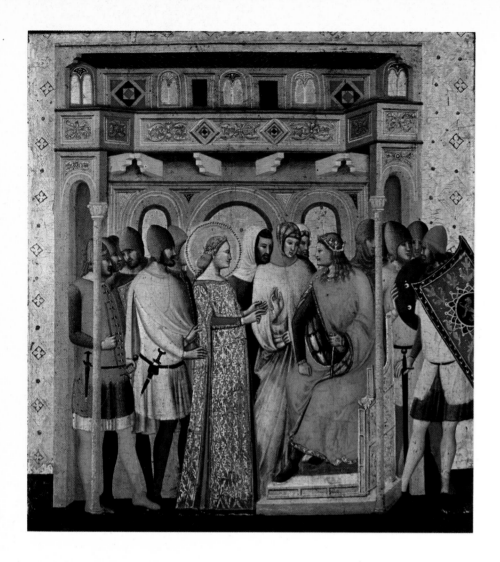

MASTER OF ST. COLOMBA. *Scenes from the Life of St. Colomba.*
St. Colomba, the virgin of Sens, was martyred during the reign of the
Emperor Aurelian. Confined in a house of prostitution, she was rescued
from dishonor by a bear. The same animal saved her again when an
attempt was made to kill her by burning down the cell in which she was
locked. Finally, the Emperor — instigated by the devil — had her dragged
out of town, where she was beheaded by the soldiers. In these three small
panels by an anonymous artist, the main episodes in this legend are repre-
sented with subtle variations in composition and rhythm. In *St. Colomba
before the Emperor* (opposite, above) the courtyard is shown frontally, and
the foreshortening of the architecture does not follow a unified perspective
scheme. The splaying out of the sides appears to enlarge the ground on
which the motionless figures stand. In *St. Colomba Saved by a Bear* (above)
the architectural background and the figures are laid out on diagonal lines,
which are most evident in the beams of the ceiling and in the balcony. Freer
and more animated, the composition of *The Beheading of St. Colomba* (op-
posite, below) is based on the repeating rhythms of the figures, the lances, the
shields and the trees. The line of the hills is reflected in the frail body of
the decapitated saint, which forms an elegant, undulating pattern.

MASTER OF ST. COLOMBA
Anonymous follower of Giotto, active in the
early fourteenth century.
Scenes from the Life of St. Colomba (circa
1340)
Tempera on panel; each of the three panels
21 1/2″ × 21 1/2″.
From the Sessa collection (Cologne Bresci-
ano). The triptych was probably executed for
the old cathedral of Rimini, demolished in
1815, which was dedicated to St. Colomba.
According to a plausible theory that is not
universally accepted by scholars, the panels
belonged to a double-faced composition
placed on the high altar of the cathedral.
Other panels of this work are in the Museé
Jacquemart-André, Paris; the Galleria Sa-
bauda, Turin; and the Friedenthal collection,
Ingenheim.
Above: detail, *St. Colomba Saved by a Bear.*
Opposite, above: detail, *St. Colomba before
the Emperor.*
Opposite, below: detail, *The Beheading of St.
Colomba.*

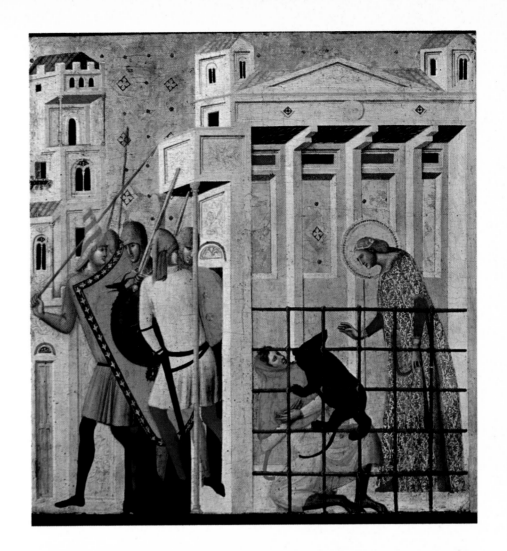

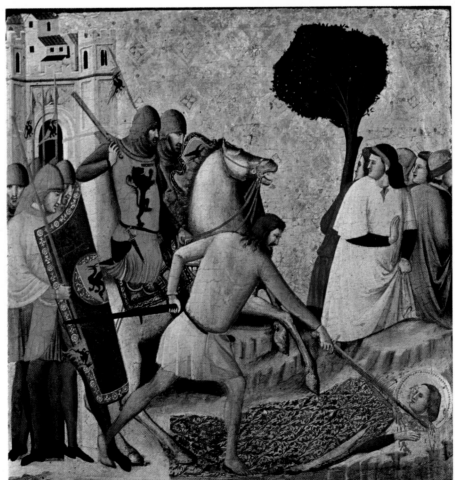

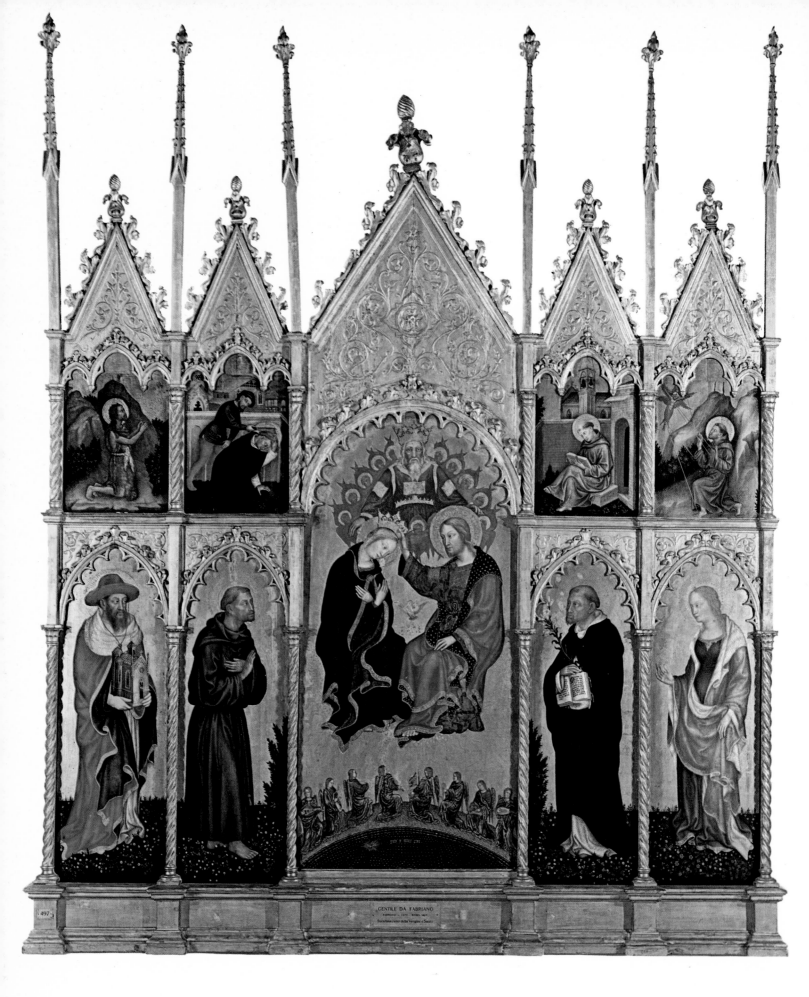

GENTILE DA FABRIANO
FABRIANO · 1370 · ROMA 1427
Incoronazione della Vergine e Santi

GENTILE DA FABRIANO. *Coronation of the Virgin and Saints.*

This polyptych was executed for the convent of Valle Romita at Fabriano around 1400. A familiarity with late fourteenth-century Lombard miniatures and graphic work undoubtedly was an important element in Gentile da Fabriano's training, as is indicated by the clear affinities between his work and that of Michelino da Besozzo. He was also influenced by masters of mixed tendencies, such as Barnaba da Modena and Taddeo di Bartolo, and more incisively by Venetian and Tuscan art.

In the central panel the Virgin is shown being crowned by Christ, in the presence of God the Father and the Holy Ghost. The refined and delicate composition is made up of the three weightless figures — which seem to be disembodied in their draperies — and insubstantial elements, such as the radiant and flaming nimbus that supports the apparition of the Trinity. Curved forms — including the band of angel musicians, the contours of the figures of Christ and the Virgin, and the crowd of seraphim around God the Father — echo the arched shape of the panel.

In the side panels the bodies of the saints also disappear within the fluid coils of their robes. There is a highly refined play of color variations among the four figures. The red, white and gold robe of St. Jerome and the pink and violet costume of Mary Magdalene contrast with the more sober brown of St. Francis' habit and the black of St. Dominic's mantle. St. Francis' bare feet, an attribute of his iconography, are almost disconnected from the figure. The feet of the other figures remain invisible, hidden by their robes and the thick carpet of flowers.

Indifference to the rendering of space and to the relative sizes of figures can also be seen in the smaller panels of the altarpiece. St. John the Baptist and St. Francis, shown kneeling in profile, are squeezed in among rocky peaks without regard to realistic proportions. Similarly, St. Thomas is placed in a narrow garden, hemmed in by the wall and the door which emphasize the atmosphere of private meditation. St. Peter's martyrdom, which is not very sanguinary despite the flow of blood, creates an impact by being brought forward toward the spectator.

GENTILE DA FABRIANO
Fabriano circa 1370 — Rome 1427
Coronation of the Virgin and Saints (circa 1400)
Side panels: *St. Jerome, St. Francis, St. Dominic, Mary Magdalene.* Upper panels (whose sequence has not been definitively reconstructed): *St. John the Baptist in the Desert, The Execution of St. Peter Martyr, St, Thomas Aquinas, St. Francis Receiving the Stigmata.*
Tempera on panel. Central panel 31 1/2" ×

1 5/8"; side panels 15 3/4" × 46"; upper panels 15 3/4" × 23 5/8".
Signed: "GENTILIS DE FABRIANO PINXIT."
The central and side panels came to the Brera in 1811 from the convent of Valle Romita near Fabriano. The four upper panels were acquired by the Gallery from a private owner in 1901. A fifth panel, of the *Crucifixion*, is lost.
Right: detail of *Mary Magdalene.*

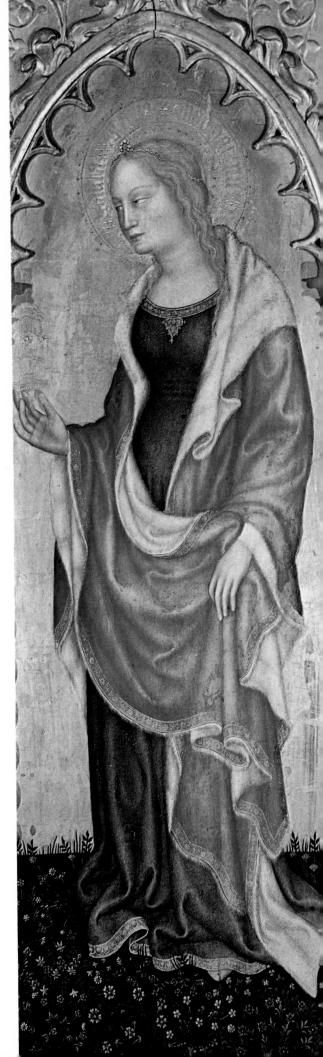

PIERO DELLA FRANCESCA. *The Brera Altarpiece.*

With the *Flagellation* in the Urbino museum (circa 1455) and the diptych of the *Triumph of the Duke and Duchess of Urbino* in the Uffizi (circa 1465), *The Brera Altarpiece* reveals the crucial role played by the artist in contemporary life. As artist, mathematician and thinker, Piero della Francesca was one of the great leaders of the court at Urbino of Federico da Montefeltro. The duke attracted artists and scientists as well as teams of architects, master masons and cabinet makers who spent years building or refurbishing his palaces. Plays he sponsored, such as the *Judgment of Cupid,* in 1474, became famous; and he himself was also celebrated for his library of rare manuscripts.

The six saints are generally identified as St. John the Baptist, St. Bernardino of Siena and St. Jerome, on the left; St. Francis, St. Peter Martyr and St. Andrew, on the right. Kneeling in the foreground is the unmistakable figure of the Duke of Urbino, Federico da Montefeltro. The duke ordered the picture to celebrate the birth of his son, Guidobaldo; it was probably intended for the high altar of the church of St. Bernardino in Urbino. Since the duke received the Order of the Garter in 1474 but is not shown wearing it, and since Guidobaldo was born in 1472, the panel must have been painted between these two dates.

It is possible that Guidobaldo was the model for the Child and that the Virgin — though not highly individualized — portrays Battista Sforza, the Duchess of Urbino, who died soon after the birth of her son. In some passages of the duke's figure, scholars have discerned the hand of an artist who was not trained in Italy. This almost certainly would be Pedro Berruguete, who was in Urbino in 1477.

As the bits of cornice protruding into the picture at the top clearly show, the panel was cut down from its original size, perhaps while it was still in

PIERO DELLA FRANCESCA
Borgo Sansepolcro circa 1410 —
Borgo Sansepolcro 1492
The Brera Altarpiece: Virgin and Child, Six Saints, Four Angels, and Duke Federico II da Montefeltro (circa 1472)
Tempera on panel; 8'1 1/2" × 67".
From the church of S. Bernardino in Urbino, 1811.
In the copies of Piero's work there is only one other such *Sacra Conversazione.* It is composed in the more archaic form of a triptych (now in the National Gallery of Perugia).
On page 26: detail of the architectural back-background.
On page 27: details of the heads of the Virgin and angels.
On page 28: detail of Federico da Montefeltro.

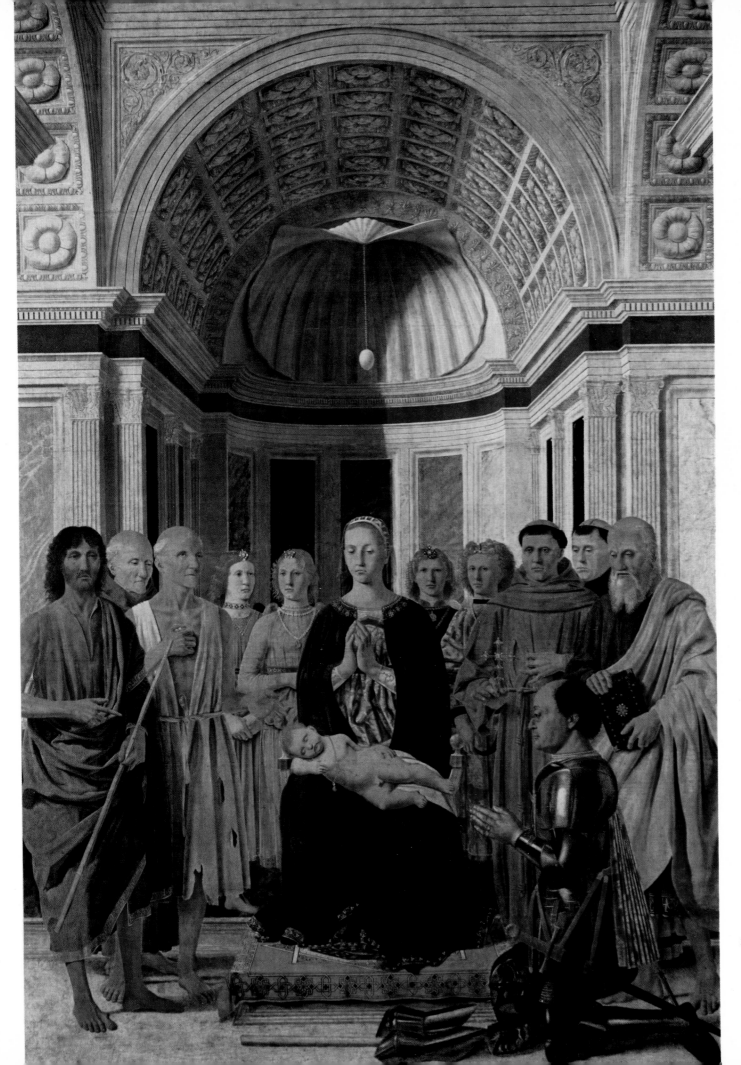

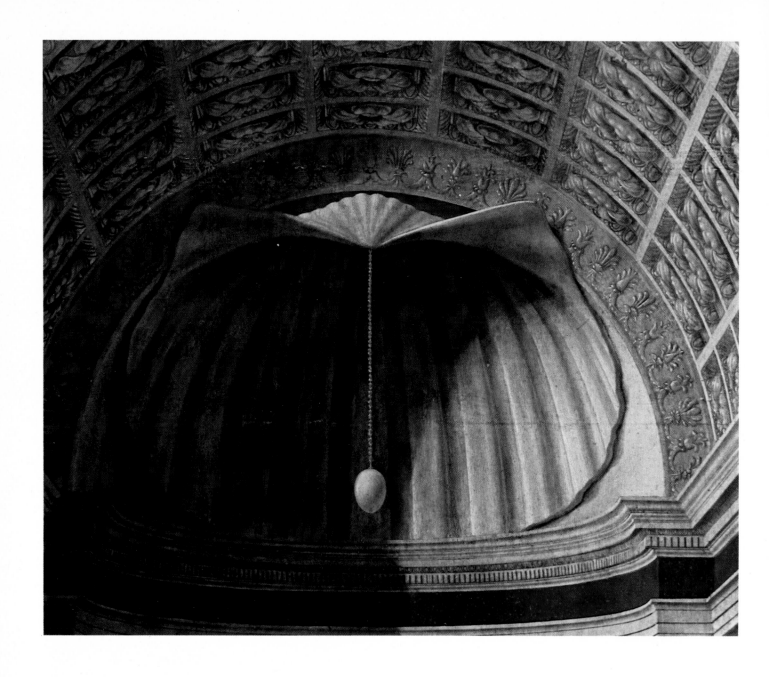

the church of St. Bernardino, in order to fit a particular space. The egg
hanging from the roof of the apse was probably the point where the two
diagonals of the original composition crossed. Besides being the geometrical
fulcrum of the work, the egg is also its symbolic center, as it is a symbol of
creation as well as the basic form of the heads of the figures seen below.
The egg form, in its clarity and immobility, is a summation of the shadow-
less, motionless, clean-cut and splendidly colored world of Piero's paintings.
His sumptuous effects are created by the marbles and intarsias of the back-
ground, the fine robes and draperies worn by the figures, the necklaces and
pins set mainly with pearls, and the magnificent hair of the women, in
which the curls appear like metal coils.

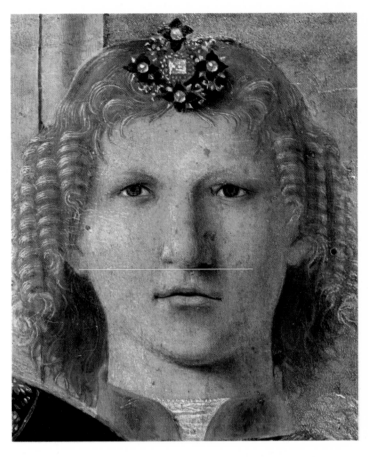

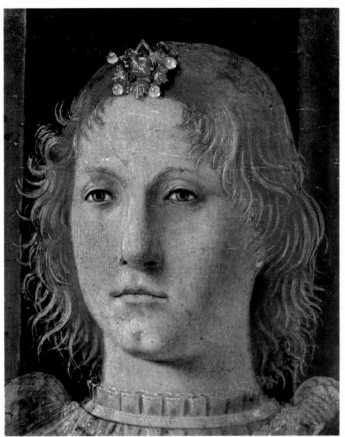

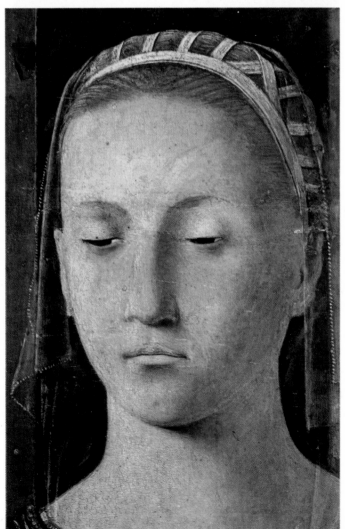

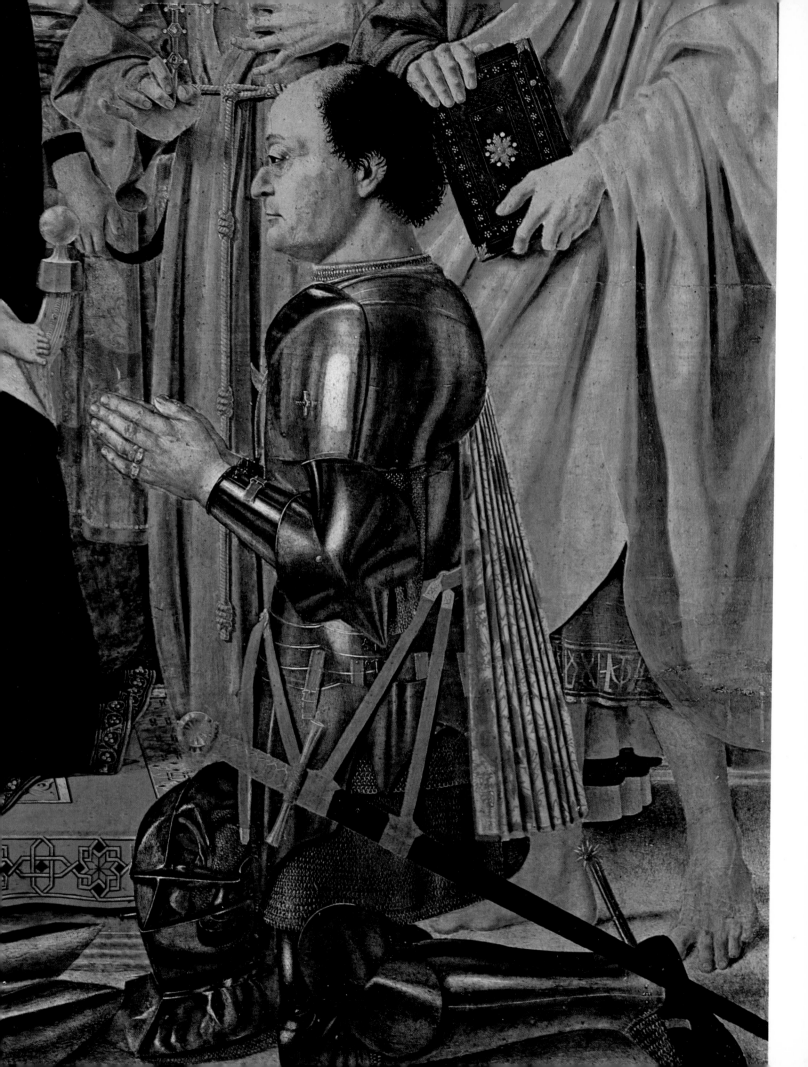

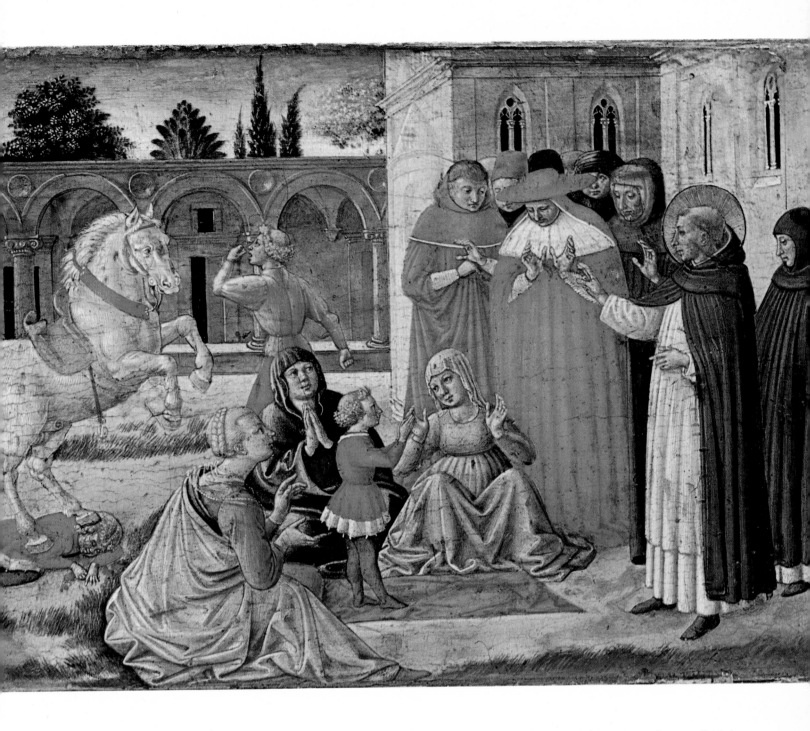

BENOZZO GOZZOLI
Florence 1420 — Pisa 1498
*St. Dominic Resuscitates Napoleone Orsini
Who Has Fallen from a Horse* (1461)
Tempera on panel; 10″ × 13 3/4″.
This is part of an altarpiece with predella
which has been dismembered. The main
panel, *The Virgin and Child Enthroned with
Angels,* is in the National Gallery, London.
The other panels are in Washington (*St.
John the Baptist*), Berlin (*St. Zenobius*),
Philadelphia (*Purification of the Virgin*),
and New York (*St. Peter*). Acquired in
1900.

BENOZZO GOZZOLI. *St. Dominic Resuscitates Napoleone Orsini
Who Has Fallen from a Horse.*

This little panel was part of a predella from an altarpiece of the *Madonna,
Angels and Saints,* which was commissioned by the Confraternity of the
Purification of the Virgin, in Florence. On October 23, 1461, the contract
for the painting was drawn up. It is a remarkable document in the number
and precision of its stipulations and instructions. The painter was asked to
use Fra Angelico's altarpiece at S. Marco as a model and to execute the
entire work by his own hand, with the greatest care. One clause stated that
". . . the said painting must go beyond all the good painting done up to

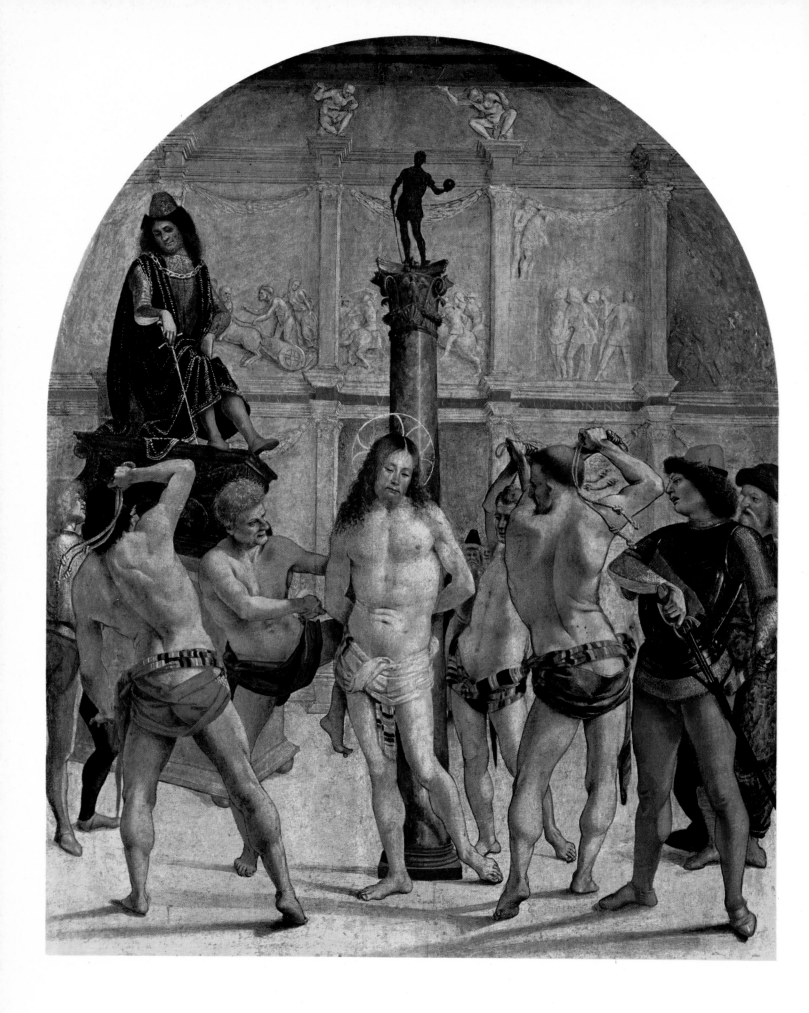

now by the said Benozzo, or at least should be comparable in quality . . ." The artist scrupulously observed the conditions of the contract. His composition is clearly articulated, with the initial episode of the narrative placed in the middle ground. The culminating moment of the miracle is brought forward toward the spectator by the figures of the women and the monks, who are following the silent dialogue between the saint and the resuscitated child.

LUCA SIGNORELLI. *The Scourging of Christ.*

This work reveals the broad influences on the young artist, who had closely studied the work of Piero della Francesca, Melozzo da Forlì, Perugino and Francesco di Giorgio. The example of Pollaiolo can be seen in the creation of space by means of the harmonious placement of the figures in a circle around Christ. A classicizing atmosphere is created by the relief running across the foreground, which places the scene on a stage and separates it from the spectator. Other classicizing elements are the column bearing an idol, and the simulated bas-reliefs of the background wall, which recalls the *scaena* of an ancient Roman theater.

DONATO BRAMANTE. *Man with a Halbard.* p. 32

This painting, *Man with a Broadsword,* and *Man-at-Arms* (all on page 32) are part of the Panigarola fresco cycle. The original placement of the frescoes required the spectator to view them from below. In that position these soldiers appeared to loom up and hang over the spectator, their gigantic forms seeming to emerge from their architectural frames. The firm perspective and luminous clarity of the composition display the artist's desire to deal in absolute abstract form.

Influenced by his background as an architect, Bramante has created here a clearly defined space in which to place his heroic figure. The young soldier, caught as he turns slowly away from the spectator, has been posed so as to highlight the three-dimensionality of the architectonic niche. The halbard (which cannot be seen in this detail) creates an effect of depth, as does the seemingly sculptured drapery on the shoulder.

DONATO BRAMANTE. *Man with a Broadsword.* p. 32

A certain exuberance in the architectural details of the niche, as well as the lucid, incisive form of the drapery and the hair, show the probable influence on Bramante of north Italian art. The example of Melozzo da Forlì and Mantegna is also apparent. Bramante's desire to make the figure heroic, and the frozen violence of the Roman pose, give the composition a remote rarefied air.

DONATO BRAMANTE. *Man-at-Arms.* p. 32

The emphasis placed on features such as the tufts of the beard and the tiny wrinkles of the face lend an almost caricatural tone to this parade figure. Bramante has also given careful attention to such psychological details as the glance of the eyes and the somewhat disdainful cut of the mouth.

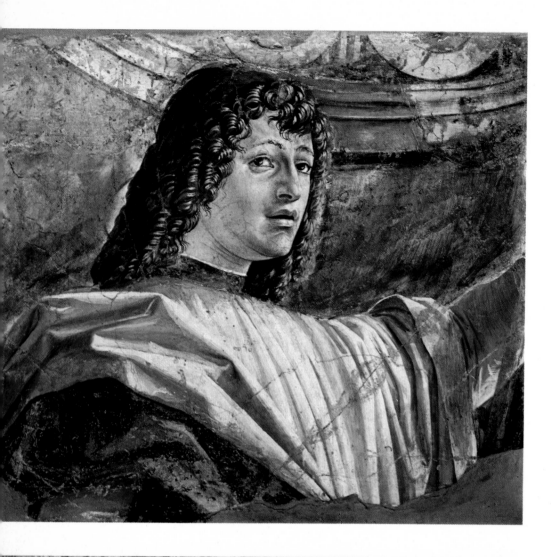

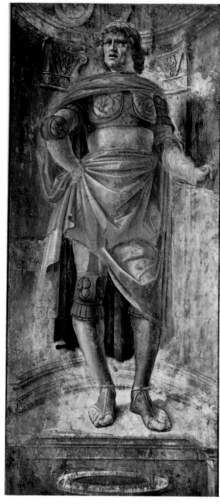

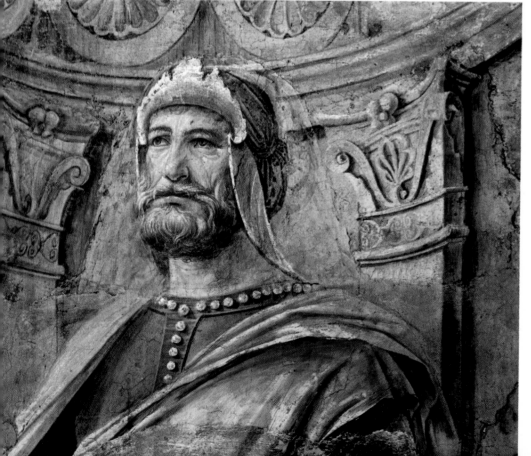

Above, left:
DONATO BRAMANTE
Monte Adrualdo 1444 — Rome 1514
Man with a Halbard (circa 1481)
Detail.
Fresco transferred to canvas;
38 1/4″ × 45 1/4″.
From the old house of the Panigarola family,
later owned by the Prinetti, where it deco-
rated the so-called Barons' Hall. Detached
and removed to the Brera Gallery in 1901.
It is likely that this painting, as well as the
entire fresco cycle, was commissioned by
Gottardo Panigarola, Chancellor to Gian
Galeazzo Sforza, Duke of Milan. According
to Lamazzo, the cycle portrays the most
famous men-at-arms of the time: Pietro
Suola the Elder, Giorgio Moro da Ficino
and Beltrame.

Above, right:
DONATO BRAMANTE
Man with a Broadsword (circa 1481)
Fresco transferred to canvas;
9′4 1/4″ × 4′2″.

Left:
DONATO BRAMANTE
Man-at-Arms (circa 1481)
Fresco transferred to canvas;
35 1/2″ × 44 1/2″.

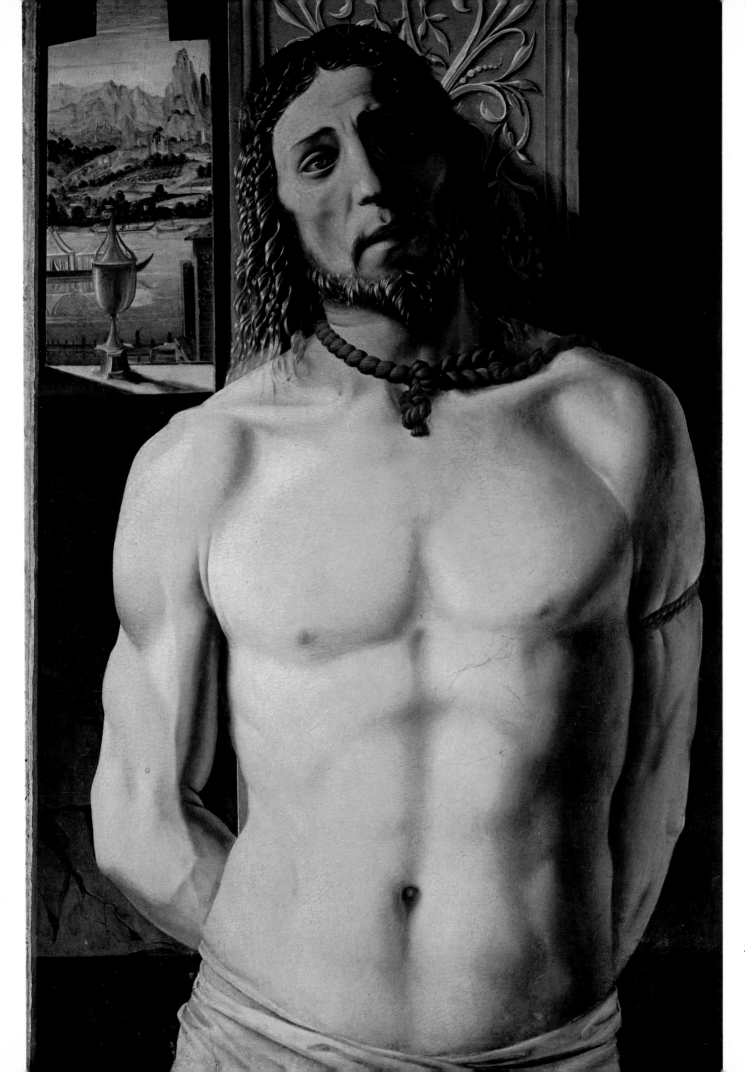

33

DONATO BRAMANTE. *Christ at the Column.* *p. 33*

The composition is built up below by conical forms that are polished by the light and finely modeled by gradations of light and shade. Above, these effects are dissipated by an emphasis on detail, as in the ornamentation of the pilaster and the uneasy linearity of the pathetic face. The atmosphere of unreality which pervades the picture is stressed by the glimpse of a violently lighted landscape in the upper left background. The pyx standing on the windowsill helps establish the vast distance of the view; by contrast, the narrow cell in which the lividly nude Christ has been placed is revealed in all its turgid bareness.

RAPHAEL. *The Marriage of the Virgin.*

Although more ambitious and complex, this painting reflects the influence of *Christ Giving the Keys to St. Peter,* the fresco executed by Raphael's master, Pietro Perugino, twenty years earlier in the Sistine Chapel. A more immediate inspiration was the architectonic compositions and figures of Piero della Francesca and Donato Bramante.

The polygonal temple in the style of Bramante establishes and dominates the structure of this composition, determining the arrangement of the foreground group and of the other figures. In keeping with the perspective recession shown in the pavement and in the angles of the portico, the figures diminish proportionately in size. The temple in fact is the center of a radial system composed of the steps, portico, buttresses and drum, and extended by the pavement. In the doorway looking through the building and the arcade framing the sky on either side, there is the suggestion that the radiating system continues on the other side, away from the spectator.

Caught at the culminating moment of the ceremony, the group attending the wedding also repeats the circular rhythm of the composition. The three principal figures and two members of the party are set in the foreground, while the others are arranged in depth, moving progressively farther away from the central axis. This axis, marked by the ring Joseph is about to put on the Virgin's finger, divides the paved surface and the temple into two symmetrical parts.

A tawny gold tonality prevails in the color scheme, with passages of pale ivory, yellow, blue-green, dark brown and bright red. The shining forms appear to be immersed in a crystalline atmosphere, whose essence is the light blue sky.

34

On page 33:
DONATO BRAMANTE
Christ at the Column (circa 1490)
Tempera on panel; 36 1/2″ × 24 1/2″.
From the Abbey of Chiaravalle, near Milan. Mentioned by Lomazzo in *Idea* as a work by Bramante, other critics ascribe the painting to Bramantino. Still others see it as a collaboration between the two artists.

RAPHAEL
Urbino 1482 — Rome 1520
The Marriage of the Virgin (1504)
Oil on roundheaded panel; 67″ × 46″.
Signed and dated:
"RAPHAEL URBINAS MDIIII."
The panel was commissioned by the Alberini family for the chapel of St. Joseph in the church of S. Francesco of the Minorities at Città di Castello. In 1798 the town was forced to donate the painting to General Lechi, a Napoleonic army officer, who sold it to the Milanese art dealer, Sannazzari. Sannazzari bequeathed it to the main hospital of Milan in 1804. Two years later it was acquired by the Academy of Fine Arts and was then exhibited at the Brera.
On page 36: detail of the Virgin and attendants.
On page 37: detail of the temple.

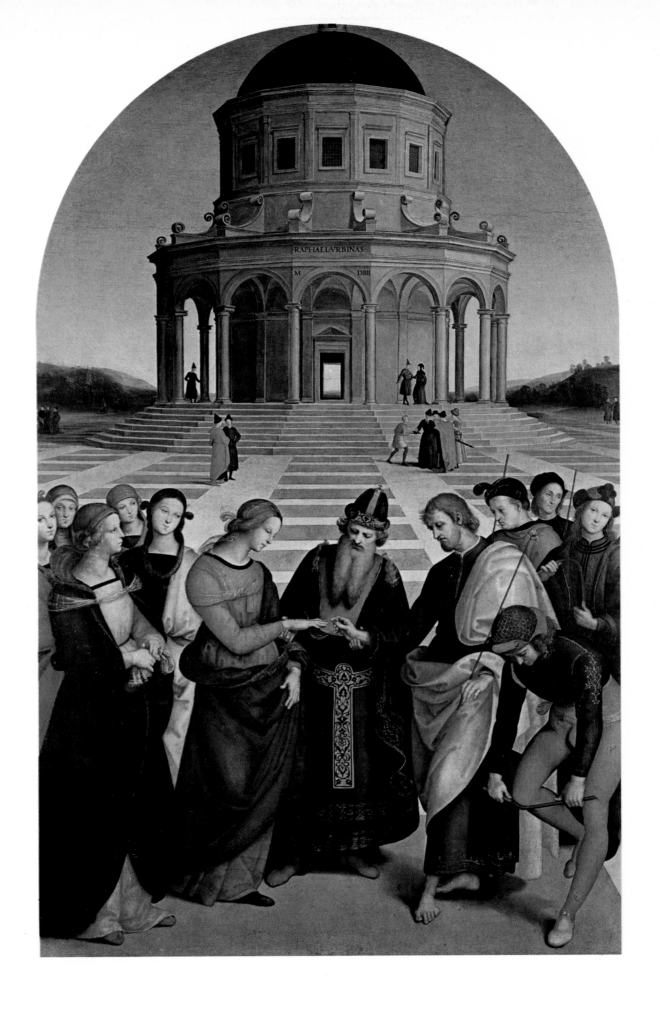

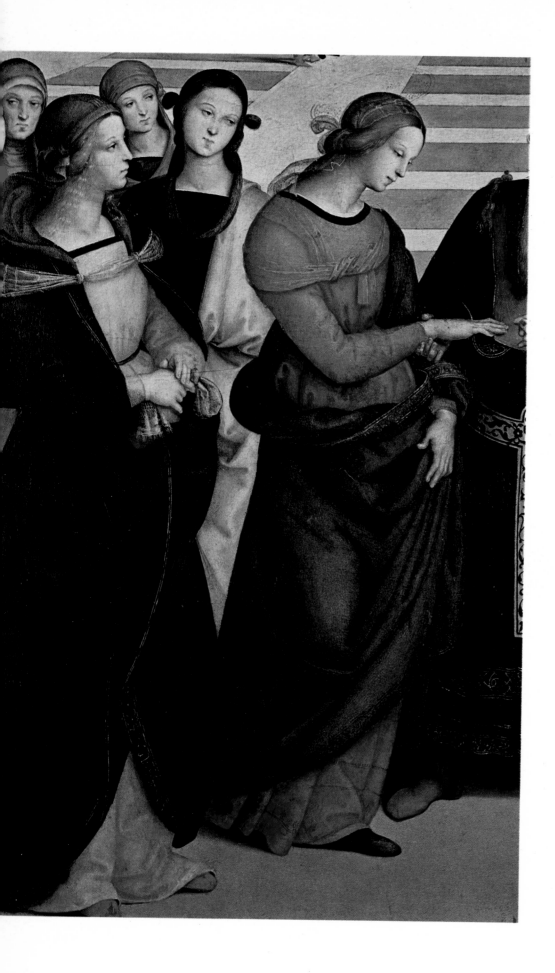

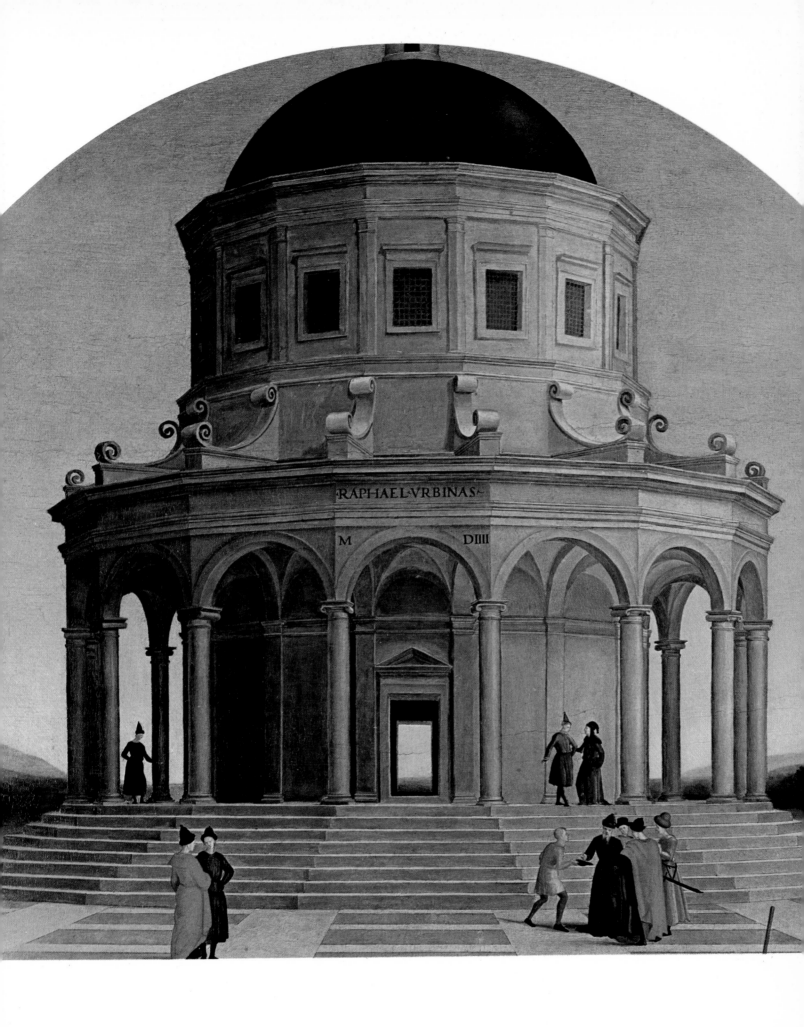

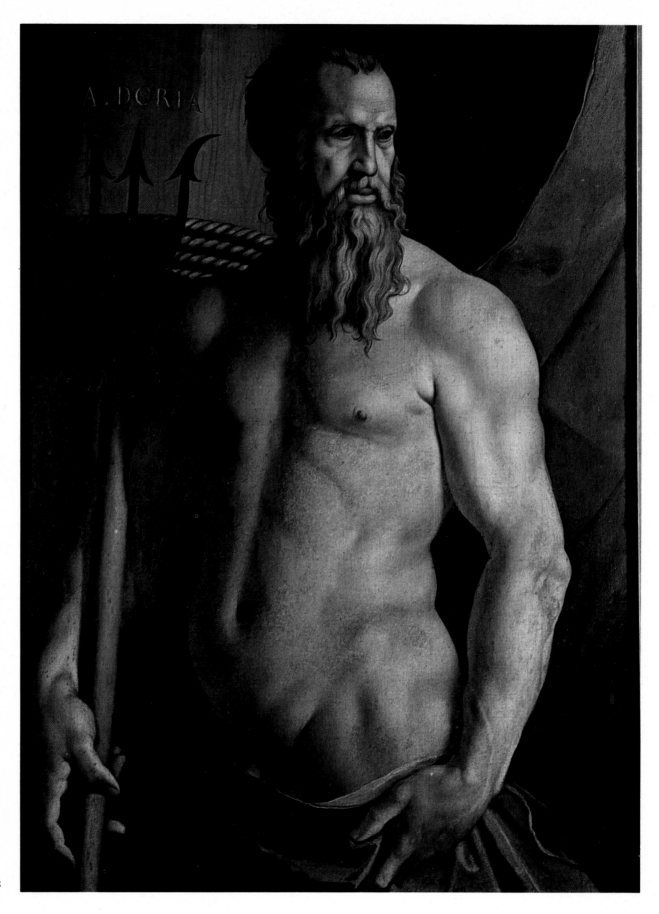

38

AGNOLO BRONZINO. *Portrait of Andrea Doria as Neptune.*

This painting of Andrea Doria — the Genoese condottiere who commanded the combined fleets of Venice, the Pope and the Emperor in their victory over the Turks — is a significant example of Bronzino's work as a portraitist of the aristocracy. Bronzino's more famous portraits of Lucrezia and Bartolomeo Panciatichi, Eleanora of Toledo and Laura Battiferri depict a class that was conscious of its nobility, set in immobile poses, with flawless alabaster skin and sumptuous clothes. In this painting, however, the allusion to ancient lineage had to be balanced by easily recognizable classicizing elements, both in style and in the identification of the subject with the marine god. This explains the use of a pictorial repertory derived from Michelangelo as well as from the portraits of Doria by Bandinelli and Sebastiano del Piombo.

ORAZIO GENTILESCHI. *SS. Cecilia, Valerianus and Tiburtius.*

pp. 40–41

The painting depicts the appearance of an angel to Valerianus and Cecilia, a young couple who had been converted to Christianity. Cecilia had taken a vow of chastity and had persuaded her husband to do likewise. Valerianus had suspected her of secretly being in love with his friend Tiburtius but the angelic apparition allays his doubts while also heralding their approaching martyrdom.

The composition — showing the three sumptuously dressed saints as they express with dignity their astonishment over the apparition of the angel — incorporates the main elements of Gentileschi's art. It represents a high point of his maturity, ranking with the *Madonna* of the Rosei family and the *Annunciation* in Turin. The disciplined, orderly construction has a Neoclassical stamp that derives from the artist's Tuscan background. The handling of the light shows the fundamental influence of Caravaggio, while

AGNOLO BRONZINO
(ANGELO TORI or ALLORI)
Monticelli (Florence) 1503 — Florence 1572
Portrait of Andrea Doria as Neptune
(1550-55)
Oil on canvas; 45 1/4″ × 21″.
Inscribed at upper left: "A. DORIA."
Vasari mentioned this portrait in his biography of Bronzino. It was acquired in 1898 from the descendants of Paolo Giovio, who had an extensive collection of portraits of famous men.

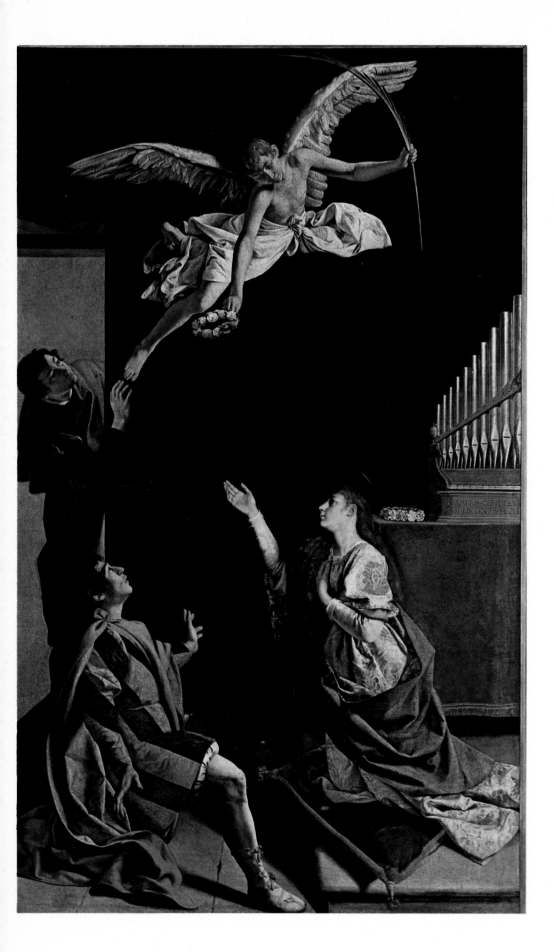

ORAZIO GENTILESCHI
(ORAZIO LOMI)
Pisa circa 1565 — London circa 1640
SS. Cecilia, Valerianus and Tiburtius
(circa 1620)
Oil on canvas; 11′ 5 3/4″ × 7′ 1 3/4″.
Signed: "ORATIUS GENTILESCUS
FLORENTINUS."
The painting was acquired in 1805, and
probably comes from the Marches.
Right: detail.

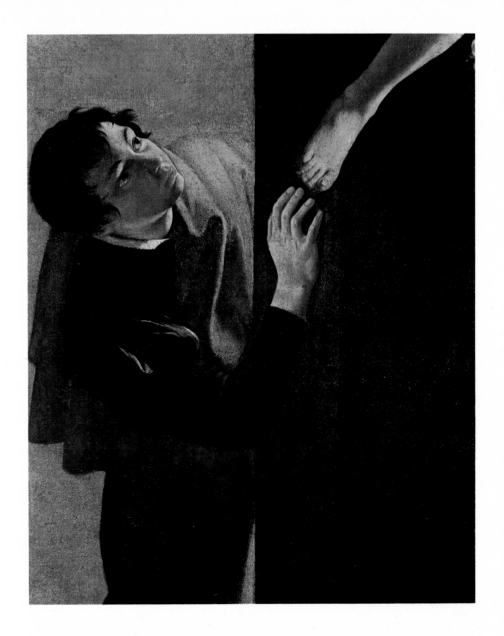

the refinement of the surfaces in the gleaming satin and damask draperies
and the soft warmth of the velvets are inspired by Bronzino. Typical of
Gentileschi are the arrested gestures standing out against the opaque
shadow of the austere interior; the figure of Tibertius, silhouetted against
the light as he cautiously peers at the angel; the system of curves formed
by the wings, the body and the long palm branch of the angel in flight;
and the outstretched arms of St. Cecilia and St. Valerianus. The structural
elements of the composition are striking: the link between Tibertius' hand
and the angel's foot; the alignment of the palm branch and the organ pipes,
and the wreath of flowers, St. Cecilia's hand and St. Valerianus' knee; and
the parallels formed by the figures of St. Valerianus and St. Cecilia, the
organ pipes and the door frame, the keyboard and the dais. Every element
is brought into complex play in this highly articulated composition, from
the tips of the wings and the palm branch to the edge of the red mantle,
St. Valerianus' foot and the velvet cushion.

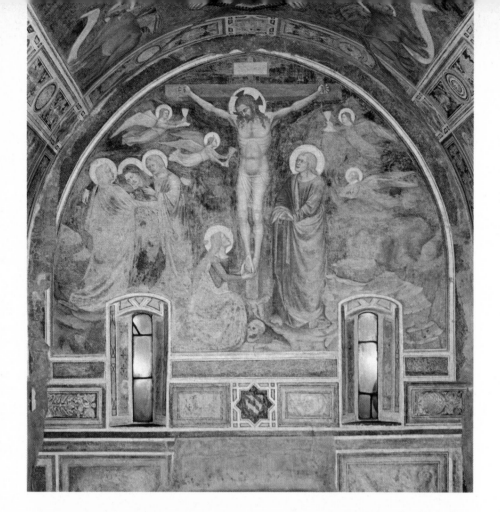

LOMBARD MASTER OF THE
14TH CENTURY
Crucifixion (1370)
Detached fresco; 12'4 3/4" × 9'1".
From the old oratory of the Porro family at
Mocchirolo, near Milan. The fresco was re-
moved to the Brera in 1949. Some scholars
attribute this work to Giovanni da Milano.
Right: detail.

LOMBARD MASTER OF THE
14TH CENTURY
The Virgin and Donor (circa 1370)
Detached fresco; 10' 7 1/4" × 7' 1 1/2".

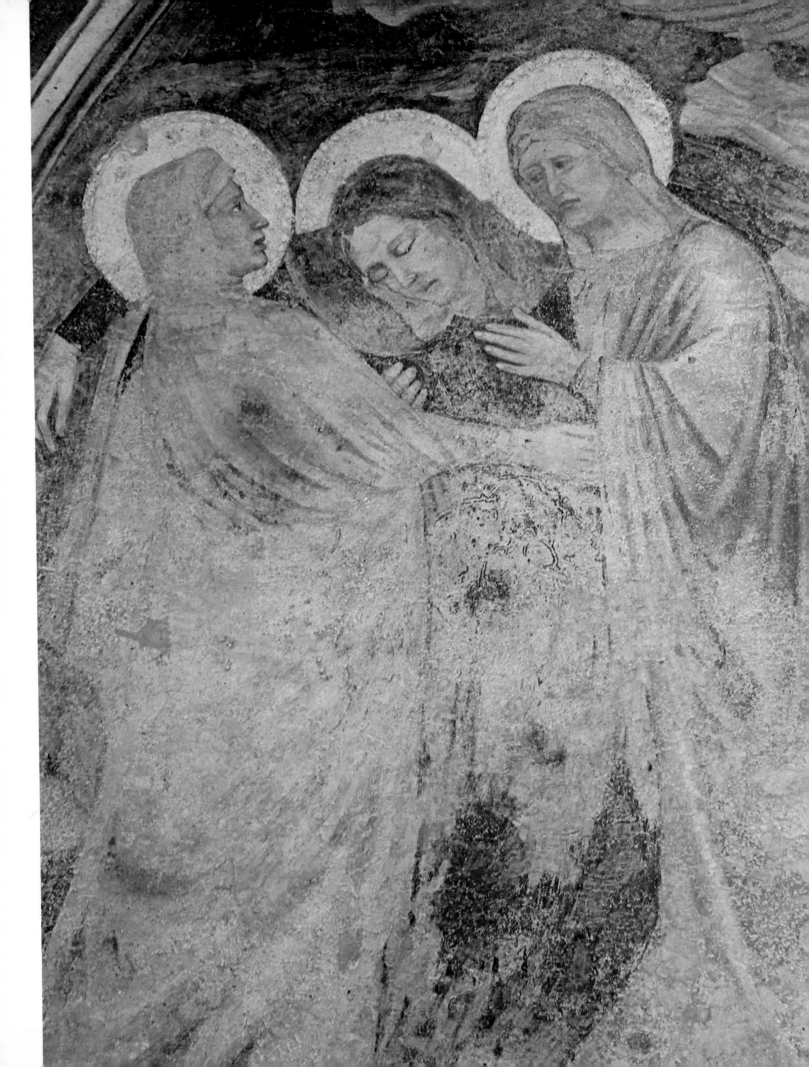

LOMBARD MASTER OF THE 14TH CENTURY. *Crucifixion*
and *The Virgin and Donor.* *pp. 42–43*

These two frescoes from the oratory of Mocchirolo constitute one of the most interesting and complete examples of the spreading influence of Tuscan art in northern Italy during the late fourteenth century. Count Porro, who commissioned the decoration of the oratory, is shown kneeling before the Madonna in *The Virgin and Donor*. Controlled and contained in feeling, the dramatic aspects of the tragedy of the *Crucifixion* are expressed in the noble pathos of the swooning Madonna. To maintain the equilibrium of the composition, the outward movement of her body is countered by the angels in flight and the columnar figure of St. John. The modeling of the figures, achieved through gradations of intense color, complements the measured narrative rhythm. In the portraits of the donors (members of the Porro family) on the walls, and in the figure of St. Catherine, the drawing is light and precise. In both paintings the roseate color is laid on in thin, transparent brushstrokes, and the tenuous compositional connections have an elegant subtlety.

VINCENZO FOPPA. *Madonna and Child with St. John the Baptist and
St. John the Evangelist.*

This fresco is fundamental to Foppa's career. The simple surface divisions of his earlier work have been replaced by representations of fully three-dimensional architecture. The grandiose barrel vault of sculptured profiles, set in medallions in the tympanums, shows the influence of Bramante. The fullness of the compositional forms and their spectacular effect, as well as the triumphant character of the Madonna, reveal Foppa's intimate lyric qualities. His lyricism is seen at its strongest in the harmonies of subdued blues, reds and greens, and in the silvery chiaroscuro of Mary's face, which is a miraculous transformation of light into substance.

VINCENZO FOPPA
Brescia circa 1427 — Brescia circa 1515
*Madonna and Child with St. John the
Baptist and St. John the Evangelist* (1485)
Fresco transferred to canvas;
5′ 7″ × 6′ 2 3/4″.
Inscribed "MCCCCLXXXV DIE X
OCTVBR" on the lower fillet of the parapet.
Originally in the sacristy of S. Maria di Brera, it was removed in 1808 when the church was dismantled. The fresco was formerly attributed to Bramantino.

VINCENZO FOPPA. *Altarpiece.* *pp. 46–47*

This altarpiece belongs to Foppa's early stylistic maturity and retains the archaizing tendency toward simplification of his youthful period, before he was influenced by Leonardo and Bramante. It also shows the pungent impetuosity of Mantegna's influence in the sharply drawn perspective, and in the tension and almost metallic consistency of the forms. In this resplendent altarpiece, the central panels are particularly fine examples of Foppa's masterly interweaving of color and light. The Madonna's face, lightly thrown into relief, concludes a series of circling motifs enhanced by the elegant twist of the body of the Child, as he leans over to pluck the string of the lute. In the panel above, St. Francis appears as a motionless, somewhat astonished figure immersed in the limpid air of a lyric landscape.

44

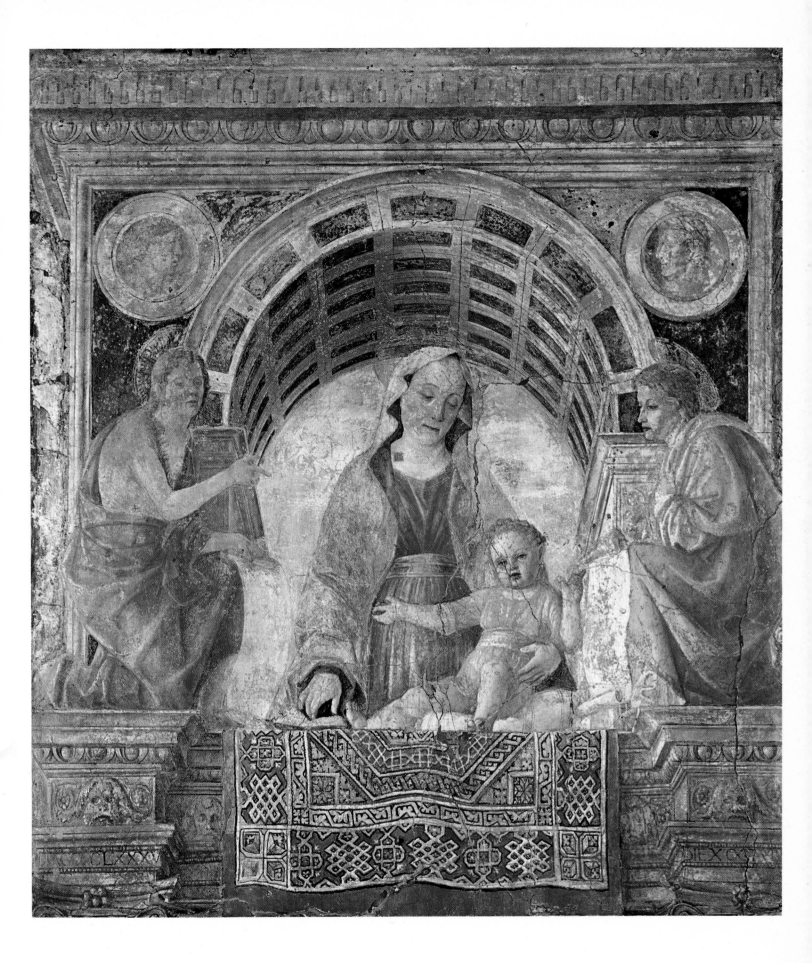

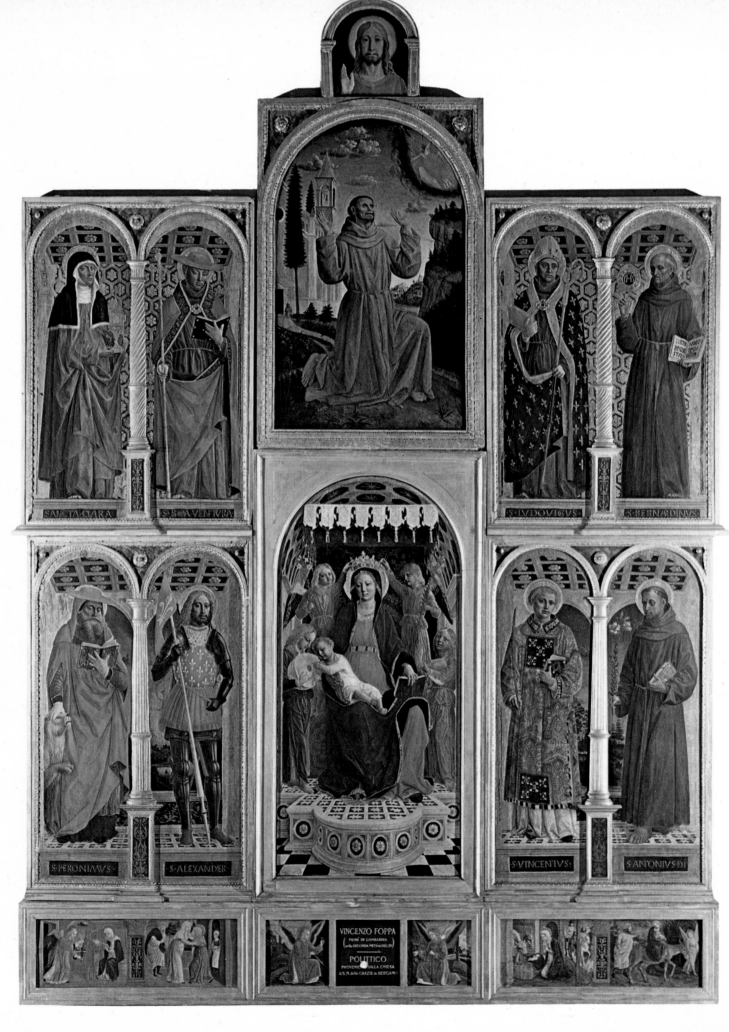

SANCTA CLARA S. BOAVENTURA S. LVDOVICVS S. BERNARDINVS

S. PERONIMVS S. ALEXANDER S. VINCENTIVS S. ANTONIVS DI

VINCENZO FOPPA
FIORI IN LOMBARDIA
nella SECONDA METÀ del SEC. XV

POLITTICO
PROVENIE DALLA CHIESA
di S. M. delle GRAZIE in BERGAMO

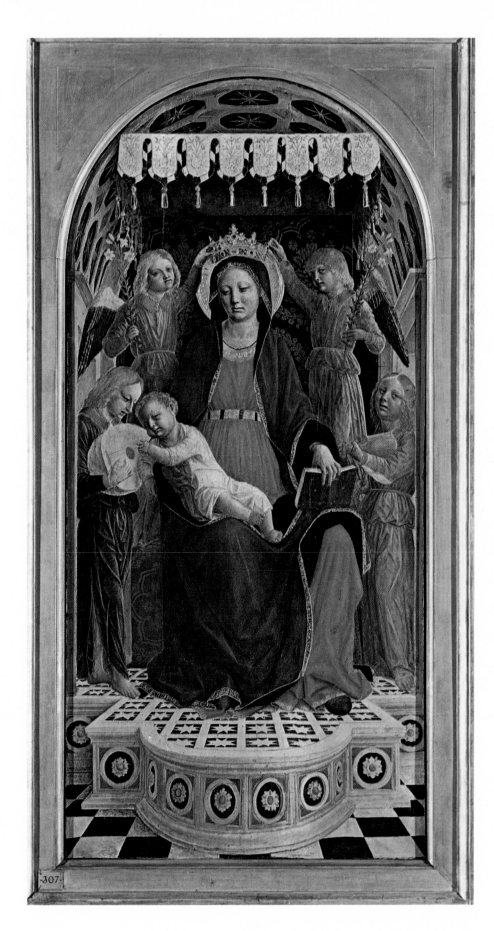

VINCENZO FOPPA
Altarpiece (1476)
Tempera on panel; central panel 65″ × 31 1/2″, side panels 54″ × 15 1/4″, upper side panels 49 1/2″ × 15 3/4″, the *St. Francis* panel 50 1/4″ × 32 1/4″. Each of the three predella panels showing scenes from the *Life of Christ* 34 1/4″ × 11 3/4″, and the two *Angels in Adoration* 10 1/2″ × 11″.
Formerly in S. Maria delle Grazie at Bergamo, it was removed to the Brera in 1811. The predella and the crowning panel were acquired from the Albani collection in 1811. It is not certain that the predella and the crowning element originally formed part of the same altarpiece; and the accuracy of the entire reconstruction is in doubt.
Right: detail.

47

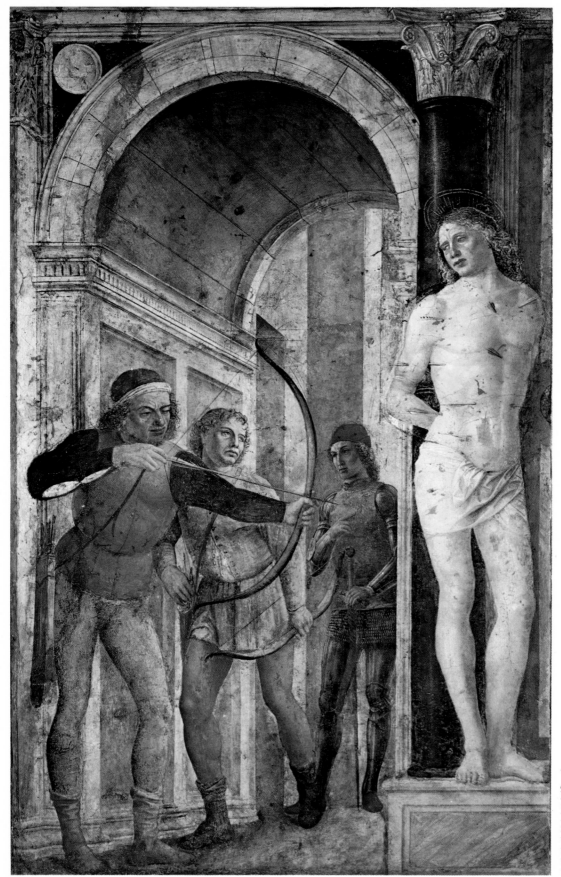

VINCENZO FOPPA
St. Sebastian (circa 1489)
Fresco transferred to canvas;
8′ 9 1/2 × 5′ 8″.
Formerly in the sacristy of S. Maria di Brera, it was removed to the Gallery in 1808. Companion frescoes showing St. Roche and the Glory of Angels (ceiling of the chapel) have been lost.

48

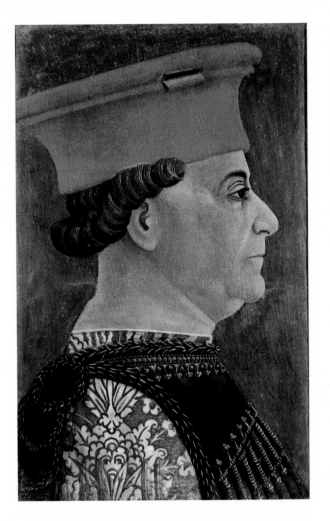

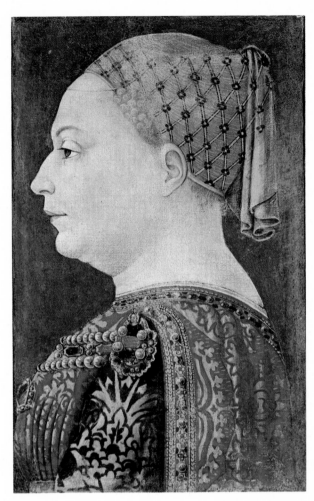

VINCENZO FOPPA. *St. Sebastian.*

In its original position in a chapel in S. Maria di Brera, this fresco had greater visual impact, with the archers appearing illusionistically before the spectator as if they had come out from behind the wall. For this reason the painting was admired and praised by art historians beginning with Lomazzo in the sixteenth century. Today the work appears somewhat labored, the figures anatomically and physiognomically overdone, and the broad composition perhaps a little vacuous. One can, of course, still admire the technique and the masterly use of light, which defines the forms and gives them a silvery cast.

BONIFACIO BEMBO. *Portrait of Francesco Sforza.*

The customary fifteenth-century scheme for portraiture used here is much closer to Pisanello's interpretation of the form than to Piero della Francesca's or Pollaiolo's versions. Francesco Sforza, Duke of Milan from 1450 to 1466, is portrayed with a certain surface realism, but the main intent is to show him as a polite and princely figure rather than a heroic one, which

49

is perfectly in tune with the painter's archaic International Gothic taste. The seignorial profile has the incisive quality of a classic medallion or cameo.

BONIFACIO BEMBO. *Portrait of Bianca Maria Sforza.* *p. 49*
By means of an extremely delicate laying on of the tempera, Bembo has built up the face in diaphanously transparent layers that are perhaps a trifle cold. The masses achieve a quality of relief that is contained by the refinement of the color and the elegance of the descriptive details.

Opposite, left:
BERGOGNONE
(AMBROGIO DA FOSSANO)
Active in Lombardy and Milan between 1481
and 1522.
St. Catherine of Alexandria (1495)
Detached fresco; 67" × 36 1/4".
From the church of S. Satiro, Milan. After
its discovery in 1865, the fresco cycle to
which this work belongs was detached and
progressively moved to the Brera during the
late nineteenth century. At one time, the sig-
nature and date, "Ambrosius Bergognonis
1495," could be read below the figure of St.
Catherine.

Opposite, right:
BERGOGNONE
St. Agnes (1495)
Detached fresco; 35 1/2" × 67".

BERGOGNONE. *St. Catherine of Alexandria.*
The aristocratic appearance of this female figure is based entirely on the
circling patterns of the robe, which builds up an ogee form embracing
vibrant spatial rhythms. These are most marked in the arm, the wheel and
the somewhat heavily rendered drapery. The well-mannered monumentality
is enhanced by the yellow color. In the embroidery of the bodice the
yellow has the quality of a goldsmith's work; it ripples as if there were a
slight movement in the air.

BERGOGNONE. *St. Agnes.*
Similar to the preceding work, this composition shows its refinements in the
architectural framework rather than in the ornamentation of the subject.
The figure of the saint is harmoniously constructed, with her arms in
subdued counter-movement, one lightly bent and the other extended. The
turn of the head is admirably shown and harmonizes with the movement
of the body. Incorporeal, Agnes emerges as if freeing herself from the large,
circling folds of her dress, which is much lighter and more diaphanous
than the silk of the big sleeves. She appears to emerge not only from the
sumptuous garb but also from the niche in which she stands. Her hand
touching the pilaster decorated with intarsia emphasizes the three-
dimensional space of the architectural background.

BERGOGNONE. *Madonna and Child, St. Catherine and the Blessed
Stefano Maconi.* *p. 52*
The background of this small panel records the lyrical feeling of a calmly
contemplated landscape. Seen with an eye for detail, the panorama in-
cludes a path going up to the church, two horsemen in conversation, a
view of the town, and figures in a boat. The intensity of the background is
to some extent dissipated by the foreground of the painting. Here the some-
what distracted and independent compositional device of the heads re-
volving around the Child suggests a desire to create an effect of distinction
and beauty that the delicate forms can scarcely sustain. In the gestures of
the hands plucking at the air or touching things without grasping them (the **51**

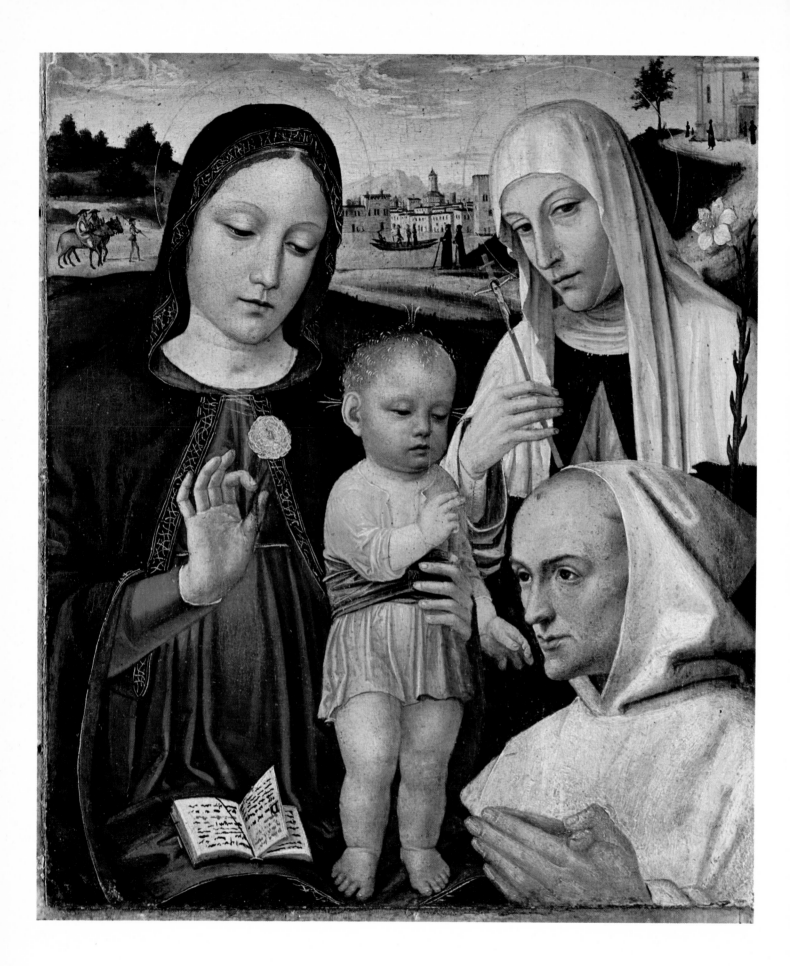

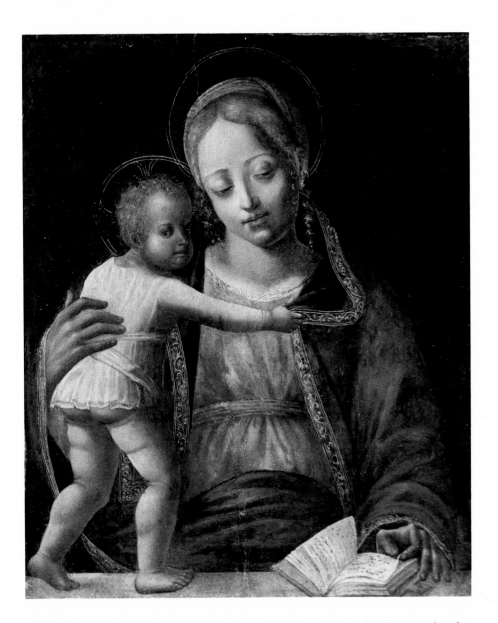

BUTINONE
Lombardy (Treviglio) circa 1450–1507(?)
Madonna and Child (circa 1490)
Tempera on panel; 13″ × 11″.
Acquired in 1901.

BERGOGNONE
*Madonna and Child, St. Catherine and the
Blessed Stefano Maconi* (circa 1490)
Oil on panel; 17 3/4″ × 15 1/4″.
Acquired in 1891.

Madonna's carnation, St. Catherine's crucifix), there is almost the in-
genuousness of a miniature painter. Another instance is the Virgin's
mantle, which swells up to support her prayer book. As a whole, however,
the composition is complex and almost scholarly. Two diagonal connec-
tions are set up, not merely to divide the surface of the work but to create
a spatial perspective. They connect the figures above and below, and in-
versely link the foreground and middle ground, converging in the figure of
the Child or rather in the tangle of hands in the middle. Foppa's silvery
hues have become here a tremulous gray, which extends from the draperies
into the faces and the hands. A high note is struck by the yellow of the
Child's shirt, and there is a sober response in the color harmonies of the
Madonna's robes.

BUTINONE. *Madonna and Child.*
The form of this painting is almost harsh, as if hammered out rather than
modeled, and the contours are as incisive as if they had been scratched 53

into the surface. In part, color dominates the form and has a perspective function, giving the planes their distance in depth. The overall effect is that of a painted bas-relief, in which the color is subtle rather than bold. Accordingly, the work reflects the two major influences on Butinone: Mantegna and Foppa. At the same time, Butinone reveals his taste for virtuoso detail in the Child's pleated shirt, the hair filleted with red-gold and the mannered gesture of the Madonna's hands as they leaf through the book.

BRAMANTINO. *Crucifixion.*

A late work, this painting reveals Bramantino's background. His roots were in the art of Ercole de' Roberti, the most energetically emotional fifteenth-century painter in northern Italy. It is from this source that Bramantino drew his highly dramatic style, which led him to freeze the tragedy of the Crucifixion within a framework of lucid abstraction. At the same time he seized the opportunity to seek out new means of formal expression. The crosses of the two thieves are arranged in terms of a centralized perspective, creating a space almost like an interior, and leading directly to the background where typical Bramantino buildings are silhouetted against an evening sky. (One of the buildings resembles the Trivulzio mausoleum, which was designed by the artist.) The marked bisymmetry of the painting, with angel and demon, sun and moon, is less structured in the choral rhythm of the foreground. The Madonna's grief is represented within the circle described by the hands of the saints, while the Magdalene lifts her arms toward the cross as if to raise it up to heaven. A strict intellectual approach dominates the color scheme, in which subdued olive greens, golden grays and browns predominate.

BRAMANTINO. *Holy Family.* p. 56

Constructed on a series of triangular rhythms heightened by the violent tension of the drapery, which seems to absorb the figures, the composition has a rarefied atmosphere. Every gesture assumes an almost hieratic dignity, and every figure tends to take on an architectonic fixity. The figure of the Christ Child violently escapes from this formal severity. The audacious, almost explosive gesture of his arms seems to introduce the more serene and contemplative effect of the background, in which unreal, almost stage-set buildings stand out against the luminous sky. The buildings recall Bramantino's work as an architect and architectural theoretician. Of his work in this field, only the mausoleum for the Trivulzio family in Milan has survived.

BRAMANTINO. *Madonna and Child with Two Angels.* p. 57

This work shows, in the relationships between figures and landscape, the innovations that Bramantino brought to Lombard painting. His drive toward "cubist" abstraction is less intense, finding expression only in the base supporting the figures, with its unusual motif of stylized palm leaves

BRAMANTINO
(BARTOLOMEO SUARDI)
Lombardy circa 1465 — Milan 1530
Crucifixion (circa 1515)
Oil on canvas; 12'2 1/2" × 8'10 1/4".
This painting was among the first acquired by the Gallery, and may have come from the church of S. Maria di Brera. At one time it was probably an organ shutter. It was formerly attributed to Bramante.

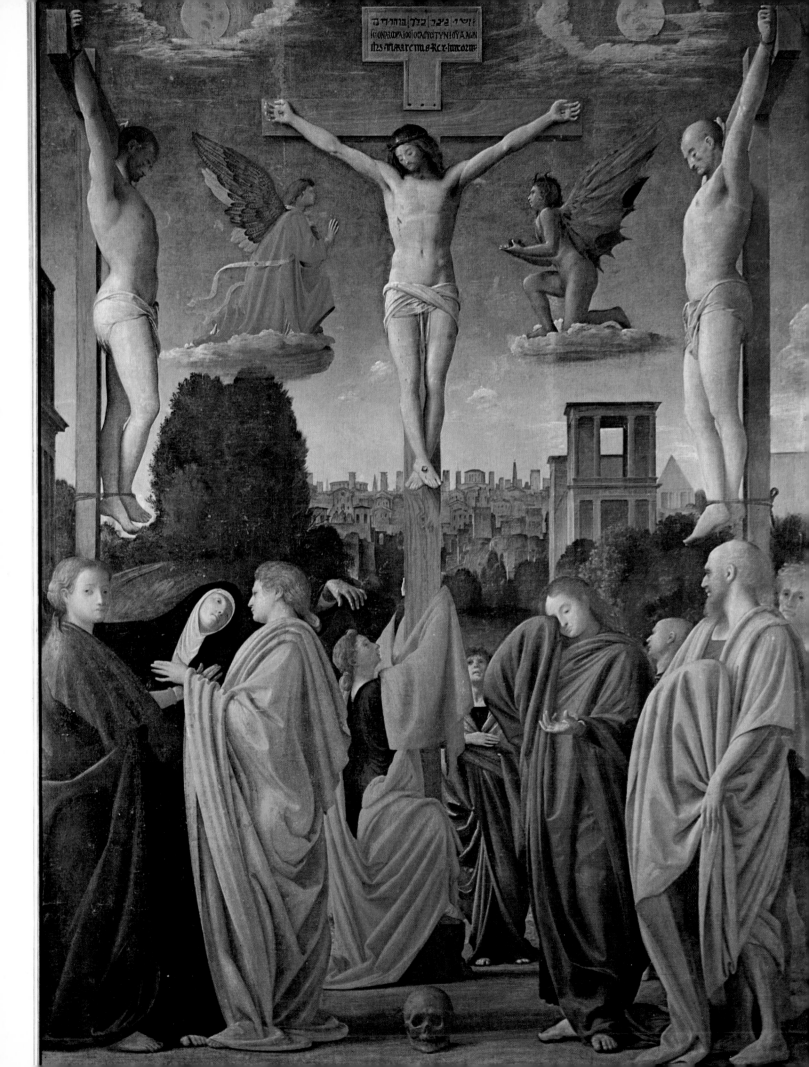

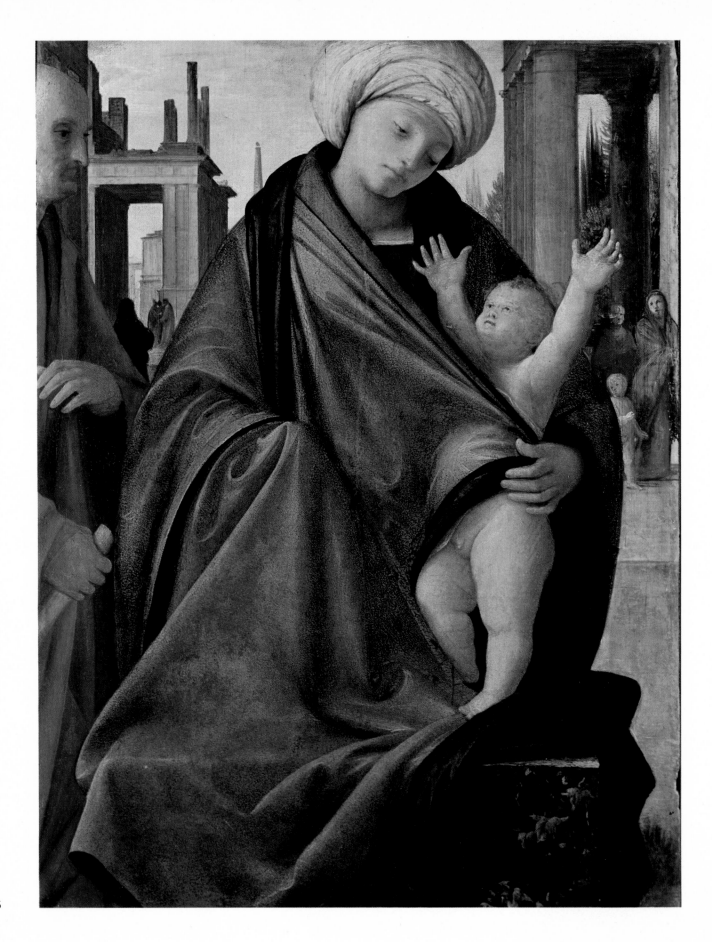

BRAMANTINO
Holy Family (circa 1520)
Poplar panel; 24″ × 18 1/2″.
From Cardinal Monti's bequest to the Archdiocese of Milan, it came to the Gallery in 1896.

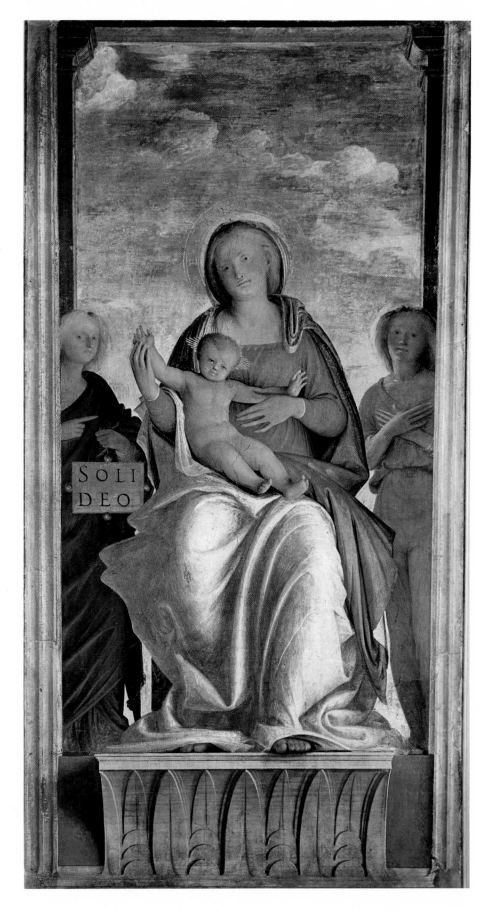

BRAMANTINO
Madonna and Child with Two Angels
(circa 1508)
Detached fresco; 7′11″ × 4′5 1/4″.
From the New Court House in Piazza dei Mercanti, Milan. It has been in the Gallery since 1808. The angel on the left holds a paper with the words "Soli Deo," one of the mottos used by Marshal Trivulzio, whose funerary chapel was designed by Bramantino.

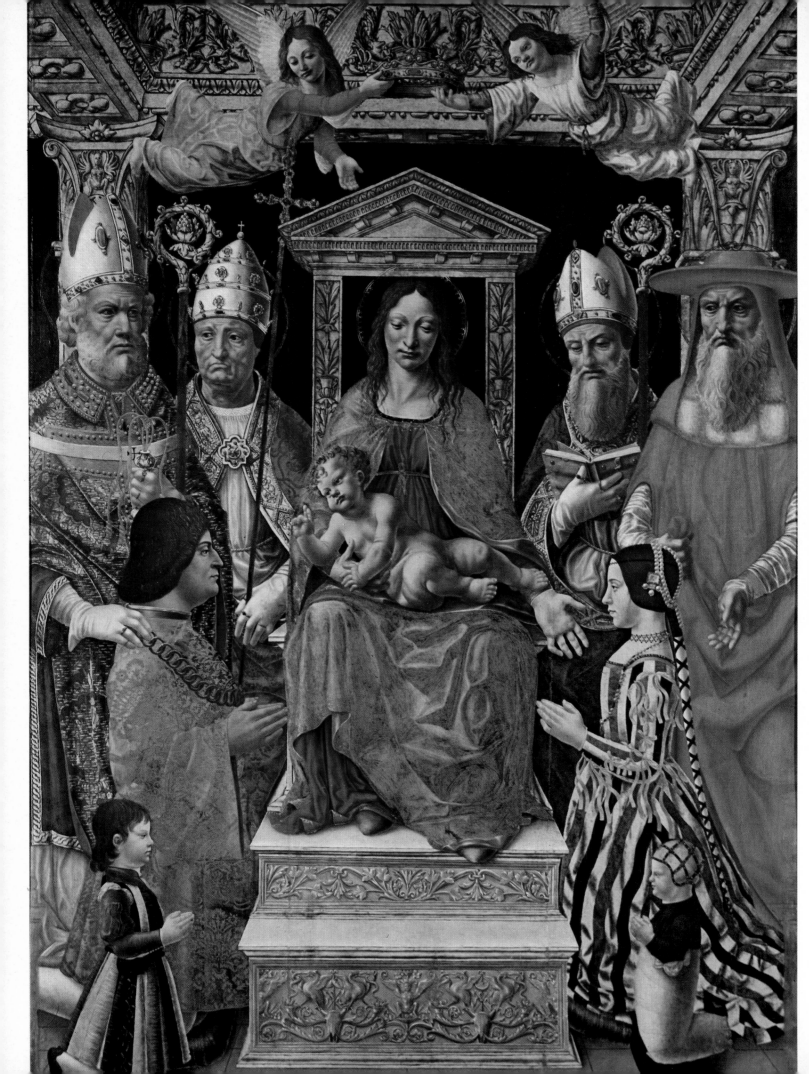

and its elegant profile. The serene frontal composition is softened by the undulating rhythm that falls from the Madonna's hand that is holding the Child's, through the body of the Infant, to its conclusion in the heavy folds of the drapery. Lighted by a source in front, and set against a predominantly white sky, the figures show an unusually lively range of colors. The angels, seen in penumbra, are dressed in olive green and red, while the Madonna wears a pale blue mantle over her raspberry robe, and has an iridescent kerchief on her head.

MASTER OF THE SFORZA ALTARPIECE. *Madonna and Child,*
Saints and Donors.

This is one of the most problematical works of the late fifteenth century in Lombardy. It shows a compromise attempt to include new ideas inspired 59

by Leonardo da Vinci in a decorative composition that is still imbued with the late Gothic spirit. Of exceptional interest is the gallery of portraits of the donors. Outstanding among them is that of Beatrice d'Este, whose biographer described her as "beautiful and dark, and inventive in designing new clothes."

AMBROGIO DE PREDIS. *Portrait of a Young Man.* p. 59
Famous mainly for having worked with Leonardo da Vinci on the *Virgin of the Rocks* (National Gallery, London), Ambrogio de Predis sought, unsuccessfully, to imitate Leonardo's style. Following a customary formula for portraiture, the bust is set in three-quarter view, with the marked features of the face modeled by the light. The mask-like face is framed by the knowingly described silken hair and the soft fur collar. Occasionally the brushwork in these secondary parts reflects the sensitive effects of the artist's master. Yet the glassy eyes, the hard, overdone plasticity of the nose and cheeks, and the marked sensuality of the lips reveal the semi-assimilated influence of other art currents, including some from Germany.

ANDREA SOLARIO
Milan circa 1477 — Milan 1524
Portrait of a Man (circa 1500)
Panel; 16 1/2″ × 12 1/2″.
Part of Cardinal Monti's bequest to the Archdiocese of Milan in 1650, this work has been at the Brera since 1811. At one time it was attributed to Cesare da Sesto.

Above, left:
GIOVANNI ANTONIO BOLTRAFFIO
1466 — Milan 1516
Portrait of Gerolamo Casio (circa 1495)
Panel; 20 1/2″ × 15 3/4″.
Acquired from the library of Bologna University in 1902. The verses written on the paper are from a work by Gerolamo Casio (1464–1533). Casio, a bizarre personality, was a merchant and troubadour of humble origin, who became one of the most popular and celebrated poets of his time.

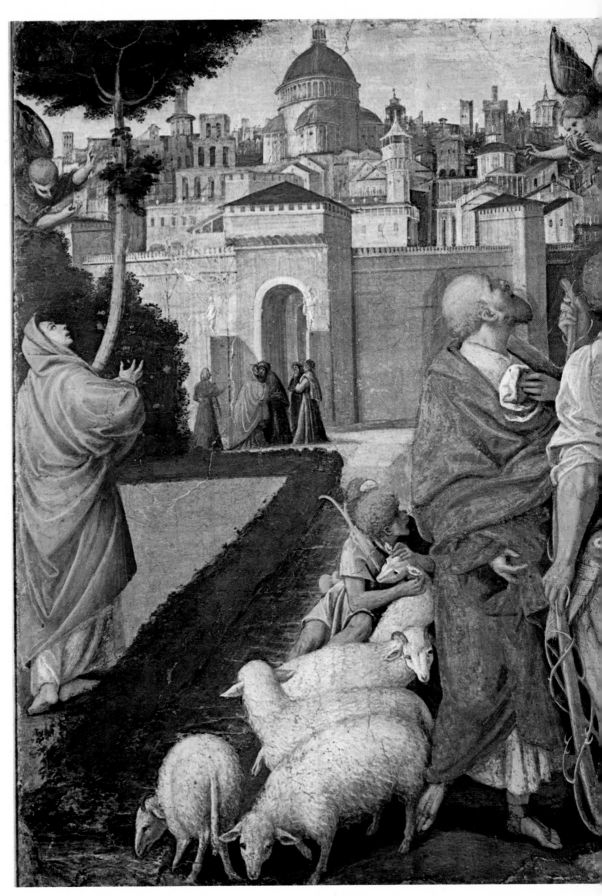

GUADENZIO FERRARI
Valduggia (Valsesia) circa 1475
— Milan 1546
The Annunciation to Joachim and Anna (1544–45)
Detached fresco, transferred to canvas; 6'2 3/4" × 4'5 1/4".
From the church of S. Maria della Pace in Milan, it was removed to the Brera in 1808.

GIOVANNI ANTONIO BOLTRAFFIO. *Portrait of Gerolamo Casio.*

p. 60

Consciously "humanistic" and commemorative, this portrait is based on the classical models of the time, but shows some uncertainty in compositional balance, especially in the placing of the hand in the same plane as the face. However, the uniqueness of the composition, slightly displaced to the right of the spectator, rescues the work from any monotonous effect. It also plays up the color values, which are displayed in broad, polished, well-defined areas.

ANDREA SOLARIO. *Portrait of a Man.* *p. 60*

In layout this painting derives from the work of Antonello da Messina, whose influence was still very much alive in north Italian portraiture in Solario's time. But a newer and more fundamental model for the face was Leonardo's art. The white edge of the collar underscores and isolates the features, which are also indicated compositionally by the hand emerging from behind the border of the parapet. The light spreads and vibrates in the chiaroscuro of the face, as if intended to soften the willfulness of its expression.

GAUDENZIO FERRARI. *The Annunciation to Joachim and Anna.*

p. 61

In his late frescoes, such as this one, Ferrari appears to have recovered the more spontaneous manner of his early work. The tormented muscular contortions and the forced gestures are simpler here, and the figures appear engaged in quiet, intense conversation. The elements of the composition are densely interwoven, yet there remains a touch of the artist's previous "stage-set" painting in the daring oblique perspective and the looming city, with its architectonic definition. It is as if Ferrari were painting an enormous predella in pure, decided colors that create rousing harmonies of pictorial splendor.

GAUDENZIO FERRARI. *St. Anna Consoled by a Woman.*

The composition of this lyrical painting is laid out symmetrically on the diagonal, not only on the surface but also in perspective depth. There is a slight thinning out of the structural interconnections above, leading to the landscape and the silent walled city, which are enveloped by the light between two wings of soft, dissolving foliage.

BERNARDINO LUINI. *The Game of the Golden Cushion.*

In this children's game, one of the players hides his head in another's lap and tries to guess who is touching him on the back. At the time that Luini

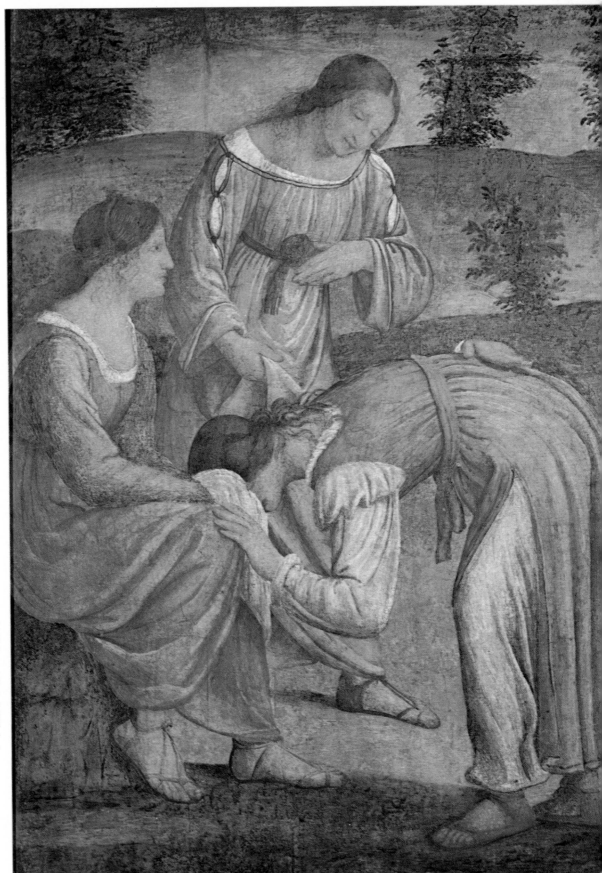

BERNARDINO LUINI
Circa 1480 — Milan circa 1532
The Game of the Golden Cushion
(1520–23)
Detail.
Fresco transferred to canvas;
55″ × 39 1/4″.
From the Villa Rabia alla Pelluca,
near Milan. The entire fresco cycle
was detached between 1821 and
1822. Since 1906 almost the com-
plete cycle has been at the Brera.

On pages 64–65:
BERNARDINO LUINI
Girls Bathing (1520–23)
Fresco transferred to canvas;
4′5 1/4″ × 8′2 1/2″.
From the Villa Rabia alla Pelluca.

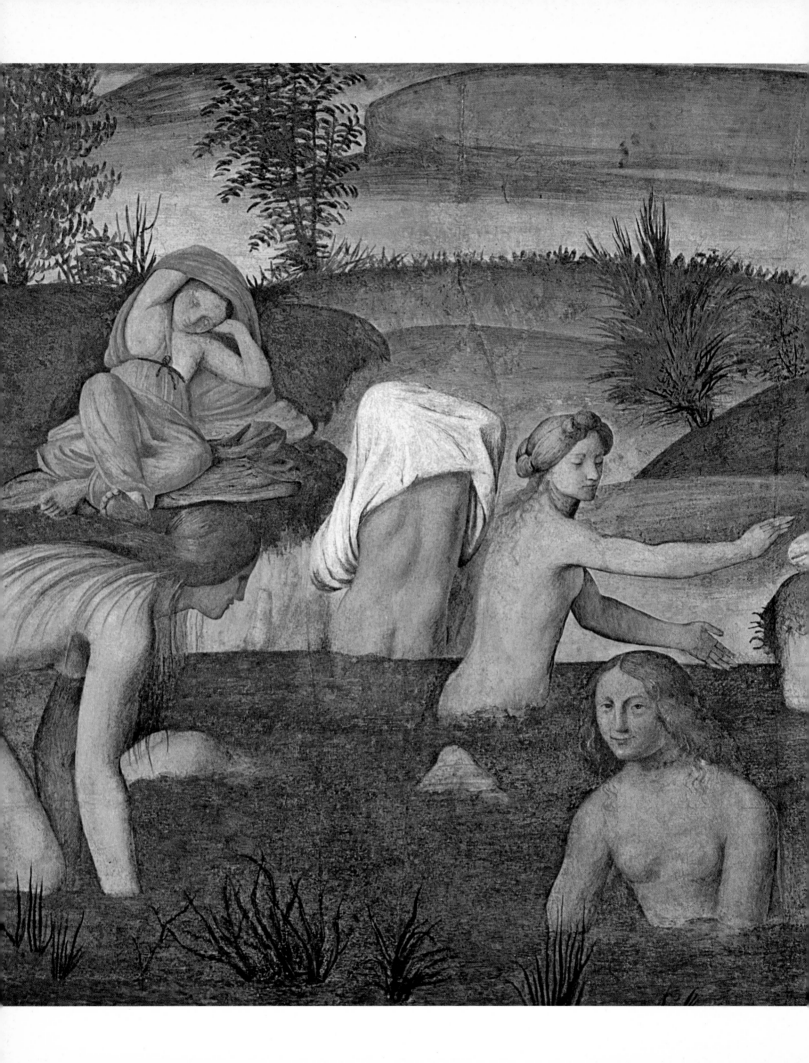

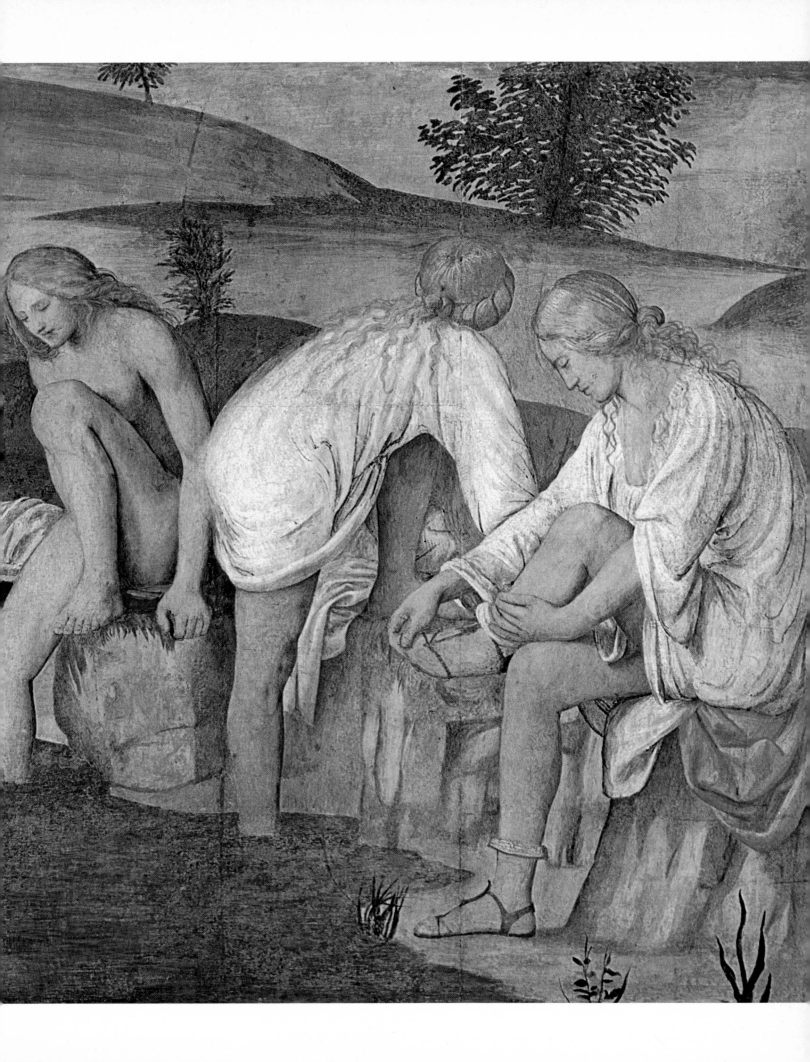

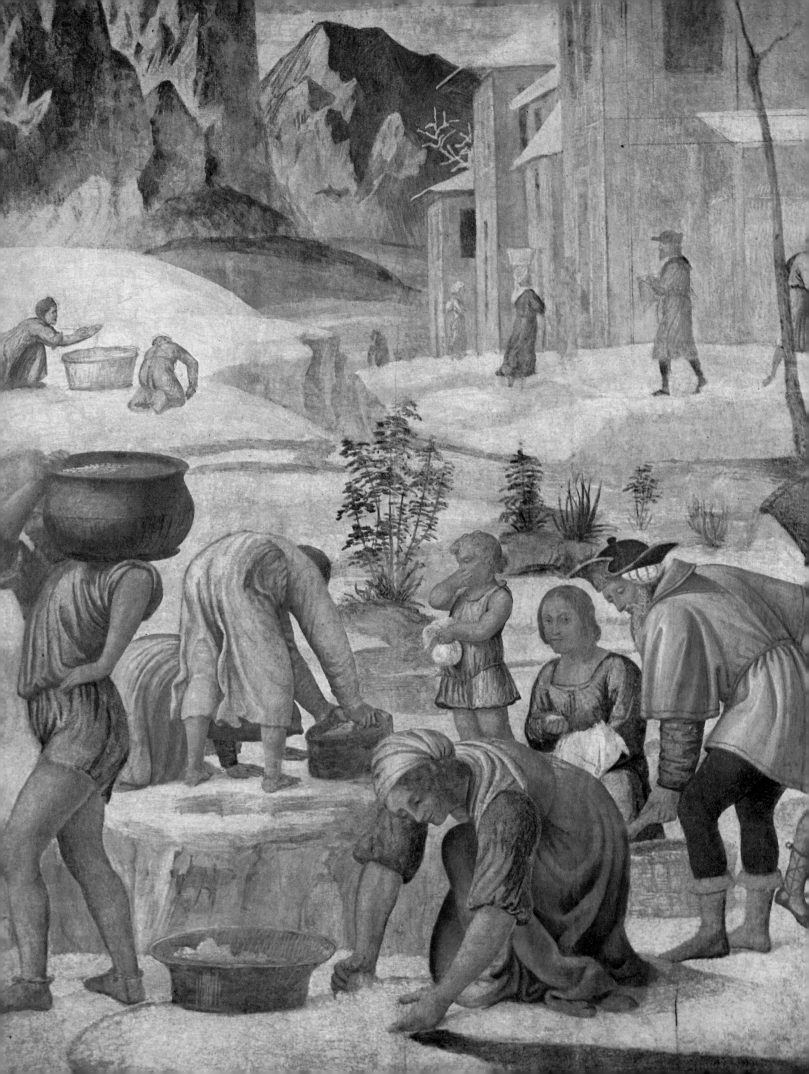

BERNARDINO LUINI
The Gathering of the Manna (1520–23)
Fresco transferred to canvas;
6'6" × 5'11 3/4".
From the Villa Rabia alla Pelluca.

was painting this scene, which is from a fresco cycle formerly in the Villa Rabia alla Pelluca, he was renewing his expressive means. This took the form of new rhythms and spaces in which to place his figures, which were already fully achieved in structure, movement and expression. At the same time he was discovering new ways of handling light, which owe something to the example of Leonardo's chiaroscuro but are certainly not imitative. Luini's mature pictorial language goes beyond the exquisite manner of Bergognone, acquires something of Leonardo through Bramantino, and derives its intense but measured color from Solario and his Venetian antecedents. This detail from his fresco cycle is in the tradition of courtly fables that goes back to the International Gothic style.

BERNARDINO LUINI. *Girls Bathing.* pp. 64–65
The composition of this painting is developed on a diagonal and frontal pattern, with countervailing volumes and areas of color. While simplicity is the dominant note, the balanced pastoral scene builds up an ample and satisfying atmosphere in its spaced-out perspective planes. The nudes have often been described as chaste and restrained.

BERNARDINO LUINI. *The Gathering of the Manna.*
The gestures and movements of everyday life have been rendered by Luini with freshness and spontaneity. The coming and going, the bending and picking up, all fall into a musical pattern, of which the landscape is an integral part. It is solemn music, played against an impassive background, and its total effect is that of a powerfully moving elegy.

BERNARDINO LUINI
St. Catherine Carried to Her Tomb by Angels
(1520–23)
Fragment.
Fresco transferred to canvas;
3'11 1/4" × 7'5".
From the Villa Rabia alla Pelluca.

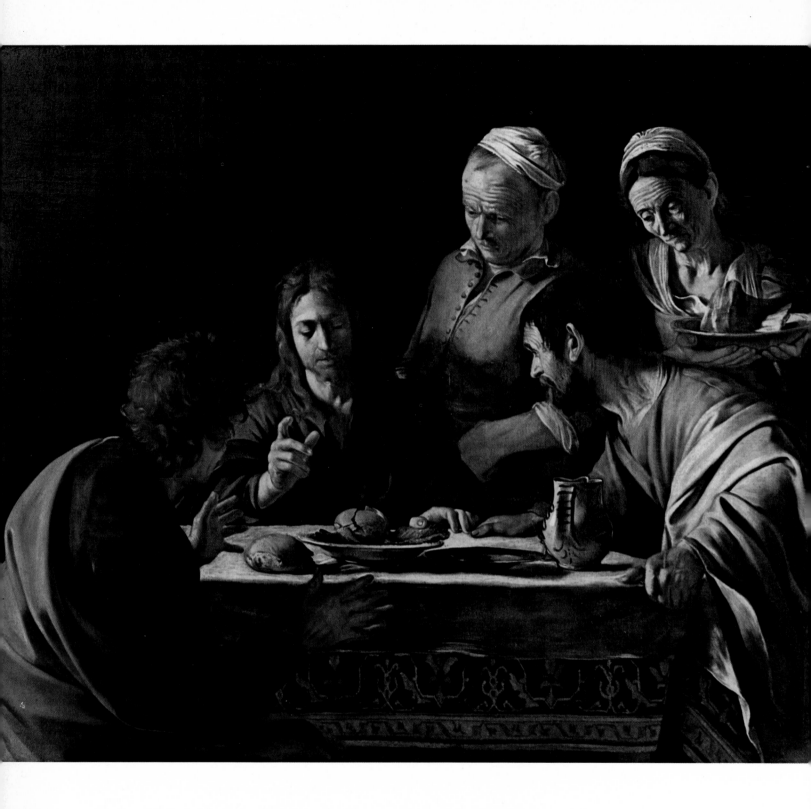

BERNARDINO LUINI. *St. Catherine Carried to Her Tomb by Angels.*
 p. 67

The contrast between the rigid line of the sarcophagus and the calligraphic
freedom of the figures profiled in flight emphasizes the figure of the saint.
It is almost as if she were being pushed back by the stony hardness of the
rigorously geometrical tomb. Accompanying the sinuous and springing

line of the angels, and the soft and heavy rhythms of the lifeless body, the refined passages of tonal color make this fragment one of the most successful of Luini's poetic achievements.

CARAVAGGIO
(MICHELANGELO MERISI)
Caravaggio 1573 — Porto Ercole 1610
The Supper at Emmaus (1606)
Oil on canvas; 55 1/2″ × 69″.
Commissioned by the family of the Marchese Patrizi, it was donated to the Gallery in 1939.

CARAVAGGIO. *The Supper at Emmaus.*
This canvas is more dramatically intense and stylistically more rigorous than Caravaggio's earlier painting of the same subject, now in the National Gallery, London. The movements are more contained and the color tends toward monochrome, which dramatizes the highlighted passages. Caravaggio's sensual pleasure in painting details is less evident here; the still-life on the table is more subdued. Yet each object has its own lyric quality: the pitcher turned to show the back of the handle, the plates edged with gleams of light. The composition is laid out on a descending diagonal; from the head of the old woman the movement passes to the disciple shown in profile and the face of Christ, and concludes in the semicircle of gestures around the table. The entire scene is bathed in a luminous dazzling light reflected by the figures.

GIOVANNI AMBROGIO FIGINO. *Portrait of Lucio Foppa.* p. 70
The only remaining example of the genre of painting for which Figino was famous among his contemporaries, this portrait also reveals the varied influences on the artist. Although it shows reminiscences of Flemish painting, the portrait is more openly "cavalier," with the noble subject posed as if on a stage. The composition plays on the contrast between the closed profile on the right and the open one on the left. The latter relates to the decorative details of the chiseled helmet, the flowers and the feathers, which are all touched by incisive highlights. Notations of light also appear on the lace of the collar and the sleeves, which correspond to the flowers and fruit on the table. Daring contrasts mark the dramatic color range of blues, reds and yellows.

CERANO, MORAZZONE, PROCACCINI. *Martyrdom of SS. Seconda and Rufina.* p. 71
Considered a rare oddity by contemporaries, this painting "by three hands" recalls the competitions that were common in the fourteenth and fifteenth centuries, in which painters vied to outdo one another in rendering the same subject. Here, however, Cerano, Morazzone and Procaccini collaborated on a single picture. Similar outlooks and experiences created a common bond, a sort of "family resemblance" among the three, so that stylistically the painting has unity, despite variations and differences.

The compositional structure of the work, probably conceived by Morazzone, pivots on the central figure of the executioner. On the left there is Cerano's

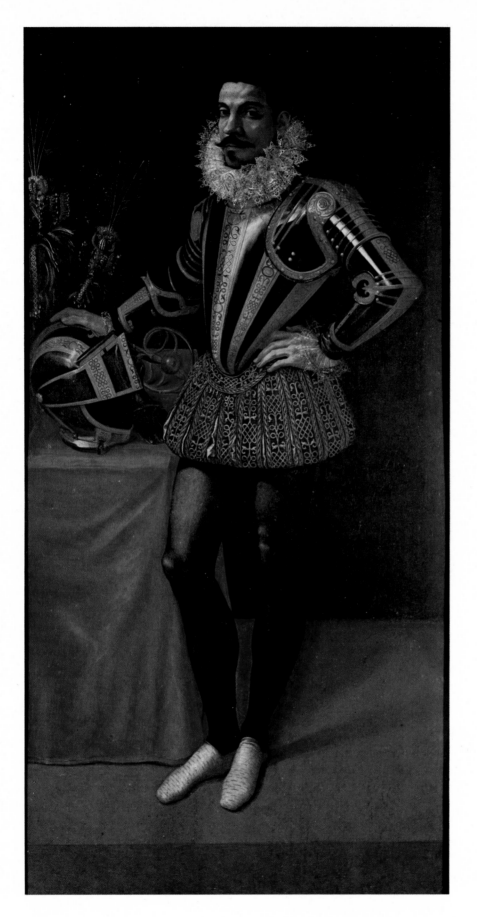

GIOVANNI AMBROGIO FIGINO
Milan(?) circa 1551 — Milan 1608
Portrait of Lucio Foppa (circa 1590)
Panel; 41 1/2″ × 39 1/2″.
Signed on the crest of the helmet: "JO AM-
BROSIUS FIGINUS P." From the Sannaz-
zaro collection in the Ospedale Maggiore,
Milan. Acquired by the Gallery in 1806. It
is not certain that the subject is really the
Field Marshal Lucio Foppa, about whom
there is little documentation.

CERANO, MORAZZONE, PROCACCINI
(GIOVAN BATTISTA CRESPI, PIER
FRANCESCO MAZZUCCHELLI, GIULIO
CESARE PROCACCINI)
Martyrdom of SS. Seconda and Rufina
(1620–25)
Canvas; 6′4 1/2″ × 6′4″.
The painting was part of Cardinal Monti's
bequest to the Archdiocese of Milan in 1650;
it entered the Gallery in 1895.

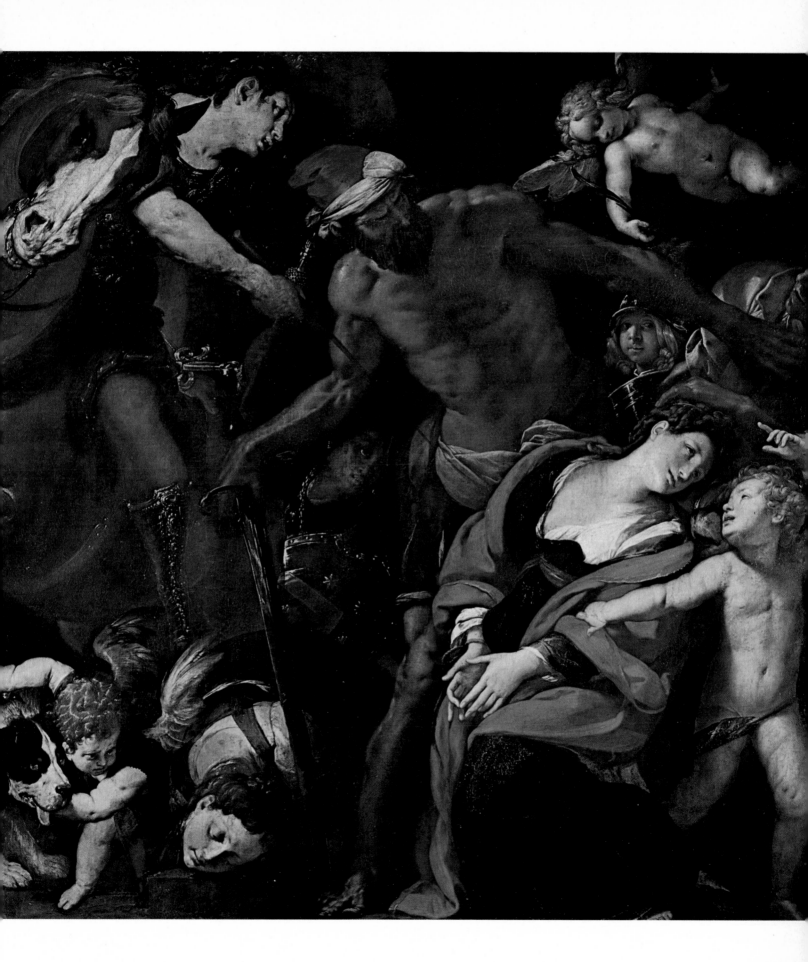

flashingly lighted horse and rider, the horse sumptuously dappled in black and white, vaguely recalling Van Dyck. Cerano's typical spiraling forms are seen in the cupid with the dog and the decapitated saint. In his broken line and repeating contours, as well as in the "marbled" effect not only of the drapery but also of the flesh, he shows unmistakably greater maturity and feeling than is to be found in Morazzone's warm theatricality or in Procaccini's softly pleasing effects. In the center, Morazzone's executioner, with his tensely elongated trunk and arms, recalls similar figures by the artist in the seventh chapel at the Sacro Monte, Varese. Also attributable to Morazzone is the angel bearing the palm of martyrdom, disposed along a diagonal paralleling the executioner's arm, and the luminous freely rendered heads in the background. Procaccini was responsible for the figure of the saint, languidly waiting for the blow to fall, and the attendant angel who comforts her and points to heaven.

GIULIO CESARE PROCACCINI. *The Mystic Marriage of*
St. Catherine.

This late painting by Procaccini shows that the painter retained the examples of Correggio and Parmigianino even in his maturity. This is evident not only in the faces and the elongated and twisted bodies (especially

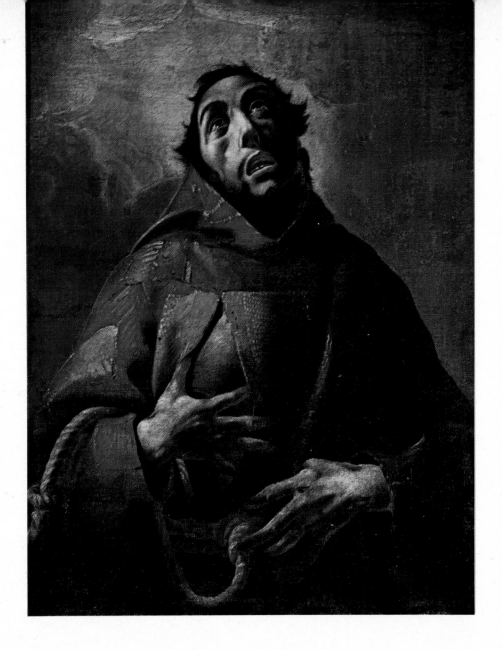

that of the Christ Child), but also in the cold, clear lighting of the brilliantly colored, almost metallic drapery. In the highly controlled, somewhat calligraphic elegance of the composition, with its closed circular rhythms operating on various planes, the typical innovations of Milanese painting are apparent. These influences are evident in the mask-like face of St. Joseph, backed by shadows, and in the fluent line and abrupt breaks — as in the right angle made by the angel's elbow, which closes off the painting on the far right.

MORAZZONE. *St. Francis.*

In some respects this work is associated with the point in Morazzone's career when he was working on the frescoes in the seventh chapel at the Sacro Monte, Varese. The painting may be viewed as a symbol of the tireless search for subtleties and depths of feeling that marked the Counter-Reformation spirit of seventeenth-century Lombard painting. Having aban-

MORAZZONE
(PIER FRANCESCO MAZZUCCHELLI)
Morazzone 1573 — Piedmont 1626
St. Francis (circa 1610)
Canvas; 39″ × 29 1/2″.
Donated to the Gallery by Paolo d'Ancona
in 1950.

73

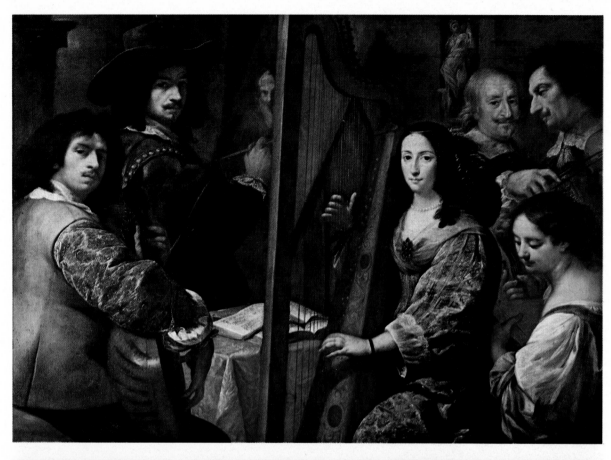

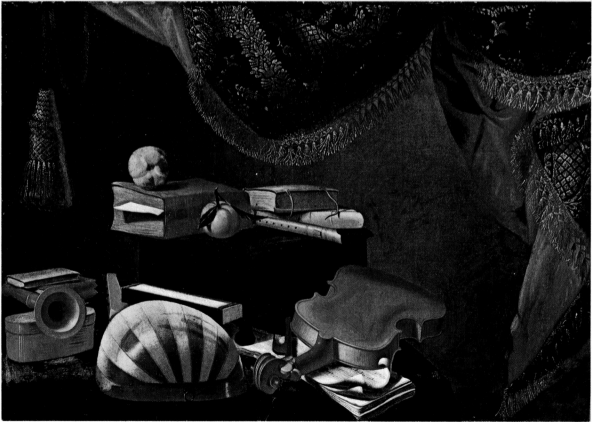

74

doned the profane elegance of the preceding period, it strains for a programmed mortification of the senses. The corrupt and corruptible body is the principal subject, and tears and sorrow prevail. Intended to show a forthright, almost brutal realism, this *St. Francis* achieves the opposite effect. From its insistent "reality" there emerges an absolute abstraction, an entirely expressionistic unreality. Impetuous rhythms explode in and around the metallic brown habit, the claw-like hands, the drawn mask of the face, the agitated sky and the highlights on the figure.

CARLO FRANCESCO NUVOLONE. *The Artist and His Family.*

Nuvolone has portrayed himself painting at an easel, surrounded by his family. His figure emerges discreetly from the luminous, silvery shadows. Around him the members of his household appear intent on their everyday activities: a quiet conversation, a harp exercise, a moment of melancholy introspection. In effect, the composition is a series of formal portraits, beginning with that of the artist. The figures seem proudly to display their costumes, which are rendered in refined color harmonies of grays, whites, yellows and blues.

EVARISTO BASCHENIS. *Musical Instruments.*

This painting is one of the most successful examples of Baschenis' lifetime pursuit: the painting of still lifes of musical instruments. It shows the artist's unflagging attention to the forms of his subjects, which are geometrical and capricious at the same time. The instruments are studied under a light that reveals their inner poetry but leaves their age-old shape and substance intact. Lovingly selected, these mandolins and horns are seen in terms of a strict construction of shadowed tones, broken only occasionally by a lighter passage. Their arrangement suggests an illusory, unchanging fixity, as if a symphony had been transposed from sound into three-dimensional composition, after the music had stopped.

GIACOMO CERUTI. *Boy with a Basket ("The Porter").*

This painting, which belongs to a series of similar subjects that in part has been lost and in part is in private collections, is among the Gallery's most recent acquisitions. It shows Ceruti's usual predilection for the humble and amiable aspects of everyday working life. His renderings of men at work and workers at rest earned him the nickname of "Little Beggarman" (*pitocchetto*); he was the bard of the otherwise unchronicled poor. This "porter" shows better than other works by the artist — which are more akin to genre scenes — his intense lyricism and idealizing abstraction. Devoid of indulgent description and reduced to essentials, the scene is composed on a system of opposed diagonals and has an atmosphere of subdued resignation. The boy, leaning against a large basket, is portrayed without apparent comment but the painting still suggests a life of hardship and Ceruti's sympathy with his subject.

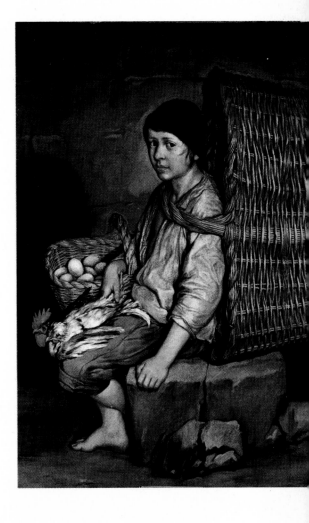

Above:
GIACOMO CERUTI
Brescia circa 1690 — circa 1750
Boy with a Basket ("The Porter") (circa 1755)
Oil on canvas; 51 1/4" × 37 1/2".
It belonged to the Barbisoni collection in Brescia. Donated to the Brera by G. Testori in 1968. It is reproduced here in color for the first time.

Opposite, above:
CARLO FRANCESCO NUVOLONE
Cremona 1608 — Milan circa 1665
The Artist and His Family
Oil on canvas, transferred from panel; 49 1/2" × 70 3/4".
The painting entered the Brera in 1806.

Opposite, below:
EVARISTO BASCHENIS
Bergamo circa 1607 — Bergamo 1677
Musical Instruments (circa 1750)
Oil on canvas; 23 1/2" × 34 1/2".
Signed in the center of the background: "EVARISTUS BASCHENIS F."
Acquired in 1912. The instruments represented are a clarinet, a mandolin, a double-bass bow and — on the crest — a recorder. **75**

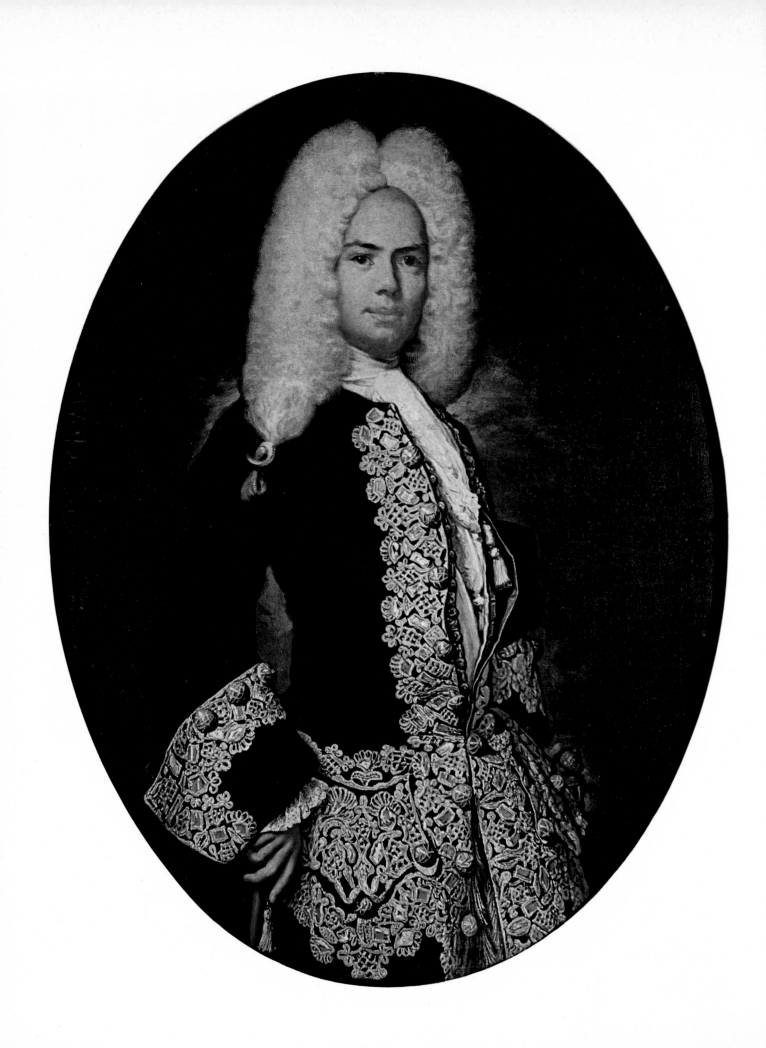

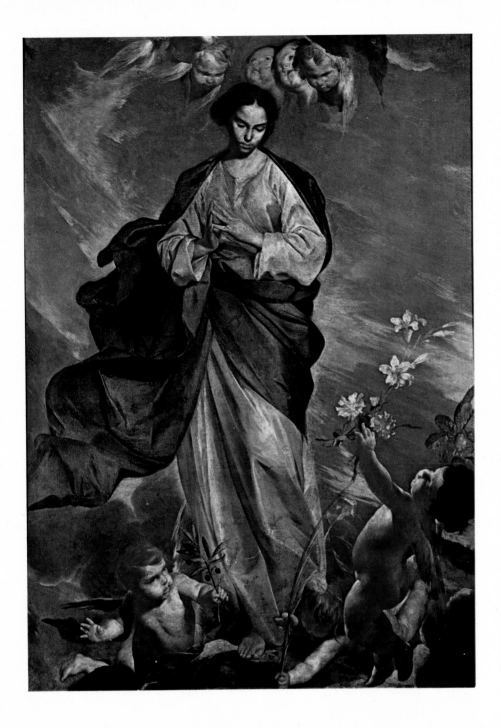

VITTORE GHISLANDI. *Portrait of a Gentleman.*

In this late painting, Ghislandi rejected the refined color schemes of his youthful portraits. His palette is now concentrated on golds, whites, browns and intense, velvety blacks. His optical inventiveness is fresh, and in the folds of a scarf, in the braid of a cuff or lapel, he succeeded in creating enchanted Rococo notes.

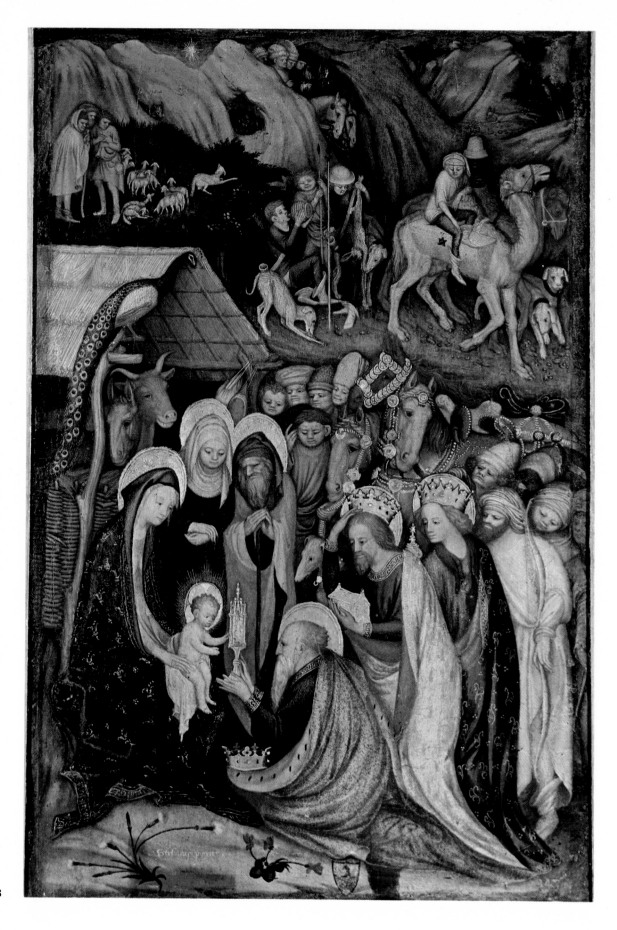

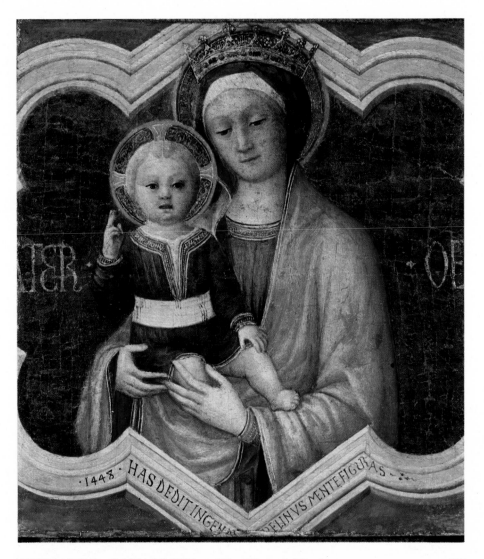

BERNARDO CAVALLINO. *The Blessed Virgin.* *p. 77*

A highly refined work, this canvas by Cavallino clearly shows his intrinsic
vibrancy and lightness of style. Figures and objects are subtly built up out
of transparent layers steeped in light and almost palpitating with atmo-
spheric currents. Weightless, except for the face inclined toward her ele-
gant fingers, the Blessed Virgin seems to be made of the same material as
the background sky. The angels, the flowers and the olive branch share in
this immaterial, vibrant world.

STEFANO DA VERONA. *Adoration of the Magi.*

A late work, this painting is clearly derived from the famous version of the
same subject by Gentile da Fabriano (now in the Uffizi). Both paintings
reveal the influence of the Veronese painter Altichiero. Stefano's panel also
reflects the new Milanese art typified by Michelino da Besozzo, with its
degree of naiveté and its esthetic refinement. The composition here is divided
into two registers, or two fields of space, united by a bird's eye view. The
first is a semicircular crowd of figures; the second is laid out in a meander
pattern that includes a number of separate episodes. The whole is closely
integrated, as in an illuminated manuscript initial. **79**

ANDREA MANTEGNA
Isola di Carturo 1431 — Mantua 1506
The San Luca Altarpiece
Twelve panels, overall measurement
7′6 1/2″ × 5′9 3/4″.
The figures represented, reading from upper left, are: St. Daniel of Padua, St. Jerome, the Virgin, Christ, St. John, St. Augustine, St. Sebastian, St. Scolastica, St. Prosdocimus, St. Benedict and St. Justina.
The work was commissioned in 1453, when the artist was twenty-two years old, for the chapel of S. Luca in the church of S. Giustina, Padua.
Right: detail of St. Justina.

80

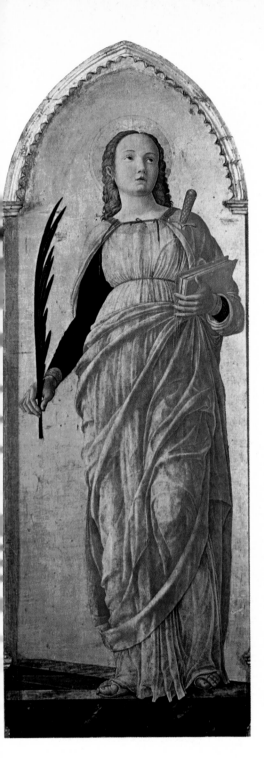

JACOPO BELLINI. *Madonna and Child.* *p. 79*
Jacopo Bellini was an "enlightened" late Gothic painter who reacted against the estheticism of his contemporaries. He added new elements such as classical antiquities, perspective and drawing to his pictorial language. As a humanist Bellini did not go beyond the taste for antiquity. In perspective he adopted Tuscan revolutionary ideas as dogma. Although he understood the independent value of drawing, he did not see it as a method of research but as a means for systematic description. His paintings thus give a hybrid impression, as in this work which also seems to owe something to Fra Angelico.

ANDREA MANTEGNA. *The San Luca Altarpiece.*
The original wooden frame in which Mantegna's signature had been incised was destroyed by lightning in the seventeenth century. Its loss radically alters the composition, as can be seen by the considerable difference in scale between the two registers. It is thus worth attempting a reconstruction, in order to grasp the meaning of the whole work. Probably commissioned by the donors to execute a Gothic-type altarpiece, Mantegna must have succeeded in altering the scheme substantially by inserting a thick molding between the two orders. This division set the two ranges much farther apart than they are today. Another device used by the artist to avoid the effect of caged images is the perspective in the center of the composition whereby the upper panels were made smaller to suggest distance while the lower panels were made larger to imply that they are closer to the spectator. But the most sensational means is the stepped pavement, which must have been the ground plane of the suggested architectural construction. The whole must have made a sort of two-storied loggia, housing figures engaged in a Sacra Conversazione.

Even without its original framework, the separate figures remain highly impressive. A lyric quality, unequalled in Mantegna's other work, is generated by the illusionistic effect of the figures, achieved by means of their "wet drapery," which Mantegna must have rediscovered by studying classic Roman sculpture.

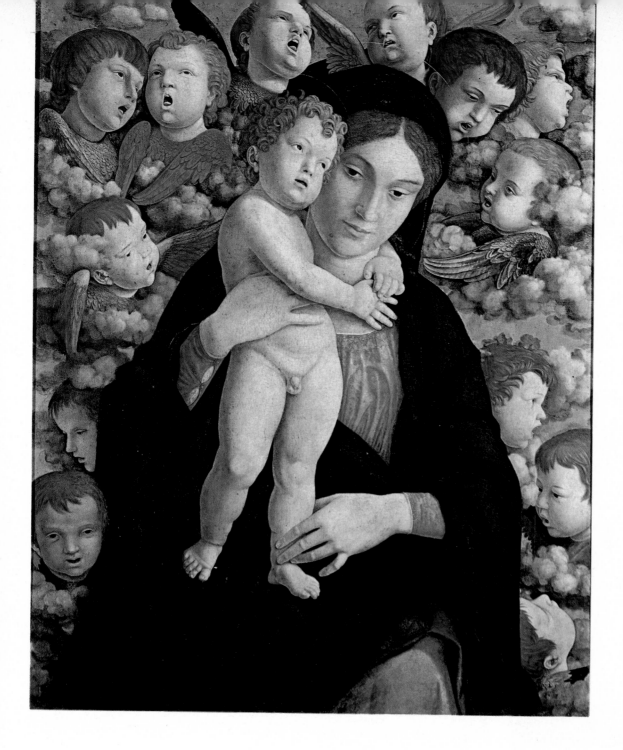

ANDREA MANTEGNA. *The Madonna of the Cherubim.*
This exquisite painting of the Virgin set against a sky thick with clouds and
cherubs shows the influence of Giovanni Bellini's palette. In fact it was at-
tributed to Bellini until Cavenaghi restored the picture in 1885. As the panel
appears to have been cut down on the sides, its original composition is debat-
able. The painting may have been commissioned by the Duchess of Ferrara;
the intensely human face of the Madonna would be suitable in a work
intended for private devotion.

ANDREA MANTEGNA. *The Dead Christ.*
It is typical of Mantegna's art that the simple window-like framing of the

ANDREA MANTEGNA
The Madonna of the Cherubim (circa 1485)
Panel; 27 1/2" × 34 3/4".
Until 1808 it was in the convent of S. Maria
Maggiore, Venice, where Sansovino saw it.

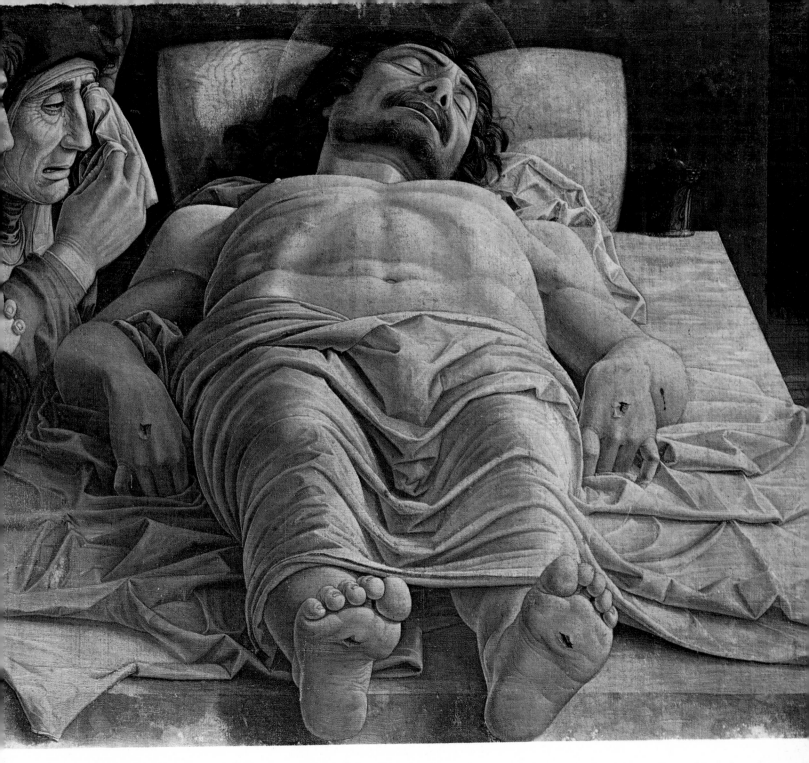

ANDREA MANTEGNA
The Dead Christ
Tempera on canvas; 31 3/4″ × 26 3/4″.
In a letter written on October 2, 1506 to the Duke of Mantua, Ludovico Mantegna mentioned a "Christ in foreshortening" among the works left by his father. It probably dates to the 1570's. In that case it must have remained in Mantegna's studio for a long time, and may have been intended for his funeral. In fact it was shown at the head of his catafalque when he died. Subsequently it was acquired by Cardinal Sigismondo Gonzaga, and it entered the Brera in 1824.

confined space in this painting architecturally defines it as the cold and dismal cell of a morgue. Looking in we see an almost monstrous spectacle: a heavy corpse, seemingly swollen by the exaggerated foreshortening. At the front are two enormous feet with holes in them; on the left, some tear-stained, staring masks. But another look dissipates the initial shock, and a rational system can be discerned under the subdued light. The face of Christ, like the other faces, is seamed by wrinkles, which harmonize with the watery satin of the pinkish pillow, the pale granulations of the marble slab and the veined onyx of the ointment jar. The damp folds of the shroud emphasize the folds in the tight skin, which is like torn parchment around the dry wounds. All these lines are echoed in the wild waves of the hair.

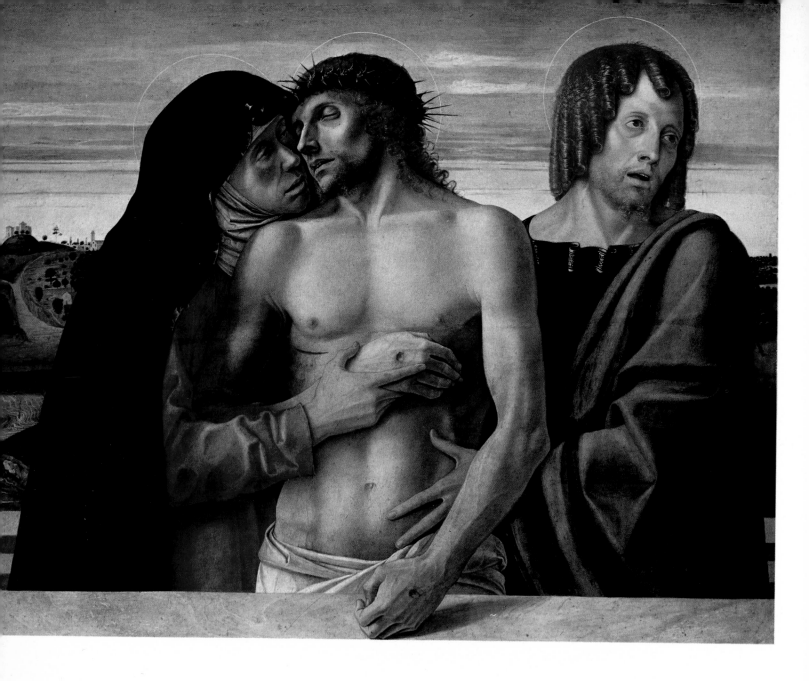

Mantegna's realism prevails over any esthetic indulgence that might result from an over-refined lingering over the material aspects of his subject. His realism is in turn dominated by an exalted poetic feeling for suffering and Christian resignation. Mantegna's creative power lies in his own interpretation of the "historic," his feeling for spectacle on a small as well as a large scale. Beyond his apparent coldness and studied detachment, Mantegna's feelings are those of a historian, and like all great historians he is full of humanity. He has a tragic sense of the history and destiny of man, and of the problems of good and evil, life and death.

84

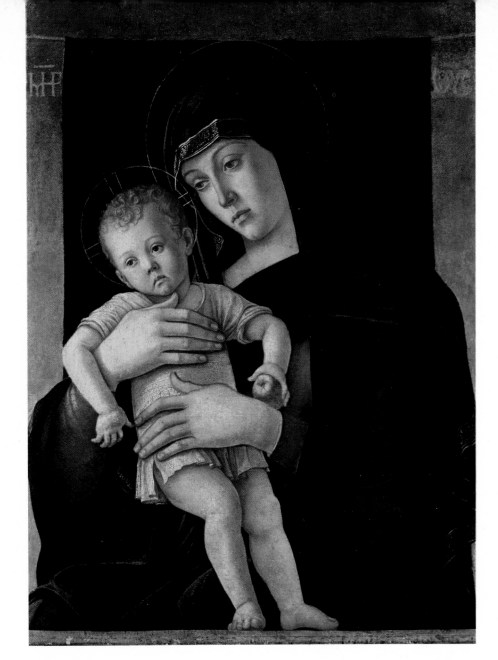

GIOVANNI BELLINI
Madonna and Child ("The Greek Madonna")
(circa 1565)
Panel; 24 1/2" × 32 1/4".
Because of the abbreviated Greek inscriptions ("Mother of God" above, "Jesus Christ" at the side) it is presumed that the work was executed for a Byzantine church. According to Pelliccioli, the sky was painted over a gold ground, with the letters allowed to emerge. From an office in the Palazzo Ducale, Venice, where it remained until 1808.

GIOVANNI BELLINI. *Pietà.*

The *Pietà* is rightly considered one of the most moving paintings in the history of art. Deep feeling is expressed throughout, from the landscape that recalls Flemish antecedents to the lucid architectonic composition of the group and the abstract geometry of their movements, deriving from Piero della Francesca. A passionate feeling that is not so much religious as human and psychological pervades the actors in the drama. The rendering of grief has here its most universal expression and, at the same time, its most private and conscious dimension. The mother's pathetic gesture is reflected in

85

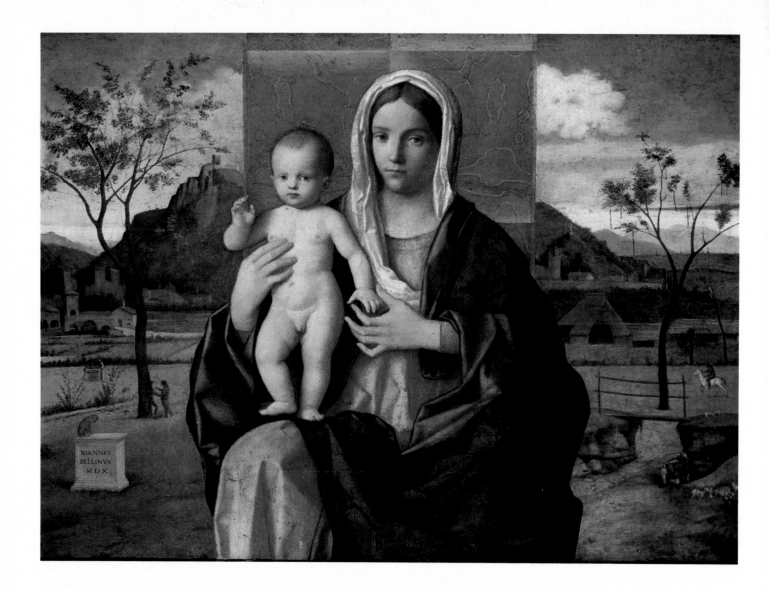

St. John's turning away. The construction of the work shows careful thought. The figures, borrowed from popular imagery, are grouped in the foreground against an infinite horizon. The pentagonal arm of Christ ending in a closed fist is that of a fallen but unvanquished athlete. The barely glimpsed landscape, with its road wandering up a height and its torrent coursing below, pulsates with earthly life.

GIOVANNI BELLINI. *Madonna and Child ("The Greek Madonna").*

p. 85

This painting is strongly archaizing in character, in the tradition of the icon. Probably the form of the painting was commissioned, and Bellini was required for liturgical reasons to repeat the pattern of an older painting that this one was to replace. It is, however, an entirely modern interpretation of the archetype. The abstract golden aura and the impassive background may be typical, but the infinite melancholy of the faces represents Bellini's personal view of a kind of liturgy that is remote from dogma.

GIOVANNI BELLINI
Madonna and Child
Oil on panel; 46 1/2″ × 33 1/2″.
Signed and dated on the stone block to the right: "JOANNES/BELLINUS/MDX."
Formerly in the Sannazzari collection, Milan.
Right: details of the landscape.

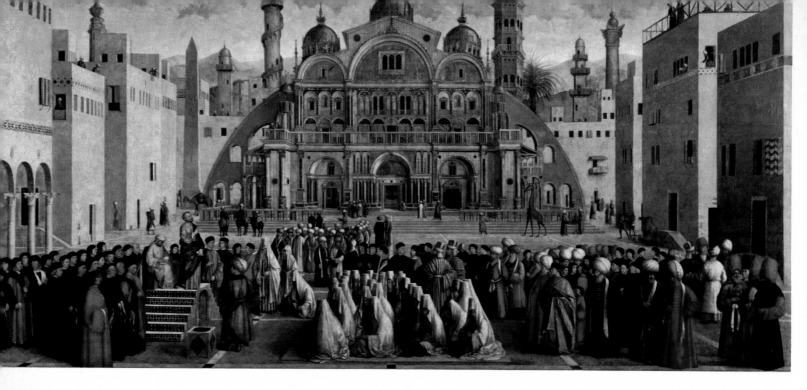

GIOVANNI BELLINI. *Madonna and Child.* *pp. 86–87*

A late work by Bellini, this painting has an archaic flavor. It is also emblem-
atic, as Bellini was the first artist to reverse the relationship between man
and landscape, with the surroundings dominating the story. A strange mys-
tery of nature is evoked, and with it a newly disquieting pantheistic feeling.
Bellini's discovery of the natural scene, as the sweet enchantment of the
universe, was the starting point for Giorgione's exalted "melancholy" land-
scapes.

GENTILE BELLINI. *St. Mark Preaching in St. Euphemia's Square in*
 Alexandria, Egypt.

Following the example of his father Jacopo, Gentile Bellini painted in a
reformed and humanistic style. But his interest was mainly documentary,
in the Flemish manner. His painted versions of the genre represented by his
father's drawings, using existing townscapes rather than imaginary or literary
settings, are the beginning of the landscape painting that was to become so
popular in Venice, especially in the eighteenth century.

In this large canvas, which was completed and softened by the artist's brother
Giovanni, a fantastic view of Alexandria has been laid out on the model of
St. Mark's Square in Venice. There is, however, a scholarly attention to de-
tails, from the Egyptian obelisk to the Moslem minarets and the flat-roofed,
white-washed cubical houses. St. Euphemia's is a Byzantine church on the
Greek-cross plan, with five domes. But it has flying buttresses pierced by
arches, and the façade shows Venetian influences from Codussi or Pietro
Lombardo. Among the portraits in this painting, including the members of
the confraternity on the left, is the striking and novel group of seated Arab
women. They enrich the foreground with their presence, veiled but vital
within the abstract architecture of their costumes.

88

GENTILE BELLINI
Venice circa 1429 — Venice 1507
St. Mark Preaching in St. Euphemia's
Square in Alexandria, Egypt
Canvas; 25'3" × 11'4 1/2".
Commissioned in 1505, the painting is from
the Scuola Grande di San Marco, Venice.
Gentile bequeathed an album of his father's
drawings (now in the British Museum) to
his brother Giovanni, on condition that he
finish this painting.
On pages 89–91: details.

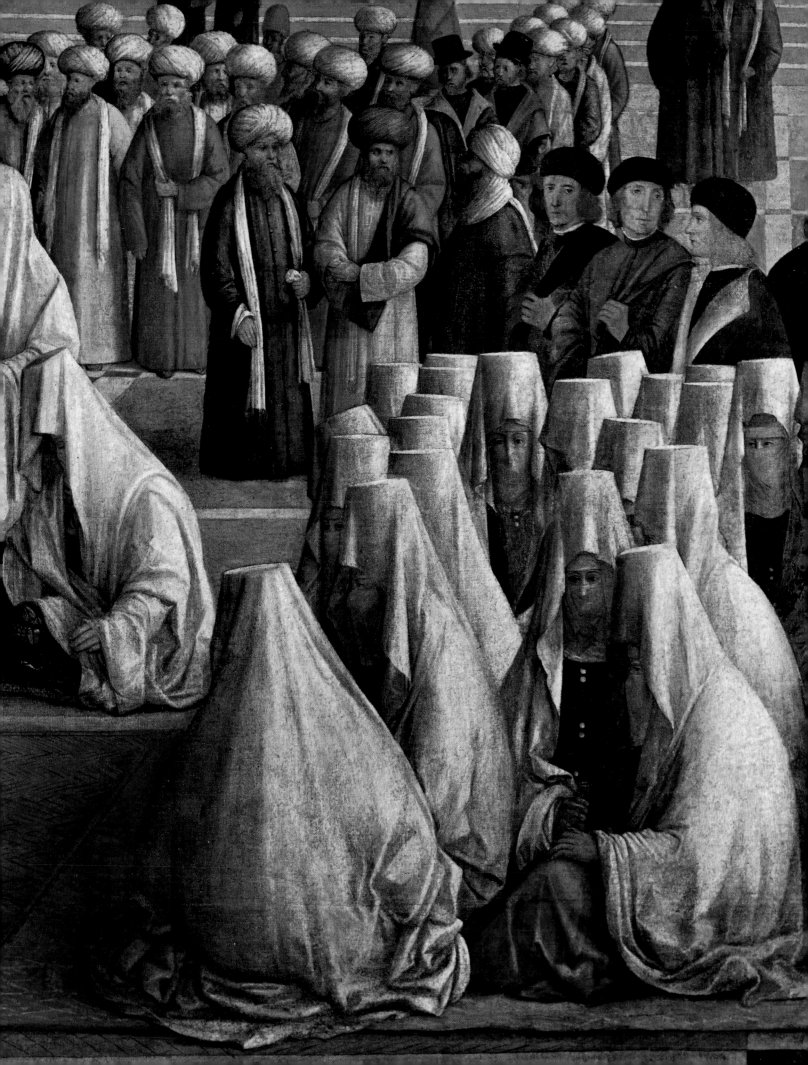

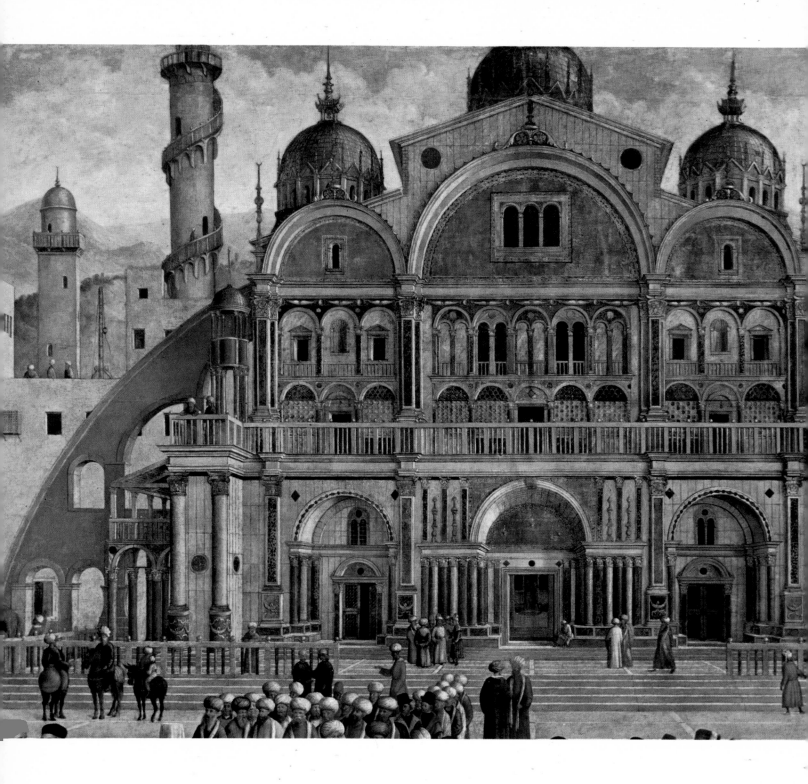

CARLO CRIVELLI. *The Madonna of the Taper* and *The Coronation of the Virgin* and *Pietà.* pp. 91–95

The characteristics of Crivelli's mature style, to which these three works belong, are sumptuous drawing, highly refined rendering of different materials and a superfluity of decoration. They are rooted in Venetian art and have some of the pungency of the tradition stemming from Squarcione. The content of Crivelli's works, however, is still that of courtly life, even though it is

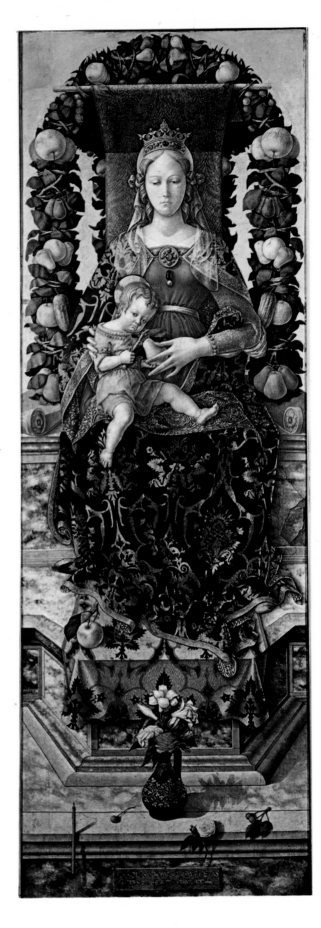

CARLO CRIVELLI
Venice circa 1430 — Ascoli 1495
The Madonna of the Taper
Panel; 2′5 1/2″ × 7′1 3/4″.
Signed in Latin on the plaque at the bottom:
"Karolus Crivellus Venetus/Eques Lavre-
atus Pinxit."
This central panel of a large altarpiece
formerly in the cathedral of Camerino has
been at the Brera since 1811. Other panels
are in the Accademia, Venice; another is in
the Brera. Side pilasters with little figures of
saints are in the museums in Lilles, Denver,
Florence, etc.
On page 92: detail.

CARLO CRIVELLI
The Coronation of the Virgin (with SS. George, John the Baptist, Catherine of Alexandria, Venantius, Francis, Sebastian and Angel Musicians)
Panel; 8'4 1/2" × 7'4 1/2".
Signed and dated in Latin on the plaque below: "CAROLVS CRIVELLVS VENETVS MILES PINXIT MCCCCLXXXXIII."
A document ordering the work on February 9, 1493 has been preserved. From the church of S. Francesco, Fabriano, it was bought by Oggioni in 1834 and presented by him to the Gallery in 1855. The altarpiece included the *Pietà* (pp. 94–95), and a predella that is now divided among the Castel S. Angelo in Rome, the Musée Jacquemart-André, Paris, and the Christian Museum at Esztergom.

detached from its social roots and is transposed to the court of heaven. The diluted cultural life of the Marches, where Crivelli worked, his detachment from major literary sources, and the local taste in forms (dominated by Camerino) led him to construct his images almost heraldically and to set them in a courtly fairyland.

His workmanship has an amazing precision and was substantially aimed at popular taste, being unsophisticated except in the visual and tactile astonishments that it provides. His tireless devotion to the same formula cut Crivelli off from other experiences, and led to dryness and involution. This can be seen in the difference in quality between *The Madonna of the Taper,* in which feeling still dominates form, and his last painting, the *Coronation* (page 93), where feeling has been lost in the vast embroidery of details. In his amazing draftsmanship, Crivelli is most closely comparable to Botticelli, who worked in Florence, an urban center of cultural exchange at every level. Crivelli, on the other hand, always worked in the provinces and, despite a magisterial command of his medium, ended by reflecting the static atmosphere of provincialism.

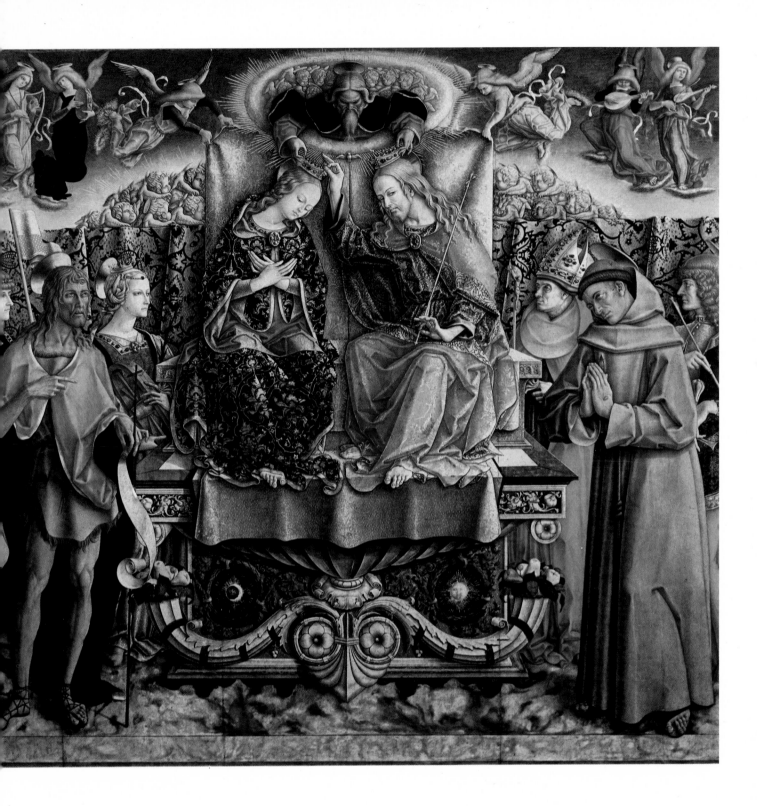

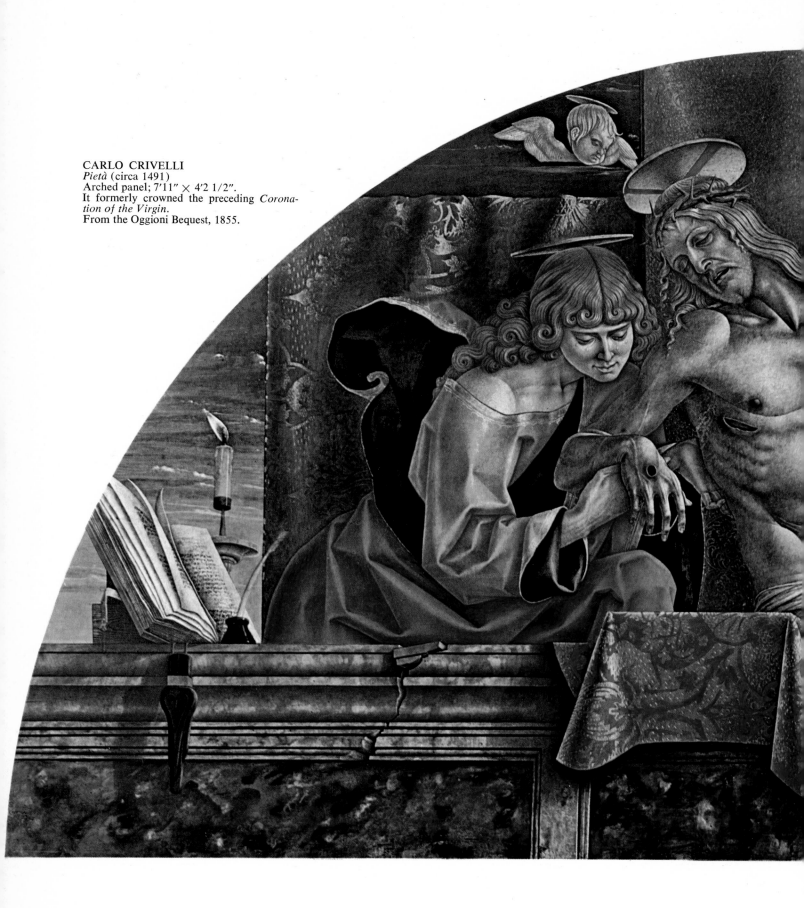

CARLO CRIVELLI
Pietà (circa 1491)
Arched panel; 7'11″ × 4'2 1/2″.
It formerly crowned the preceding *Corona-tion of the Virgin*.
From the Oggioni Bequest, 1855.

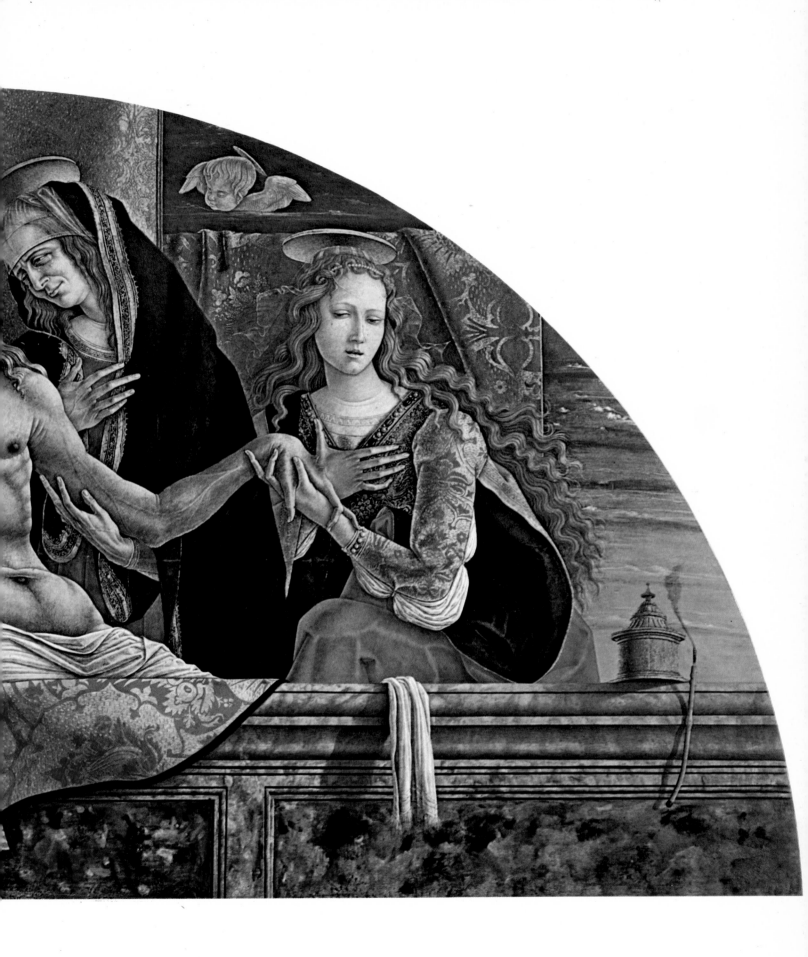

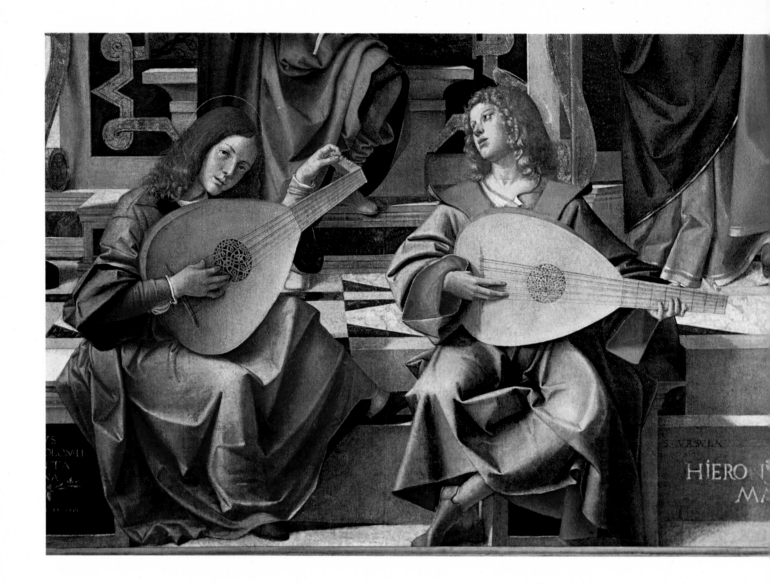

BARTOLOMEO MONTAGNA. *Madonna and Child Enthroned Between SS. Andrew, Monica, Ursula, Sigismund and Angel Musicians.*

Trained in Venice, Bartolomeo interpreted the great Venetian models in an archaizing vein, as did all the contemporary artists of the mainland. His prodigiously skillful draftsmanship defined lapidary forms that may be splintered or flaked but are always pure and as resonant as crystal. His strict sense of order is open, however, to an aristocratic feeling for nature, which is shown in pungently descriptive passages. In this altarpiece, the noble figures are displayed within a purely Lombard architectural setting. The composition is also architectonic, and its precedents go back through Antonello da Messina to Piero della Francesca, whose device of a pendant ostrich egg has been adopted here. The brown and silvery harmonies of the Lombard palette add a note of elegant austerity.

BARTOLOMEO MONTAGNA
Orzinuovi (Brescia) circa 1450 — Vicenza 1523
Madonna and Child Enthroned Between SS. Andrew, Monica, Ursula, Sigismund and Angel Musicians
Canvas; 8′6 1/4″ × 13′5 3/8″.
Signed and dated on the step: "OPVS/BAR-THOLOMEI/MONTA/GNA MCCCCLX-XXXVIIII." The large capitals in the background frieze are the initials of the Latin phrase meaning: "Implore God's grace for us." The medallion on the left portrays Matteo de' Pasti's profile plaque of Christ. Another Latin inscription on the step records a 1715 restoration, which does not seem to have much altered the painting. Preliminary drawings for this work are in the Uffizi and at Windsor Castle.
Documented as having been in S. Michele, Vicenza, it has been in the Gallery since 1811.
Above: detail of the angel musicians.

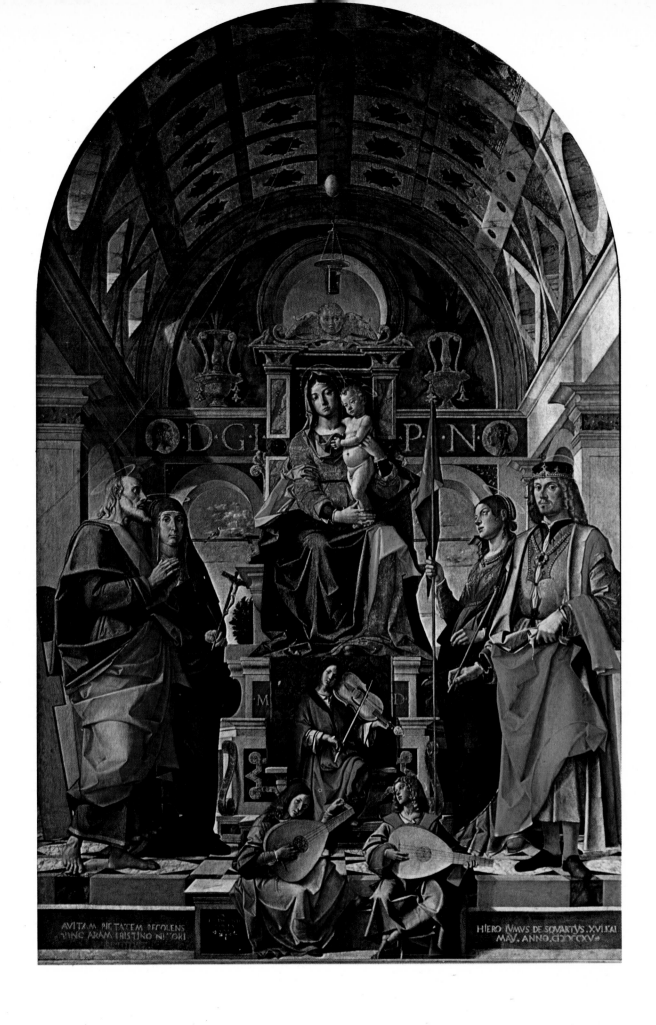

BARTOLOMEO MONTAGNA
St. Jerome (circa 1500)
Canvas; 22 3/4″ × 20″.
From the Girolamo Tomasi collection, Verona. Acquired by the Gallery in 1925 from the Frizzone collection, Milan.

GIOVANNI BATTISTA CIMA
Conegliano circa 1460 — Venice 1517
St. Peter Martyr with St. Nicholas of Bari, St. Benedict and an Angel Musician
Oil on panel; 7′1″ × 10′10″.
Signed in Latin on the paper on the base: "JOANIS BAPTISTA CIMA/CONEGLIAN(ENS)IS."
From the church of Corpus Domini in Venice. It was commissioned by Benedetto Carloni in his will of November 5, 1504. The panel entered the Brera in 1811.

BARTOLOMEO MONTAGNA. *St. Jerome.*

The most striking aspect of this picture is the fabulous landscape on the right, which seems to be only partially invented. The Veronese provenance of the work suggests the interesting theory that it was painted for the convent of St. Jerome at the Roman theater. The topographical features of Verona recur here, though in altered form: the river, the ruins, the double staircase cut into the tufa, the church and the convent. Bartolomeo's main inspiration seems to have stemmed from a reality that he returned to a state of nature, converting the townscape he knew into a rustic landscape.

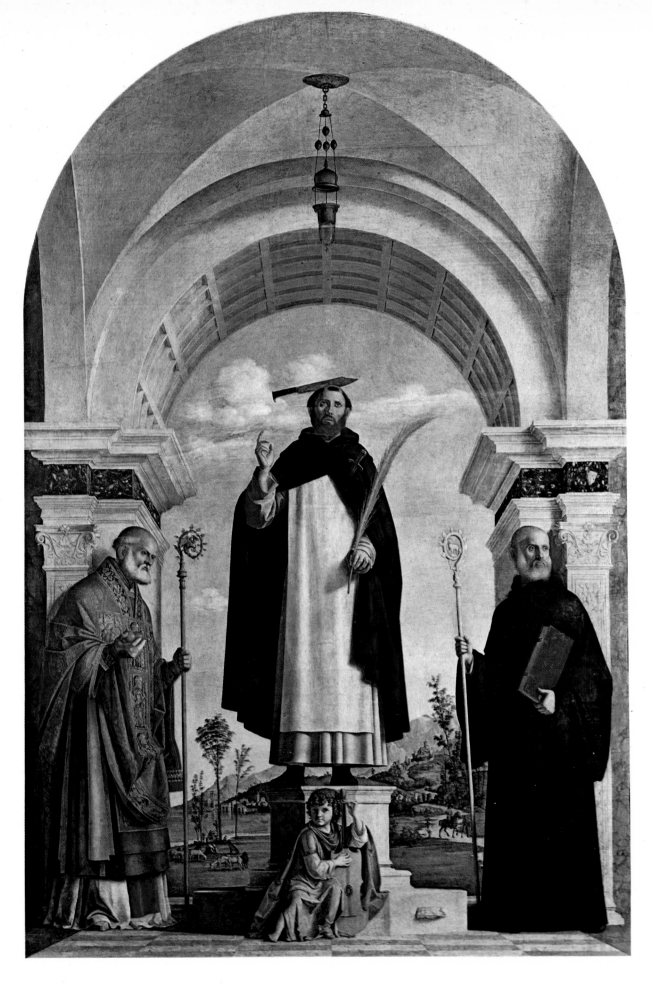

GIOVANNI BATTISTA CIMA. *St. Peter Martyr with St. Nicholas of Bari, St. Benedict and an Angel Musician.* *p. 99*

Cima must have been attracted at a very early age to Venice, where he was fascinated by the elder Bellini and Antonello da Messina. From them he acquired a pictorial repertory suited to his work on a provincial circuit, and like Montagna and Alvise Vivarini, he propagated their approach to painting on the mainland and in Emilia. His work, however, has richer color and warmth, through the influence of Giorgione.

This altarpiece shows Cima's typical mixture of the archaic and the modern. The impeccably harmonious fifteenth-century construction of architecture

VITTORE CARPACCIO
Venice circa 1455 — Venice 1523(?)
The Marriage of the Virgin
Canvas; 55″ × 51 1/4″.
One of a series on the *Life of the Virgin* for the Scuola degli Albanesi, near S. Maurizio (Venice). After the suppression of the Scuola in the late eighteenth century, this canvas and *The Presentation of the Virgin* came to the Brera; *The Nativity* went to the Accademia Carrara, Bergamo, *The Annunciation* and *The Death of the Virgin* to the Ca' D'oro and *The Visitation* to the Museo Correr, Venice. The entire cycle was completed in the early sixteenth century, with the help of considerable shop work.
Left: detail of the architectural background.

and figures is accompanied by a modern sunny atmosphere and a landscape steeped in luminous vapor. The traveling artist has evoked memories of his birthplace, setting it on the shores of a quiet lake and peopling it with shepherds, as in an Arcadian dream.

VITTORE CARPACCIO. *The Marriage of the Virgin* and *The Presentation of the Virgin* and *The Disputation of St. Stephen.*

If formal history is Mantegna's outstanding characteristic and reporting is Gentile Bellini's, then Carpaccio is predominantly a historical novelist. His

101

urban settings are often compared with those of Gentile Bellini, but there are major differences between the two. Gentile used documentation to support the accuracy of his account, and where it was lacking he relied on his imagination, but always in terms of the topographic reality of Venice. Although Carpaccio's settings are entirely Venetian in spirit, they are complete fantasies and any reference to reality is scrupulously avoided. Almost all of Carpaccio's career was devoted to producing picture cycles, for the decoration of entire interiors, that illustrated religious themes and legends connected with Venetian life. These subjects called for compositions seen as if

VITTORE CARPACCIO
The Presentation of the Virgin
Canvas; 54″ × 51 1/4″.
A preliminary drawing for this painting is in the Uffizi, Florence.
Right: detail of the boy with deer.

through an imaginary window, and they made up a fabulous but not unrealistic world.

Carpaccio's urban views are not chance inventions. They belong to the Platonic idea of Venice as a painted city, which goes back beyond Jacopo Bellini's drawings, is articulated by Filarete and proliferates in the illustrations of his manuscripts. This is a development that is seen at the same time in Lombardy and in the Lombard buildings in Venice, creating a language of forms of which Carpaccio is a later prophet. Carpaccio's townscape, with

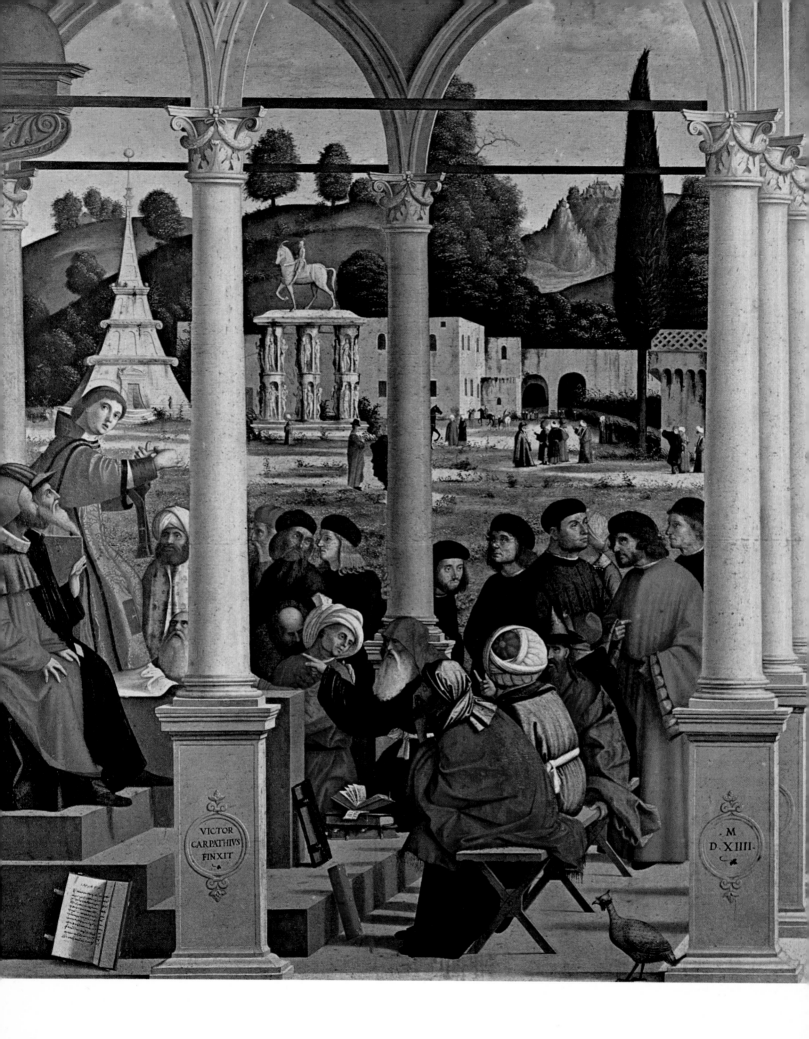

VICTOR
CARPATHIVS
FINXIT

.M.
D·XIIII.

its architecture, sculpture and street furniture, thus does not follow existing forms (note the invented Mannerist monuments in the background of *The Disputation of St. Stephen* – pages 104–105) nor does it repeat familiar architectonic systems (see the interior divisions of the temple in *The Marriage of the Virgin*). The background of *The Disputation* is expressed in terms of exotic northern motifs.

That the setting is the main theme in Carpaccio's work is shown also by his preliminary drawings, in which the scenes are empty of figures. In *The Marriage of the Virgin,* he limited the role of the figure and dwelt on the numerical rhythms, the geometry and the musical sequences of the setting. The other features of his art tend toward the same end, as for instance his use of the panoramic view, which in turn meant abandoning a monumental style. Planes dominate the surface, and atmospheric perspective gives way to a constant focus embracing nearby and distant images. In this view of the cosmos, Carpaccio had learned from Antonello da Messina how to introduce Flemish vision into Italian painting.

VITTORE CARPACCIO
The Disputation of St. Stephen
Canvas; 67 3/4″ × 57 7/8″.
Signed and dated in Latin in the roundels of the column stylobates: "VICTOR/CARPA-THIUS/PINXIT/"MDXIII."
From the church of S. Stefano of the Scuola dei Lanieri, Venice, which was suppressed in 1806. There were five scenes from the life of the patron saint of the church, painted between 1511 and 1528. One, showing the trial of the saint, has been lost. The others are in Berlin, Stuttgart and Paris. The altarpiece of the church, by Bissolo, is also at the Brera. Bissolo probably collaborated with Carpaccio on this canvas.

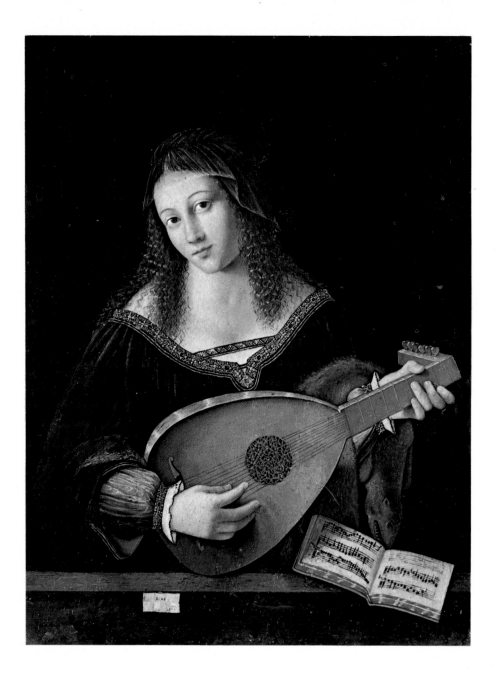

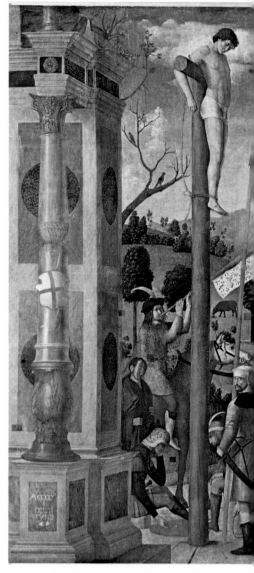

BARTOLOMEO VENETO. *Woman Playing a Lute*.
The woman is represented in the guise of St. Cecilia, a typical example of sixteenth-century "court art." In fact the artist worked for three years at Ferrara for Lucrezia Borgia. Bartolomeo's formation derives from Cima da Conegliano and the later work of Bellini, with influences from Leonardo, Costa and northern European art. His signature on a painting that was formerly in the Donà delle Rose collection in Venice shows how aware he was of his mixed development: "Bartolamio half Venetian and half Cremonese." He liked to paint half-figures of women, and chose subjects with strong personalities. In this respect he provides a distant precedent for the work of Del Cairo.

BARTOLOMEO VENETO
Active between 1502 and 1530
Woman Playing a Lute
Oil on panel; 25 1/2″ × 19 1/2″.
The date appears on the paper below the lute: 1520. A replica, perhaps by the artist himself, is in the Gardner Museum, Boston. From the house of the Vassalli del Majno family in Milan; it was acquired by the Gallery in 1932.

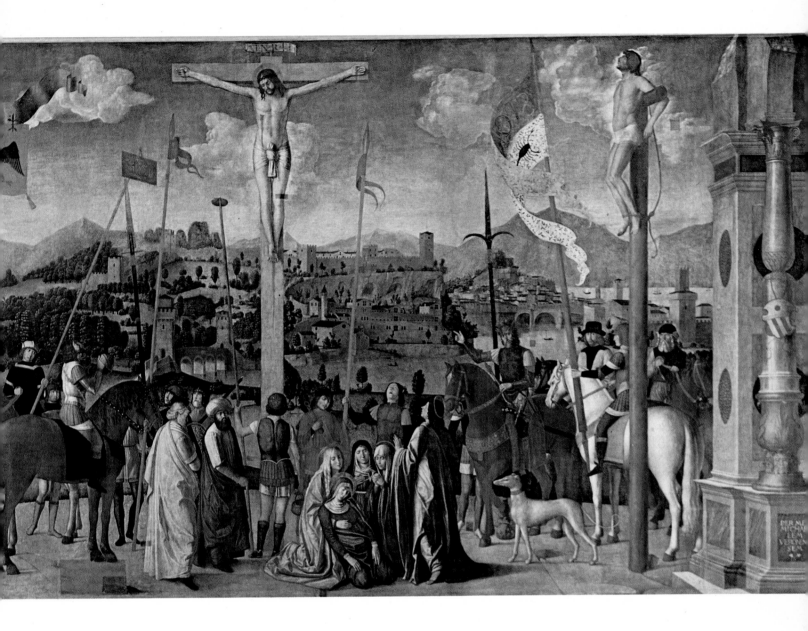

MICHELE DA VERONA
Verona circa 1470 — circa 1540
Crucifixion
Canvas; 23'7 1/2" × 11'.
The date and signature appear in Latin on
the bases of the columns at either side of the
picture. Although some critics think the
landscape represents Verona, more likely it
is imaginary. From the monastery of S. Gior-
gio in Braida, Verona, where it remained
until 1811.

MICHELE DA VERONA. *Crucifixion.*

At one time Michele was thought to have been the pupil of Domenico
Morone; today, the range of influences that went into his formation is be-
lieved to include Diana, Alvise Vivarini and the late Giovanni Bellini. Thus
he was not strictly a provincial product, but operated within the sphere of
a strongly archaizing purism. The *Crucifixion* is Michele's masterpiece,
with its unusual cold color and silvery reflections.

LORENZO LOTTO. *The Assumption of the Virgin.* *p. 108*

In this work of his early maturity, Lotto rejected the classicizing models of
the Venetian tradition and affirmed a freedom of expression based on com-
plex cross-currents from Dosso, Dürer, Raphael, Correggio and others. There
is nothing comparable in the art of the time, and there is also no precedent

for the high drama of his uprooted artistic conscience. This interior torment gives some of his images a grotesque, almost demonic, excitement.

The freedom achieved by Lotto in this extremely simple representation borders on the naive. There is a strip of wild desert landscape. The figures, with their arms raised, are as agitated as if at a witches' sabbath. The Madonna rises to heaven among the angels. A little figure, seemingly overcome by emotion, runs off to the right. Yet in this narrow space and with such limited means, life pulsates with a cosmic unrest.

LORENZO LOTTO. *Portrait of Laura da Pola* and *Portrait of Febo da Brescia.*

These two paintings belong to the period in his career when Lotto was particularly active as a portraitist. Rather than painting monarchs and prelates, as did Titian, Lotto portrayed the local nobility, fixing their traits with an acute eye. There is no rhetorical decorative detail but only the existential truth of the subject.

The handling of the paint, especially in the *Portrait of Laura da Pola,* is Titianesque in the brushwork, the broad and uneven strokes and the warm tonality. The register is kept predominantly low, however, and is almost monotonous in the costume and the background, except for the warm rays of the velvet chair and the explosive color of the fan. The abstract oval of the face, framed by the regular coiffure and headdress, is reminiscent of the Tuscan tradition.

108

LORENZO LOTTO
Venice circa 1480 — Loreto 1556
The Assumption of the Virgin
Panel; 22 3/4″ × 10 1/2″.
This panel was part of the predella of the Recanati *Transfiguration* (circa 1512), which also included *Christ on Mount Tabor* in Leningrad and a lost *Agony in the Garden.* It was formerly in the church of S. Maria di Castelnuovo, where Vasari saw it. Subsequently it was in the Annibale Mattei collection, Rome, where it was attributed to Raphael. Acquired in the Oggioni Bequest, 1855.

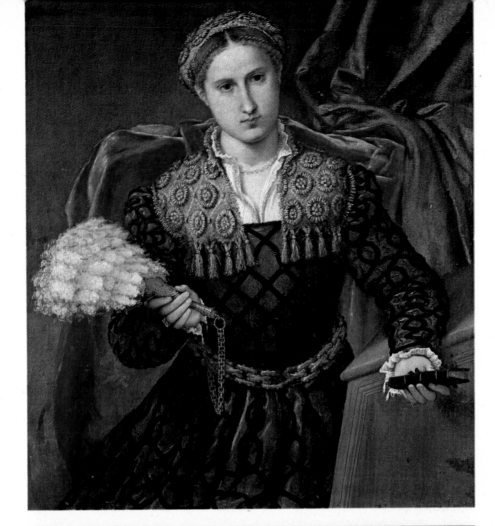

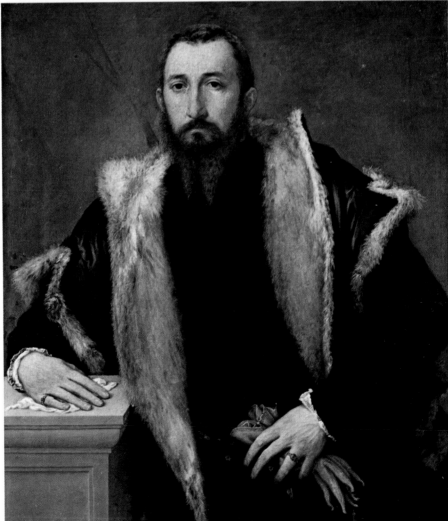

LORENZO LOTTO
Portrait of Laura da Pola and *Portrait of Febo da Brescia*
Oil on canvas;
30 1/4″ × 35 3/4″; 29 1/2″ × 35 1/2″.
Both paintings are signed and dated 1544.
Formerly in the Darache collection, Turin.
Acquired in 1859 with funds provided by
Victor Emmanuel II. They were identified
by Berenson as works of Lotto from the artist's account book.

TITIAN
Pieve di Cadore circa 1488 — Venice 1576
St. Jerome (circa 1560)
Oil on canvas; 4'1 1/4" × 7'8 1/2".
Signed: "TICIANVS F."
The rounded part of the panel is a later addition (perhaps by the artist), as shown by copies such as in the Accademia di San Luca, Rome. Ridolfi mentions the painting as being in the church of S. Maria Nuova, Venice, from which it was taken in 1808 to the Brera.

TITIAN. *St. Jerome.*

A clearing in the woods is immersed in the reflections of a fiery sunset, and the stones and the skin of the old ascetic share the same old-gold fluorescence. This chromatic blaze is the real subject of the painting. In composition, the Mannerist framework of crossed diagonals is not an end in itself but accentuates the vitality of wild nature, and suggests that the wind is blowing. Having broken the old relationship between tonal painting and the twilight effects of Giorgione, Titian devoted himself to the monumental style without, however, any rhetorical preconceptions. Following the single principle of rendering the strongest visual emotion, he achieved the highest lyrical freedom. The success and popularity of this painting is shown by the existence of numerous replicas, copies and derivations, including one by Rubens in Haarlem and another by Brusasorzi in Rovereto.

TITIAN. *Portrait of Count Antonio Porcia.* *p. 111*
A magnificent work of Titian's early maturity, this is certainly one of his greatest portraits. The half-figure in three-quarter view is shown beside a window open on a distant landscape whose high-keyed harmonies contrast with the low tones of the interior in the foreground. The figure is stylistically akin to Titian's portrait of Francesco Maria della Rovere, which is now in the Uffizi.

BONIFACIO VERONESE. *The Finding of Moses.*
This painting and *The Feast of Dives* (Accademia, Venice) are considered Bonifacio's masterpieces. He has used the subject as an excuse to paint an open-air holiday scene, in which the luxuriousness of the clothes melts into the opulent landscape dotted with little genre scenes. In overall decorative effect, the painting is much like a tapestry. Bonifacio's sources of inspiration include Titian and Dosso, with some influence from northern European painters.

BONIFACIO VERONESE
(BONIFACIO DE' PITATI)
Verona circa 1487 — Venice circa 1553
The Finding of Moses
Oil on canvas; 11'3 3/4" × 5'9".
In Cardinal Monti's bequest to the Archdiocese of Milan, it came to the Brera in 1811. A sketch was cited by Malaguzzi Valeri as being in the Mond collection.

112

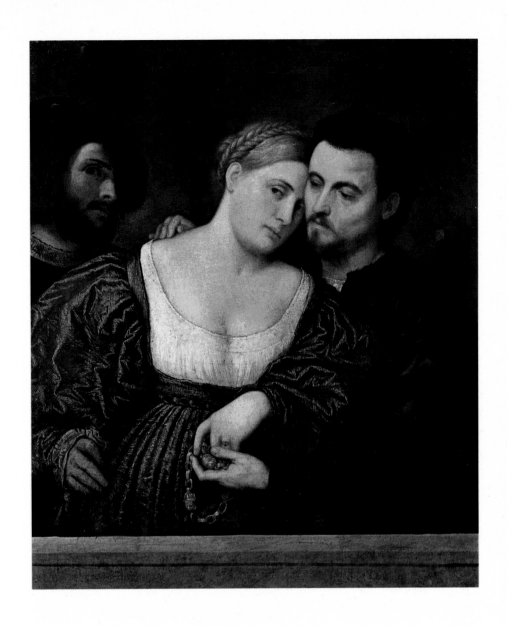

PARIS BORDONE. *The Venetian Lovers.*

One of Bordone's most celebrated works, this painting represents a favorite subject of early sixteenth-century Venetian art. Its Giorgionesque reminiscences, here reduced to a sort of bourgeois languor, date it around 1525–30. Yet it also shows a Mannerist restlessness that relates it to contemporary work by Palma il Vecchio. The scene is one of venal love (note the pallor of the man embracing the woman). Although the mysterious third figure with the swaggering air may portray a procurer, his artist's beret suggests that it may be a self-portrait. In that case the meaning of the work would be allegorical rather than specific.

PARIS BORDONE
Treviso 1500 — Venice 1572
The Venetian Lovers
Oil on canvas; 31 1/2″ × 37 1/2″.
Formerly it belonged to Prinetti, Milan. The painting was purchased by the Gallery in 1890.

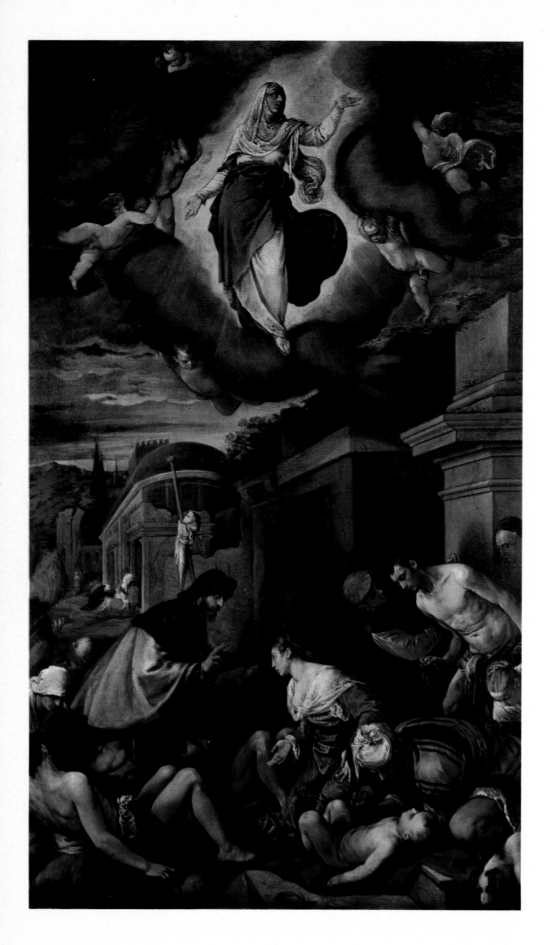

JACOPO BASSANO
(JACOPO DA PONTE)
Bassano circa 1518 — Bassano 1592
*St. Roche among the Plague Victims and
the Madonna in Glory* (circa 1575)
Oil on canvas; 6'10 1/2" × 11'5 3/4".
Signed in Latin at lower right: "IAC.s
PO(N)TE/BASS.is/PINGEBAT."
Formerly on the main altar of the church of
S. Rocco in Venice, it has been in the Brera
since 1811.
Right: detail.

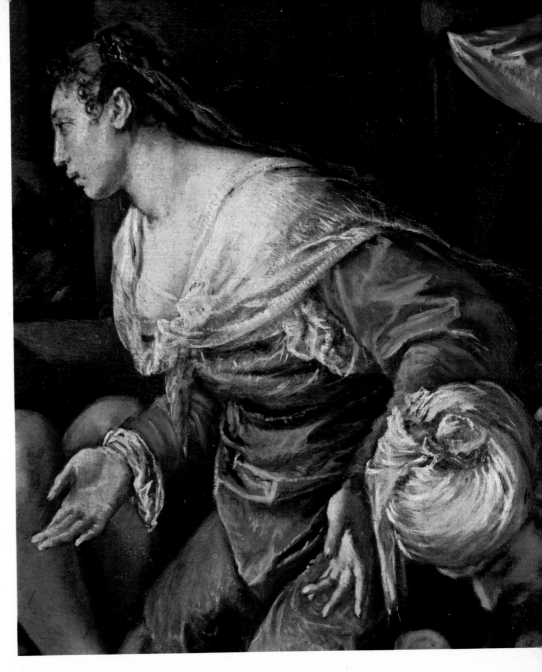

JACOPO BASSANO. *St. Roche among the Plague Victims and the Madonna in Glory.*

This work shows an attempt to introduce a scene from life into an altarpiece, utilizing scenic devices derived from Mannerism but achieving very different results. There is an obvious kinship with Tintoretto, but Bassano has retained his own style in the impasto brushwork, the subtle taste for the picturesque and the peacefully slow movements. The novelty of this painting can be seen by comparing it with Titian's *Pesaro Madonna*. That work is composed similarly, on a diagonal in depth, and is also connected with a given social class, though a different one. In Titian's painting the scene is solemnly ceremonial and is laid at the door of a temple out of which the Virgin has just come. It is clear that the Venetian aristocrats and the Virgin all belong to the same exclusive elite. Here, however, the Virgin is relegated to a respectful distance, like a pendant image. The figures scattered about below, who are entirely absorbed by their own daily life and humble piety, do not notice her.

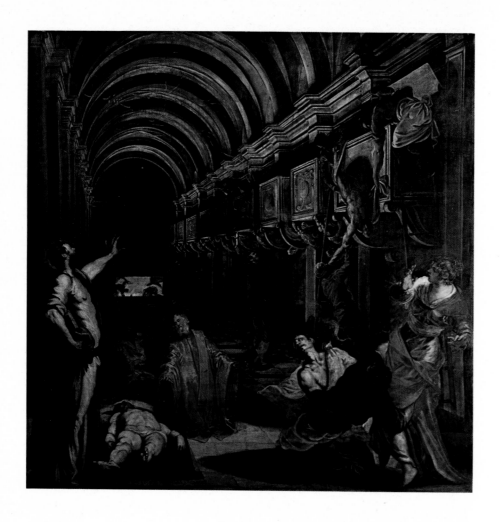

TINTORETTO. *Miracle of St. Mark: The Discovery of the Saint's Body.*
A masterpiece of Tintoretto's full maturity, this painting is a profound expression of his originality. It creates a lyric spectacle out of extreme disquietude. In fact, it expresses a visionary notion that borders on hallucination, and in this way the scene of the stealing of the body becomes a meteoric
display. A memorable image is created that has the impact of a clap of
thunder at a witches' ritual.

The scene shows the saint appearing on the left and reacting to the finding
of his own body. The corpse at the saint's feet is to take the place of his
body in the sarcophagus. The kneeling figure in the center is the donor of
the canvas, Tommaso Rangoni, who was called "the scholar of Ravenna."
On the right, to balance the composition, a victim of the plague, a possessed
man and a woman invoke the help of the saint.

TINTORETTO
(JACOPO ROBUSTI)
Venice 1519 — Venice 1594
*Miracle of St. Mark: The Discovery of the
Saint's Body* (1562–66)
Oil on canvas; 13'1 1/2" × 13'1 1/2".
Painted for the hall of the Scuola Grande di
S. Marco with three other canvases (now in
the Accademia, Venice), the panel has been
in the Brera since 1886. Two preliminary
drawings have been published in Tietze's
Venetian Drawings.
Right: detail.

Tintoretto has adopted here and carried further the expressive means of Tuscan and Roman Mannerism. There is the explosive perspective (note how the peak of the visual pyramid coincides with the raised hand of the saint performing the miracle). There are the dynamic crossing of the compositional diagonals, the nervous contortion and the bold foreshortening of the figures. Then there is the light from various sources that erupts from the tombs or spreads from the mouth of the long hall, like a nocturne in the porticoes of St. Mark's. It prints rainbows along the bays, leaving an impression of instability and obsession. Finally there is the macabre element of the tomb-robbing scene and the anxiety of the jumble of figures in the foreground. Unreality reaches a peak in the pictorial rendering. The disintegration of the color, an inheritance from Titian's late work, is seen in the dissociation of the brushstrokes from the material and their flickering, like a multitude of flames, against a somber and blurred surface.

117

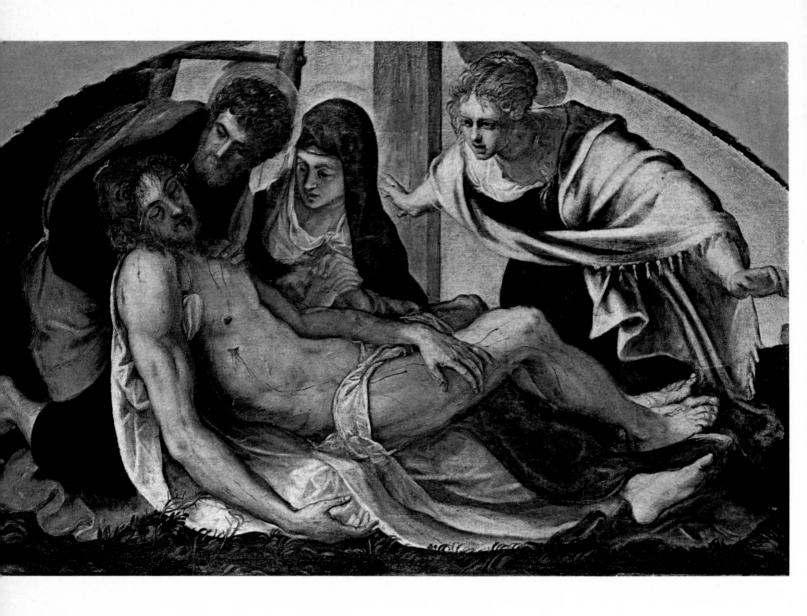

TINTORETTO. *The Deposition.*

Tintoretto achieved the highly oratorical effect of this work by the studied compression of the attendant figures bending over the body of the dead Christ. In its original placement over a door, the large, heavy corpse, waxen and running with blood, loomed ominously above the spectator.

GIOVANNI BATTISTA MORONI. *Portrait of Antonio Navagero.*

This is a typical example of an alternative form of portraiture to Titian's heroic and solemn type, Tintoretto's uneasy and dramatic renderings, and Lotto's subtly tormented and introspective works. Moroni's portrait is purely bourgeois and combines the measure of Veronese's portraits with the more worldly effects of Moretto. The result is entirely new, for it amounts to the discovery of a different type of ethical and psychological balance.

118

TINTORETTO
The Deposition
Canvas lunette; 67″ × 42 1/2″.
A document showing payment for this picture is dated 1563. Since the payment was an advance, the work was actually completed in successive years. It was painted to go over a door in the courtyard of the Procuratie, Venice. The damage from exposure to the elements is still visible; Tintoretto himself restored it in 1590, when it was moved to the inside of Scamozzo's new building. It has been at the Brera since 1808.

GIOVANNI BATTISTA MORONI
Bondo di Bergamo circa 1525–1578
Portrait of Antonio Navagero
Oil on canvas; 35 1/2″ × 45 1/4″.
A Latin inscription on the lower right identifies the subject and gives the date of the painting: 1565. It is mentioned as being at the Brera in 1841.

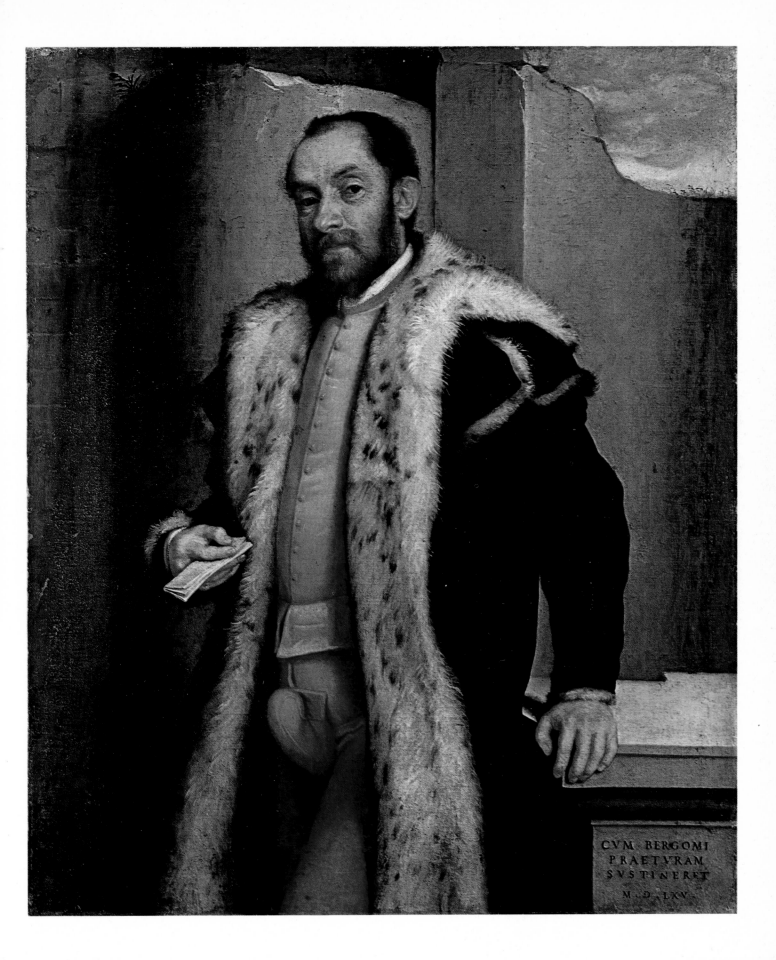

CVM BERGOMI
PRAETVRAM
SVSTINERET
M . D . LXV

PAOLO VERONESE. *The Feast in the House of Simon.*

Typical of Veronese, the subject of this painting is an excuse for composing an elaborate sequence of episodes showing contemporary life and manners. On the left is the biblical scene of Mary Magdalene doing homage to Christ by washing his feet. Although this work is not one of his famous pictures and some scholars have even questioned its authorship, it is in Veronese's usual grand manner. The scene is set at a country villa and the event is private and intimate, less worldly and ceremonial than it would be in a city palace. Like Tintoretto, who had turned religious representation into something theatrical, Veronese gave the subject a metaphorical and pro-

120

PAOLO VERONESE
(PAOLO CALIARI)
Verona 1508 — Venice 1588
The Feast in the House of Simon
Oil on canvas; 23'3 1/2 × 9' 1/4".
The painting was mentioned by the artist during his trial before the Inquisition in 1573. From the refectory of the convent of S. Sebastiano, Venice, where Ridolfi saw it. It came to the Gallery in 1817, in exchange for the *Supper of St. Gregory the Guest,* which was returned to the sanctuary of Monte Berico at Vicenza. The work is in somewhat poor condition, even after Pelliccioli's cleaning, because of numerous restorations beginning early in its history.

fane interpretation. It is not, however, irreligious, but an expression of religious freedom, which he defended in his trial before the Inquisition. The figures from Christian mythology are devoid of the miraculous, as they are projected in a felicitous and incorruptible time and space.

PAOLO VERONESE. *Christ in the Garden Supported by an Angel.*

p. 122

Unlike *The Feast in the House of Simon*, this painting is highly refined in execution. Its new and rare inventive aspects are musically rendered by the fresh and dewy quality of the paint. While the archaeological features of

PAOLO VERONESE
Christ in the Garden Supported by an Angel
(circa 1580)
Oil on canvas; 42 1/2″ × 31 1/2″.
From the church of S. Maria Maggiore in
Venice, where it was seen by Ridolfi. At the
Brera since 1808. A variant of uncertain au-
thorship is in the Palazzo Ducale, Venice.

PAOLO VERONESE
Baptism and Temptation of Christ
Oil on canvas; 14′9 1/4″ × 8′1 1/2″.
Formerly in the church of S. Nicolò, Venice,
which has been destroyed. In the Gallery
since 1809.
Right: detail.

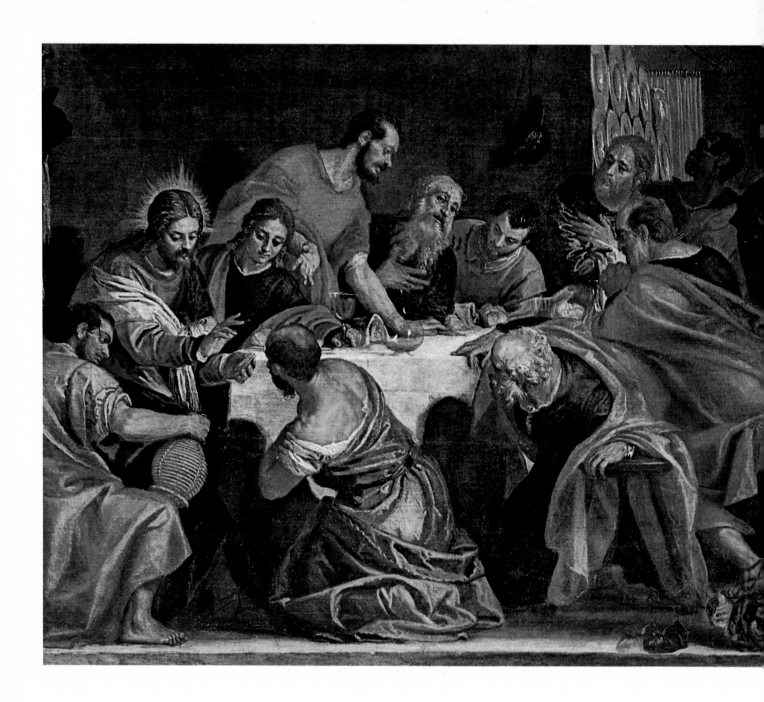

the background powerfully prefigure the leaden atmosphere of Guardi's ruins, the mystic light pouring down in the foreground seems to anticipate the phosphorescent distortions of El Greco.

PAOLO VERONESE. *Baptism and Temptation of Christ. pp. 122–123*
The painting is organized as a continuous narration. On the left is the Baptism, a theme usually handled statically by Veronese but here so animated that the action almost explodes around the dove of the Holy Ghost. On the right is the Temptation, with Christ being offered the possession of the king-

PAOLO VERONESE
The Last Supper
Oil on canvas; 17'2" × 7'6 1/2".
From the church of S. Sofia in Venice, where Ridolfi saw it. At the Brera since 1811. Probably a late work, its attribution to Veronese is not certain.

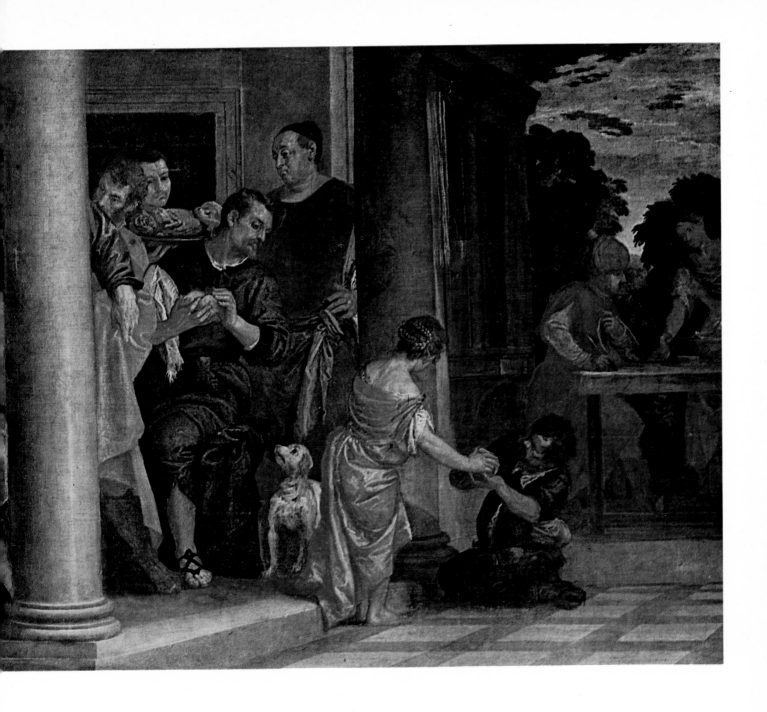

doms of the earth. Airy architecture dominates the landscape, into which the cities of the world have been crowded. The fabulous, invented Oriental architecture anticipates Borromini and Guarini.

PAOLO VERONESE. *The Last Supper*.
In this late work, Veronese has again used a religious theme to portray scenes of contemporary life. He freely adopted the architectural ideas of Palladio and Sanmiche. The painting repeats a detail of the interior from an earlier work by the artist, *The Washing of the Feet*.

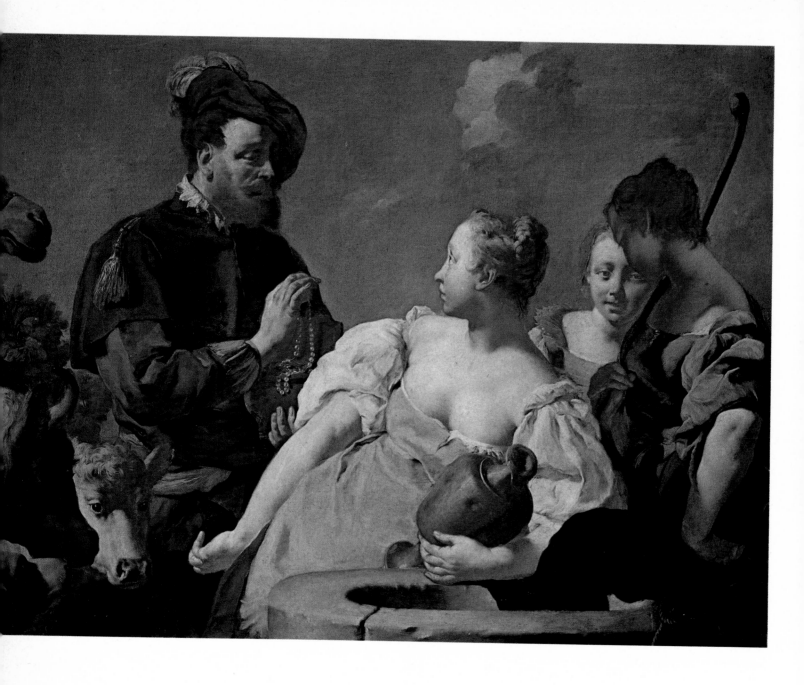

GIOVANNI BATTISTA PIAZZETTA. *Rebecca at the Well.*
This work, with its warm proto-Rococo air, like the celebrated *Fortune Teller* in the Accademia, Venice, is one of Piazzetta's outstanding paintings. Piazzetta's innovation consisted of developing an increasingly light palette. This is not, however, related to Ricci's high-keyed mythological fables, but to a more substantial "naturalism" in the eighteenth-century sense, that is, in the Arcadian taste. The biblical scene is thus turned into a gallant episode of an elderly gentleman approaching a little shepherd girl. Piazzetta derived his preference for Christian rather than pagan subject matter — as well as his rejection of rhetorical effects — from Crespi, though he shares Crespi's social content only on the level of manners. In the solid compositional framework of his pictures, Piazzetta is a typical eighteenth-century painter.

126

GIOVANNI BATTISTA PIAZZETTA
Venice 1683 — Venice 1754
Rebecca at the Well (circa 1740)
Oil on canvas; 54" × 40 1/4".
Bequest of Emilio Treves, 1916.

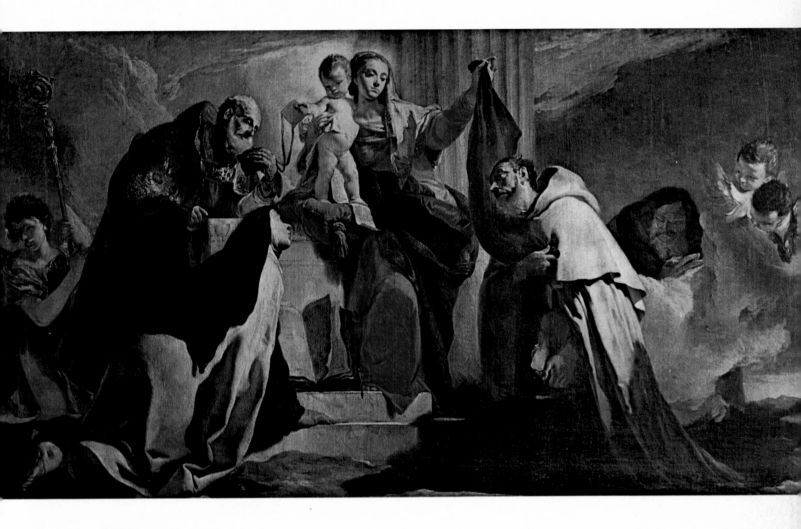

Effects such as the projection of the figures against an open sky are taken from Tiepolo; however, Piazzetta rejected Tiepolo's theatricalism in favor of a greater emphasis on the paint itself, so that the figures have the refined consistency of gleaming plaster statues.

GIOVANNI BATTISTA TIEPOLO. *The Madonna of Mount Carmel and the Souls in Purgatory.*

An early work by Tiepolo, this painting is violent and agitated in its composition, construction of the figures, impastos and in the Baroque light effects. The influences on Tiepolo that can be discerned range from Balestra to Piazzetta. Veronese's example is seen in the broadness of the space and the juxtaposition of episodes. The painting shows one of the fundamentals of Tiepolo's spiritual approach: a skeptical, disenchanted detachment from his subject matter. This typical attitude of the Enlightenment later carried him to the supremely undramatic balance of his maturity, in which he returned, in more modern terms, to the sardonic ideal of Veronese.

GIOVANNI BATTISTA TIEPOLO
Venice 1696 — Madrid 1770
Our Lady of Mount Carmel and the Souls in Purgatory
Detail of the central portion.
Oil on canvas; 21'4" × 6'10 1/2".
Formerly in a chapel in the church of S. Aponal, Venice. After the suppression of the church, the picture was taken to France and cut in two. Both pieces were bought by the Chiesa family for the Brera; the painting was restored to its original form in 1950.

127

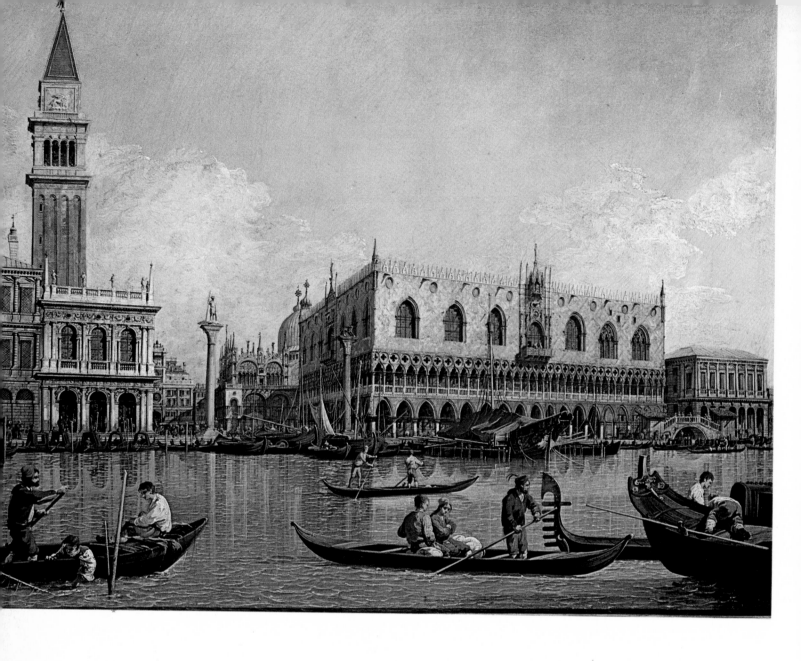

CANALETTO. *View of the Quay from St. Mark's Basin* and *View of the Grand Canal from Campo S. Vio.*

Canaletto is not only the main representative of Venetian view painting, but also one of the major exponents of the Enlightenment mentality. There is obviously an active rationalism behind his orderly approach to the laying out of this scene, with every object observed from reality but arranged in an almost numerical sequence. This reaction to Baroque irrationalism is part of the Neoclassical movement popular in England, where in fact Canaletto achieved great success.

128 Canaletto's vision of reality is constructed on a perspective system, with a

CANALETTO
(ANTONIO CANAL)
Venice 1697 — Venice 1768
View of the Quay from St. Mark's Basin
Oil on canvas; 28″ × 20 3/4″.
This is a variant of a larger prototype now in the Matarazzo collection, São Paolo. It was acquired with its companion piece, *View of the Grand Canal from Campo S. Vio*, in 1928.

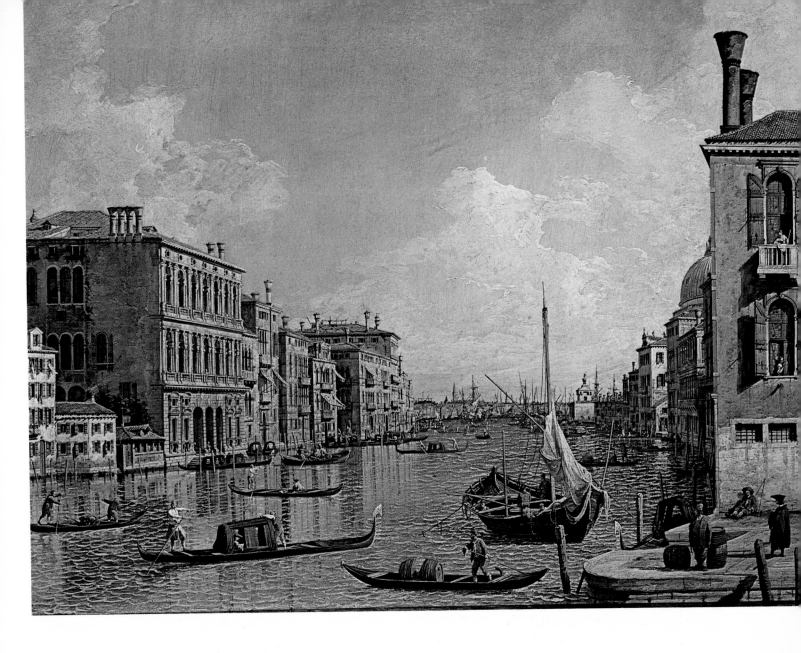

highly dynamic compositional balance marked by a complex "choral" harmony. His art transcends mere documentary; he is the inventor of a seemingly scientific visualization in which the content of the scene reveals its true nature. The best proof that his are works of controlled imagination identified with reality is to observe the townscape of Venice after having scanned Canaletto's paintings. The city appears under a new guise, with striking forms and rhythms. The stage-set perspective that served Canaletto as a point of departure was fundamentally a means of showing illusionistic-ally something that was not there. He reversed this process in his painting: instead of applying theoretical perspective to an object in order to simulate another, he rediscovered an object's natural perspective.

129

PIETRO LONGHI. *The Little Concert.*

A contemporary of the view painters, Pietro Longhi could be called the master of the human landscape. He followed the topography of manners and social custom rather than that of psychology. He did not play the role of judge or moderator, but simply described what he saw with a sharp eye. This painting, set in an interior, shows some French influence, probably stemming from Liotard, who was in Venice in 1745.

PIETRO LONGHI. *The Tooth-Puller.*

Longhi derived his inspiration from the main sources of eighteenth-century Venetian painting: the Bolognese school, through Crespi, and English art, through Hogarth. The limpid color of this painting dates it in the 1740's. It belongs to a genre that has some connection with Ceruti's work.

PIETRO LONGHI
Venice 1702 — Venice 1786
The Little Concert
Oil on canvas; 24 1/2″ × 19 1/2″.
Signed: "Pietro Longhi."
Probably from the Gambardi collection in Florence.

130

PIETRO LONGHI
The Tooth-Puller
Oil on canvas; 24 1/2″ × 19 1/2″.
Signed: "Pietro Longhi."
The inscriptions on the columns, which represent those of the Palazzo Ducale, mention Pietro Grimani as the incumbent Doge and the election of Antonio Poli as parish priest of S. Margherita (which took place in 1746). A preliminary drawing for the dwarf is in the Museo Correr, Venice. The painting probably comes from the Gambardi collection in Florence.

FRANCESCO GUARDI. *View of the Grand Canal at the Pescheria (The Fish Market).* pp. 132–133

Formerly considered an imitator of Canaletto, Guardi is actually a romantic interpreter of Canaletto's "scientific" views. In his hands the crystalline geometry of buildings is dissolved in atmospheric color. Guardi is a "virtuoso," like those eighteenth-century musicians who went from execution to interpretation, to variation, to improvisation, and sometimes even to creative invention. His variations, with respect to Canaletto, concern not only the technique of painting, but also the perspective framework. The composition of this work is less rigidly constructed and less scientific, with a multiplicity of vanishing points that slow down and articulate the scene in more dramatic form. An outstanding passage is on the right, where the shifting of the vanishing points creates a succession of images and conveys the sense of the canal's turn.

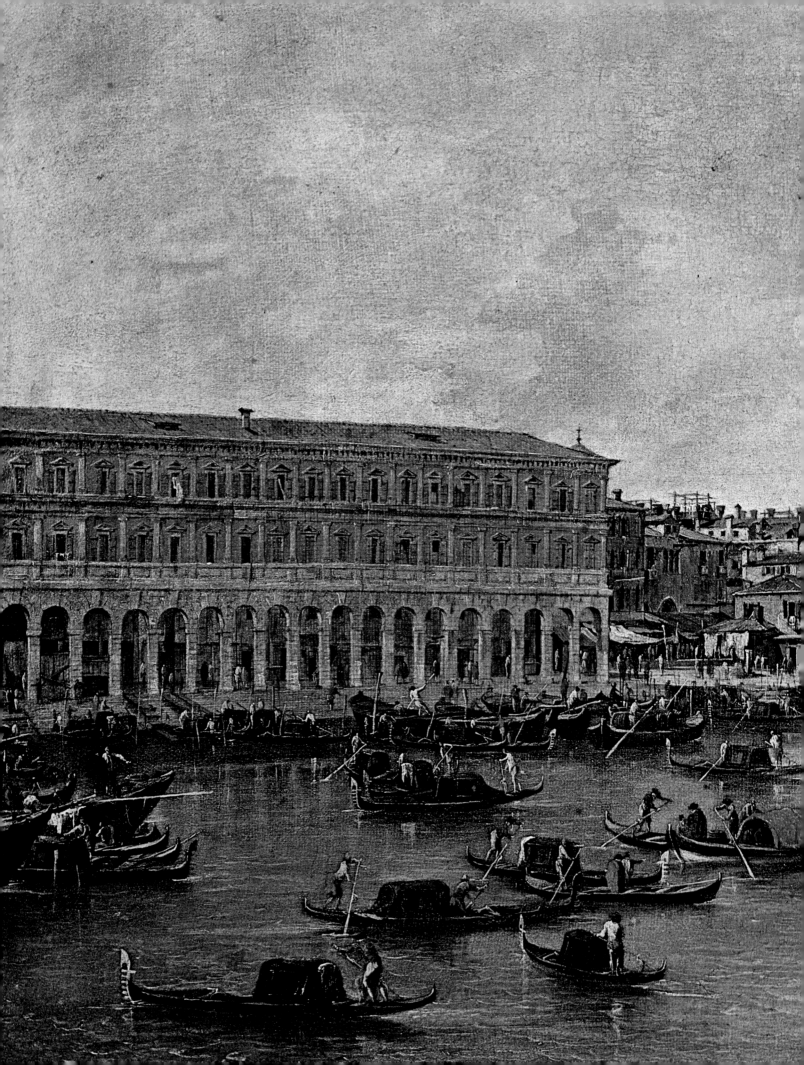

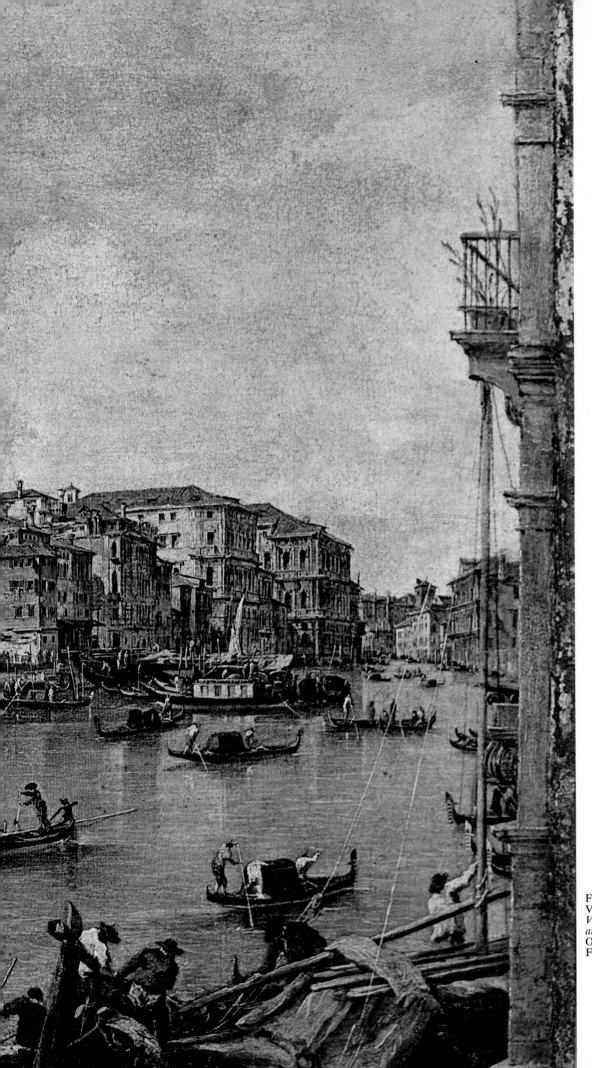

FRANCESCO GUARDI
Venice 1712 — Venice 1793
View of the Grand Canal
at the Pescheria (The Fish Market)
Oil on canvas; 29 1/2" × 22".
From the Oggioni bequest, 1855.

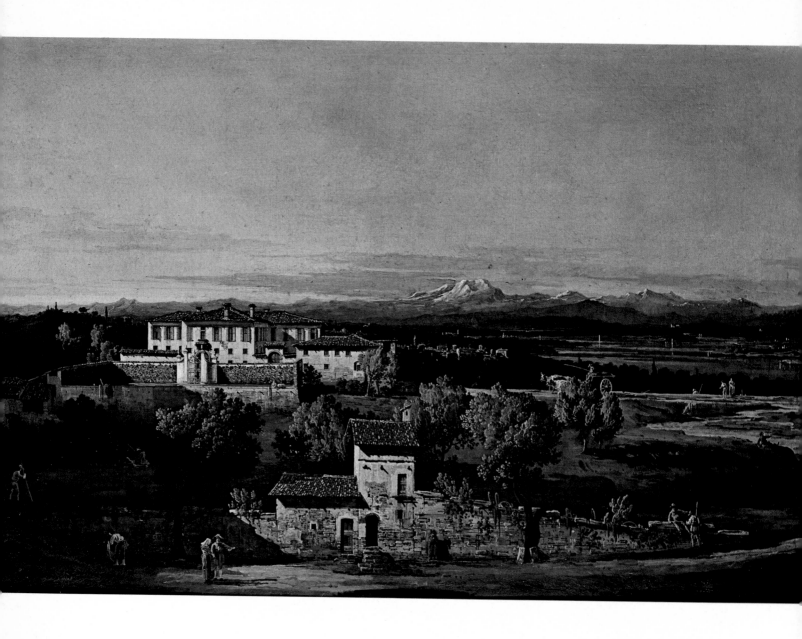

BERNARDO BELLOTTO. *View of the Villa Cagnola at Gazzada near Varese* and *View of Gazzada near Varese.*

One of the great Venetian view painters, Bellotto can be compared to Canaletto and Guardi. Canaletto's abstract poetry was dependent on a visual rediscovery of the historic landscape, while Guardi gave it a lyric vibrancy by means of atmospheric effects. Bellotto's views, however, present specific and impressive images of reality. He is thus the major representative of the objective view, obtained by the use of the camera obscura. Bellotto's purpose in utilizing the device was not to give a photographic order to things, nor to exalt their atmospheric emanations; his aim was rather to

BERNARDO BELLOTTO
Venice 1720 — Venice 1780
*View of the Villa Cagnola
at Gazzada near Varese*
Oil on canvas; 39 1/4″ × 25 1/2″.
Acquired in 1831.

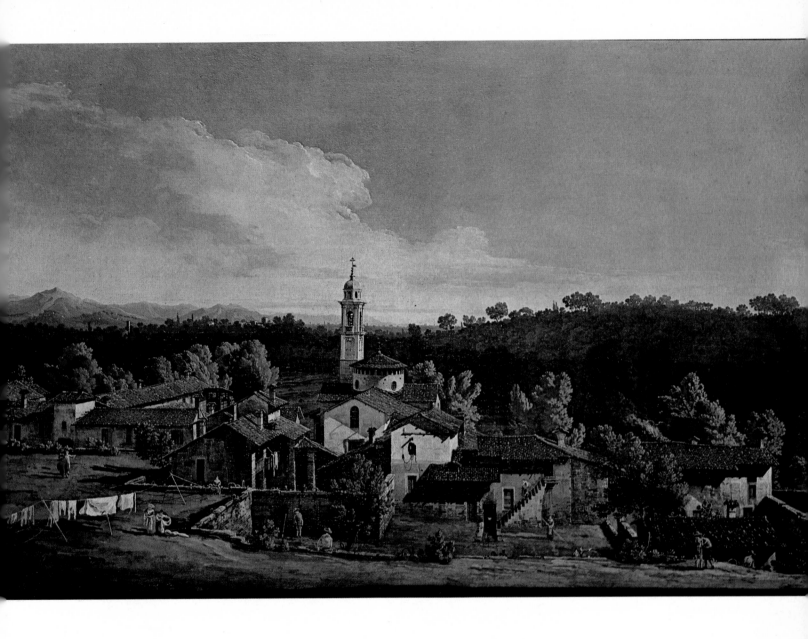

seek out the nature and inner truth of the landscape, whether urban, rural or marine. His intuition anticipated Romanticism.

In these two rural landscapes, the effects of light are closely observed and convey the truth of the season, time of day and temperature. The light varies when it strikes vegetation, the sky, stains on the walls and the textures of the ground. It was this new, subtle sensitivity to the nature of things that determined Bellotto's success as a court painter.

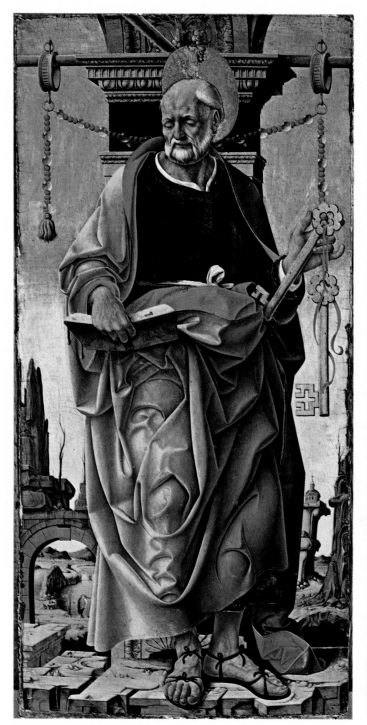
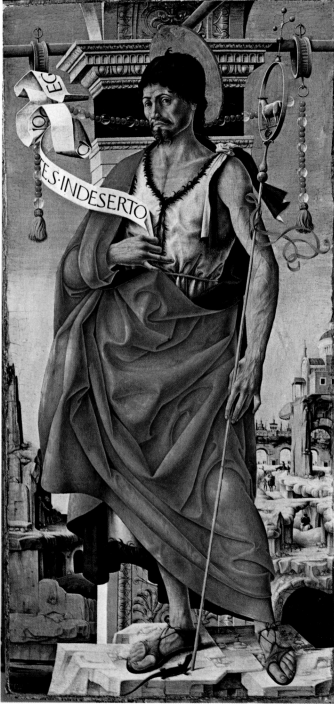

FRANCESCO DEL COSSA. *St. Peter* and *St. John the Baptist.*

Francesco del Cossa and Ercole de' Roberti, two of the most important fifteenth-century Ferrarese painters, worked together on this altarpiece. Francesco del Cossa, who painted the delightful scenes of life at the court of Duke Borso d'Este in the Palace of Schifanoia at Ferrara, had a disagreement with the duke and after 1470 moved to Bologna. In the two saints, which were painted entirely by Cossa, the hard and unyielding Ferrarese mode of representing humanity takes on another dimension because of the warmth of the color. The painter's powerful imagination found

FRANCESCO DEL COSSA
Ferrara 1436 — Bologna 1478
St. Peter and *St. John the Baptist*
(circa 1470–73)
Each panel 44″ × 21 1/2″.
The two paintings are the side panels of the triptych ordered by Floriano Griffoni, between 1470 and 1473, for his family chapel in the Basilica of S. Petronio, Bologna. The central panel, representing St. Vincent Ferrer, is in the National Gallery, London; the

predella, showing miracles performed by St. Vincent, is in the Pinacoteca of the Vatican. Other parts of the triptych are divided among the National Gallery, Washington, the Louvre and various private collections. A document in the Archive of S. Petronio, dated July 19, 1473, mentions a payment to Maestro Agostino de' Marchi of Crema for the frame of the Griffoni altar. At the Brera since 1893.

Above: four details.

expression in the impressive placing of the large figures, which are handled more like architectural elements than human forms. In the beautiful landscape of *St. John the Baptist,* little scenes of courtly life are set among rocky declivities overhung by elegant Renaissance buildings. These details and the image of the bird among the rocks, the river and the ruins in *St. Peter* carry the spectator into a magic world. The effect is heightened by the precision of the details. The beads and the pastoral staff are archetypal forms, timeless in their evocative power.

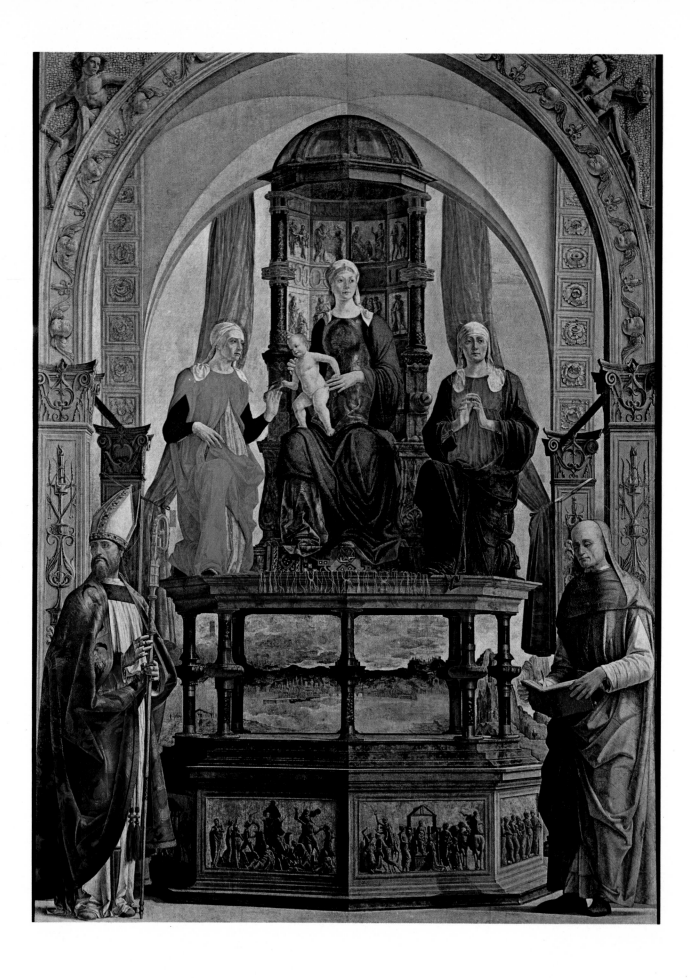

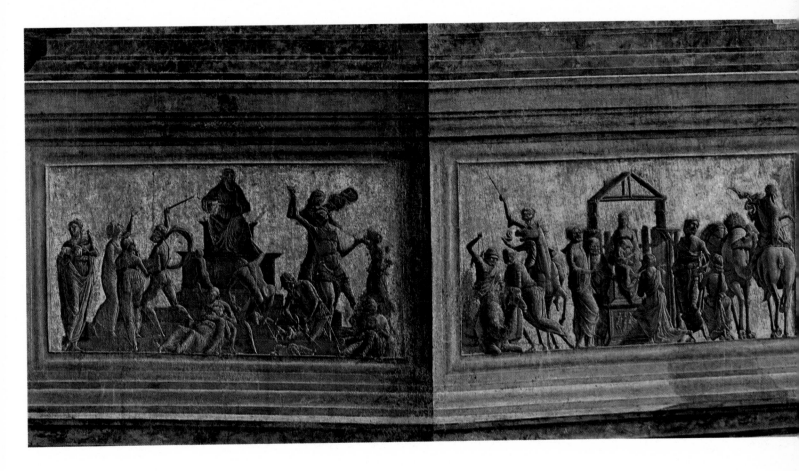

ERCOLE DE' ROBERTI. *Madonna Enthroned Between SS. Anna, Elizabeth, Augustine and the Blessed Piero degli Onesti.*

Ercole de' Roberti, who worked in the school of Cosmè Tura and Francesco del Cossa, was the last of that trio of painters who made the name of Ferrara famous. He took part in the great decorations commissioned by the ducal court and worked at Schifanoia and Belriguardo. In this altarpiece, which is the first documented work by Roberti, his style is independent, although it shows the influence of his Ferrarese antecedents. The altarpiece reveals a familiarity with Venetian art and the work of Giovanni Bellini and Antonello da Messina in particular. Under a beautifully constructed architectural canopy, the Virgin is seated on a throne; beside her, on the octagonal podium, stand St. Anna and St. Elizabeth. The space that opens up in the marble base of the throne allows a view of the landscape around Ravenna between the colonettes. The grisaille bas-reliefs represent *The Massacre of the Innocents, The Adoration of the Magi* and *The Presentation of Jesus in the Temple;* the triangular spaces above the arch show *Samson with the Jawbone of an Ass* and *David with the Head of Goliath.* The candelabra on the pilasters and the grisaille reliefs on the back of the throne and along the base show the Ferrarese taste for rigid, timeless form and for almost grotesque rock-like figures.

139

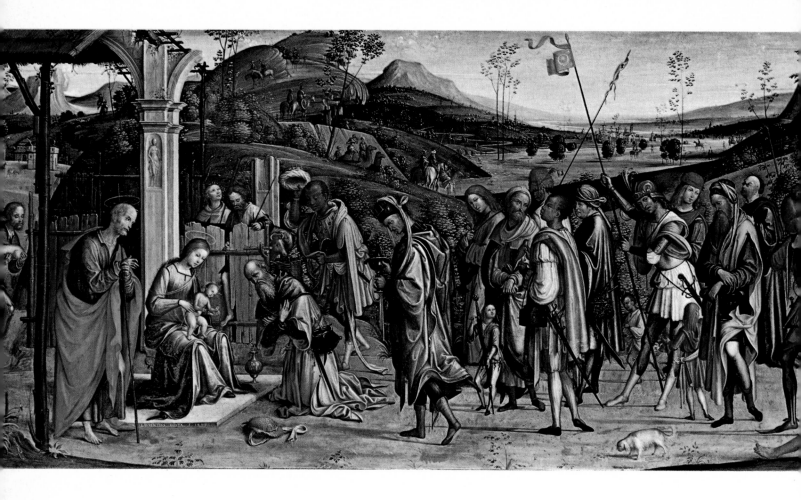

LORENZO COSTA. *The Adoration of the Magi.*

Costa was one of the generation of Ferrarese painters following that of Francesco del Cossa and Ercole de' Roberti. A pupil of Roberti, Costa often worked with the Bolognese painter Francesco Francia. One of the results of this collaboration was the *Misericordia Altarpiece. The Adoration of the Magi* or *The Manger,* which formed the predella of the altarpiece, was executed entirely by Costa. Unquestionably it is closely connected with the central part of the composition, which was painted by Francia. According to the chronicles, Costa boasted that "because of the industriousness of the painters this work was finished in only two months." In this painting, Costa shows a keen interest in the figures, and gives each a particular character and individuality. In the background a beautiful landscape extends into misty distances typical of the Po Valley. Amid cities, castles, stretches of woods and the lazy meandering of the river, the horsemen escorting the three kings wind their way toward their holy destination. From the right appear the pious kings, courtiers and equerries, who stop to pay homage to the Christ Child. Their banners at rest, the men-at-arms sit or lean, unaware of the significance of the moment. Behind the shed more modest worshipers, poor shepherds bringing their simple offerings, appear. Renaissance culture is apparent in the fact that the shed has been built onto classical ruins.

140

LORENZO COSTA
Ferrara 1460 — Mantua 1535
The Adoration of the Magi (1499)
Panel; 26 1/4" × 70 1/2".
Signed in Latin and dated:
"LAURENTIUS COSTA FECIT 1499."
The panel formed the predella of an altarpiece ordered by Antonio Galeazzo Bentivoglio for the church of the Misericordia in Bologna. Obliged to flee from Bologna, Giovanni II Bentivoglio, the lord of the city, took the altarpiece with him. Subsequently it was returned to Bologna. In 1809 the public-property office of Bologna, following the requisition of church goods by the Napoleonic government, shipped the panel to Milan. That same year the picture was consigned to the Brera.

DOSSO DOSSI
(GIOVANNI LUTERI)
Dosso? (Mantua)
circa 1489 — Ferrara 1542
St. Sebastian (circa 1540)
Panel; 71 3/4" × 37 1/2".
From the convent church of the Santissima Annunziata in Cremona. At the time of the suppression of the religious orders, in 1808, the picture was consigned to the Brera by the Ministry of Finance of the Kingdom of Italy. The panel shows affinities with the contemporary *St. John the Baptist,* also at the Brera.
Right: detail of the landscape.

DOSSO DOSSI. *St. Sebastian.*

Dosso Dossi introduced the influence of Venetian and Mannerist painting to the Ferrarese tradition. In Venice, he met Titian and in Rome he became acquainted with Raphael. In the course of his travels he took part in the Mannerist movement when it was at its height. *St. Sebastian* was painted in the artist's maturity. The landscape derives from the Giorgione tradition, but its relationship to the arched body of the saint, the full movement of the mantle that follows the body, the glinting armor heaped on the ground and the clear contours of the fruit and leaves is not a mechanical juxtaposition of different influences, but the fully achieved expression of a rich and complex personality.

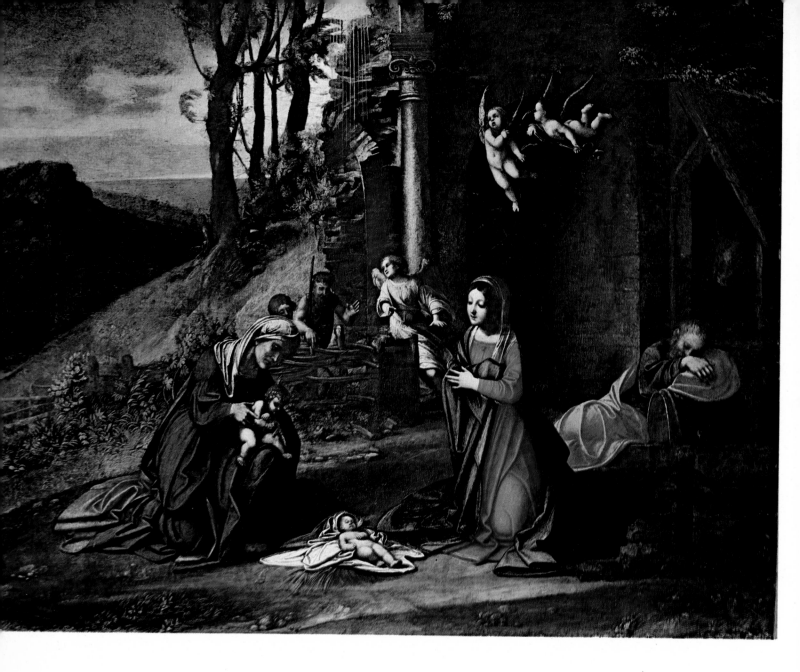

CORREGGIO. *The Nativity.*

An important influence on Correggio's art was the presence of Mantegna's paintings in the church of S. Andrea at Mantua. The lords of the city of Correggio were in constant touch with the sovereigns of Ferrara, Mantua and neighboring Parma, and the painter frequented the courts of Emilia, where he found stimulation and opportunities to work. In this youthful painting, Correggio's knowledge of Mantegna is grafted onto a familiarity with Dosso's methods. The clarity of the composition saves the picture from falling into sentimentality. The scene is almost a factual description of a Po Valley farming family. The old peasant woman, St. Elizabeth, leans with rough tenderness over the newborn Child lying on a white sheet laid over fresh straw from the manger. The Infant St. John, struggling to reach his new playmate, is lovingly restrained by St. Elizabeth. The Virgin looks on with maternal pride, while Joseph, overcome by emotion and the

142

CORREGGIO
(ANTONIO ALLEGRI)
Correggio 1489 — Correggio 1534
The Nativity (1513–14)
Panel; 30 3/4″ × 39 1/4″.
Acquired by Bernardino Crespi in London as a work by Dosso Dossi, this painting was donated to the Brera in 1913 by the Crespi family.
On page 144: detail of the landscape.

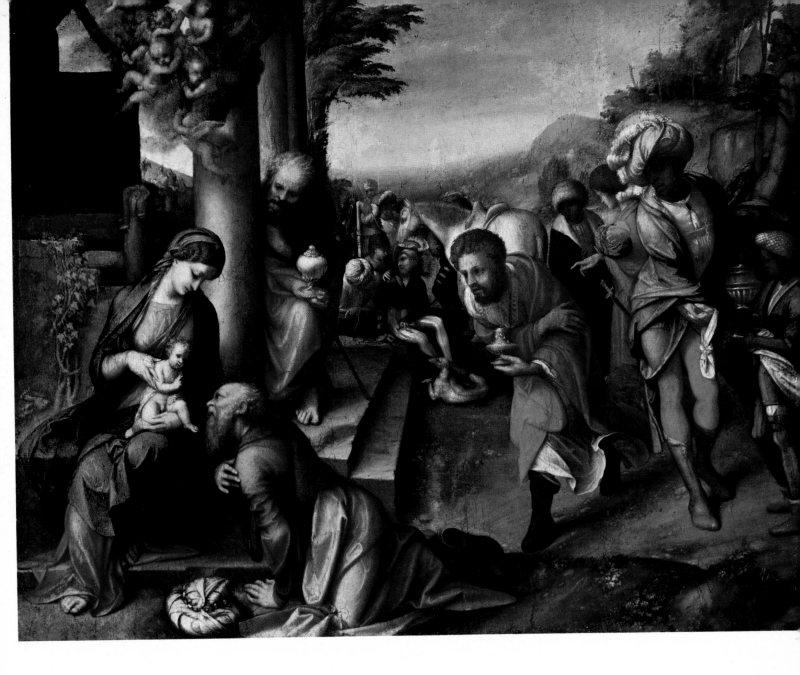

CORREGGIO
The Adoration of the Magi (circa 1514)
Canvas; 33″ × 42 1/2″.
The painting belonged to Cardinal Cesare Monti, Archbishop of Milan, who bequeathed it in February, 1650 to his successors, along with his entire collection of paintings, on condition that the works remain inalienable. It was exchanged with sixteen other pictures under the terms of an agreement among the Cardinal Archbishop, the director of the Brera, and the municipality of Milan. It entered the Brera in 1895.
On page 145: detail of the ivy.

fatigue of the flight, has fallen asleep. An angel leads the shepherds, who come through the ruins to pay homage. The landscape with its vast distance conveys the artist's love of his native land. At the same time, the fragments of classical architecture show an awareness of ancient tradition.

CORREGGIO. *The Adoration of the Magi.*
Although painted less than a year after *The Nativity,* this canvas shows that Correggio had acquired a new sense of scale. The influence of Dosso Dossi and Lorenzo Costa is apparent in this magnificent scene. Clearer and more definite colors have been used to focus the viewer's attention on the stranger kings paying their homage. The atmosphere is no longer that of intimate family affection but of an almost triumphant ceremony in which proud rulers, magnificent retainers and splendid horses take part.

143

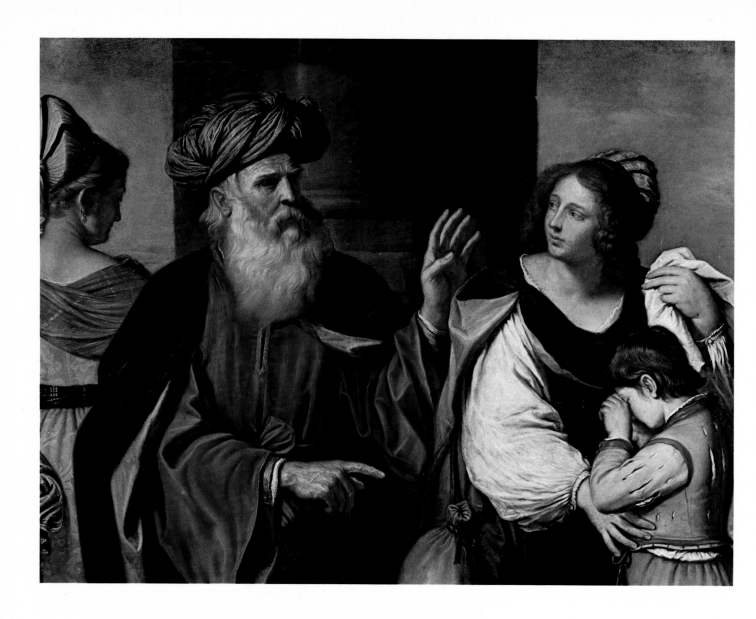

GUERCINO. *Abraham Casting Out Hagar and Ishmael.*

Guercino is one of the most interesting personalities in seventeenth-century
Bolognese art, and his activity in Rome made him an important influence
on all Italian painting. More than from Venice and Correggio, his work
derives from Dosso Dossi and the school of Ferrara. This painting repre-
sents one of the high points of Guercino's mature style. Its restoration by
the Brera's laboratory has revealed the original colors and eliminated the
yellowish patina that obfuscated and partially hid the composition. The
painting is built up on a measured circular rhythm, and the prominent
gestures of the figures are emphasized almost to the point of theatricality.
Little Ishmael is crying and leaning his head against Hagar. As she con-
soles him and holds out a handkerchief, she turns toward Abraham, who
stands stern and still, making a gesture of repudiation. Sarah, seen from
behind, appears to be moving away from the scene. The low-keyed color
helps avoid any rhetorical suggestion, while the slow rhythm of the compo-
sition creates a sense of inevitability.

GUERCINO
(GIOVANNI FRANCESCO BARBIERI)
Cento 1591 — Bologna 1666
Abraham Casting Out
Hagar and Ishmael (1657)
Canvas; 45 1/4" × 60 1/2".
The city of Cento commissioned this paint-
ing, which was then presented to the Car-
dinal Legate of Ferrara, Lorenzo Imperiali.
It then entered the collection of the Mar-
chese Sampieri in Bologna. The painting was
acquired in 1811, with five other paintings,
by the government of the Kingdom of Italy,
for 344,000 francs. It was consigned to the
Brera in 1811.

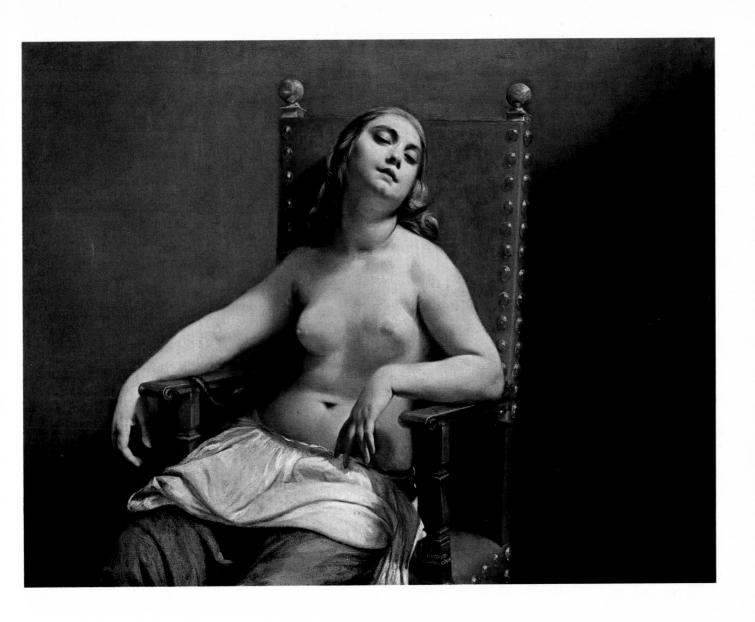

GUIDO CAGNACCI
Sant'Arcangelo di Romagna 1601 — Vienna
1681
The Death of Cleopatra
Canvas; 47 1/4″ × 62 1/4″
Signed in Latin on the left-hand upright of
the chair: "GUIDUS CAGNACCIUS."
Probably painted in Vienna, the canvas was
in the Spiridon collection in Rome. In 1962
it was presented to the Gallery by the
"Friends of the Brera and the Museums of
Milan."

GUIDO CAGNACCI. *The Death of Cleopatra.*
Cagnacci's familiarity with the work of Guido Reni and the masters of the
Bolognese manner, and his stay in Rome and encounter with Caravaggio's
painting, were a vital influence on his work. *The Death of Cleopatra* was
painted during the period when the artist's broad figurative range was en-
riched by the Dutch pictures he had seen in Vienna. An outstanding ex-
ample of Cagnacci's art, the painting is part of the long tradition of nudes
that were painted under the pretext of representing mythological subjects.
The sweet sensuality and languid amorous fatigue of the blond young
woman contrast with the stiff and angular armchair. The entire composi-
tion is built up on an "architectural" system of regular units of form which
does not allow for any ambiguity in the representation but rigorously sup-
ports the pictorial creation. Light and color complete the definition of the
figure.

147

GIUSEPPE MARIA CRESPI. *Village Fair*.

Crespi rejected the opaque quality of Bolognese academic art to develop a
realist vein that enlivened his work as a painter in Venice and Parma. His
best pictures express an affectionate and sharp-eyed participation in the
minor moments of the life of simple, unaffected people. Crespi was also a
skillful caricaturist, as is shown by his expulsion from the Accademia
Ghisilieri in Bologna for having represented Count Cesare Malvasia, a
highly respected compiler of the city's art history, as a plucked capon. This
Village Fair is similar to the one in the Uffizi. It has the same warmth of
color, acute description of the characters and sympathetic participation in

148 the life of the market day.

GIUSEPPE MARIA CRESPI
(LO SPAGNOLO)
Bologna 1664— Bologna 1747
Village Fair (circa 1709)
Canvas; 30″ × 33″.
Acquired from a dealer in 1916.

FRANCESCO HAYEZ. *Portrait of Alessandro Manzoni.*

Hayez, a Venetian, was influenced by the Roman milieu around Canova; he was famous as a painter of historical subjects, ranging from his *Sicilian Vespers* to *Mary Stuart.* His best works are his portraits, in which drawing and color are skillfully used for penetrating interpretations of his subjects On October 22, 1841, Giacomo Beccaria wrote to Giacomo Cantù: "Yesterday I went to see Alessandro, who showed me his portrait painted by Hayez, which is really a masterpiece by this capable artist. It [is] an exquisite and perfect likeness in all its parts."

GIOVANNI FATTORI. *The Red Cart.*

The composition of this painting is extremely simple. Within an unusually
elongated format, which is justified only by the placement and the form of
the elements it contains, the red cart strikes the viewer by the aggressive
out-thrusting of the shaft. Most of the vehicle is cut off, but the wheel gives
its diagonal position, which is further emphasized by the plow. Like a
faithful shadow, the plow repeats the line of the shaft on the ground, and
the long supporting rod touching the plow connects the two elements to
make a single framework. The oxen are arranged at a right angle to the
cart, their unmoving heads stretched forward. A parallel movement starts
from the curved end of the plow and goes on to the figure of the resting
peasant silhouetted against the irregular ground of the plain. The firm line
of the horizon and the limitless sky are dominated by the diagonals cutting
the composition and opening up perspectives beyond the limits of the pic-
ture. Intense sunlight rigorously models the angular shapes of the cart and
the plow. Without any gradations, sharply defined edges separate lighted
from shadowed surfaces. The strong-boned, powerfully-muscled oxen are
laid out in broad planes. In the severe bareness of the compositional
structure, Fattori reflects the severe silence and hidden reality of his native

150 soil.

GIOVANNI FATTORI
Livorno (Leghorn) 1828 — Florence 1908
The Red Cart
Oil on canvas; 70 1/2" × 34 1/2".

FLANDERS
SPAIN
HOLLAND

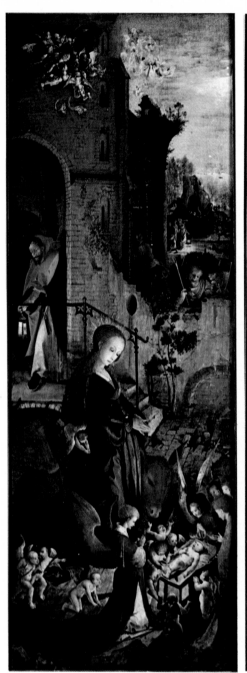

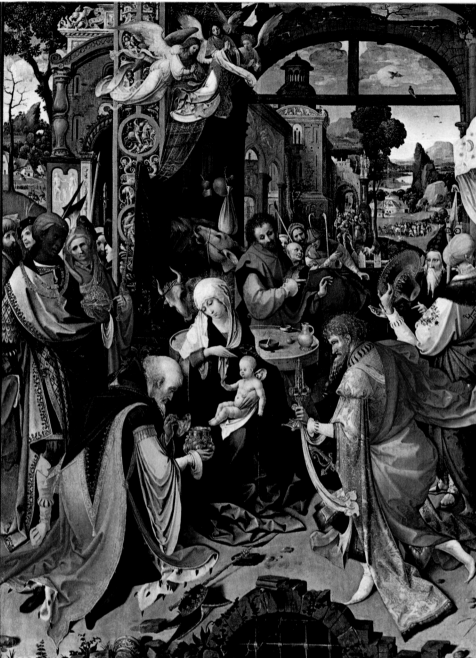

JAN DE BEER
Antwerp circa 1504 — circa 1536
The Nativity and *The Adoration of the Magi* and *Rest on the Flight into Egypt*
Oil on panel; central panel 60 1/4″ × 47 1/4″, wings 60 1/4″ × 21 1/4″.
The painting entered the Gallery in 1808 with the works from the church of the Convertite in Venice.

On page 154, above: detail of angels from *The Nativity.*

On page 154, below: detail of the still life from *The Adoration of the Magi.*

On page 155: detail of the landscape with figures from *The Adoration of the Magi.*

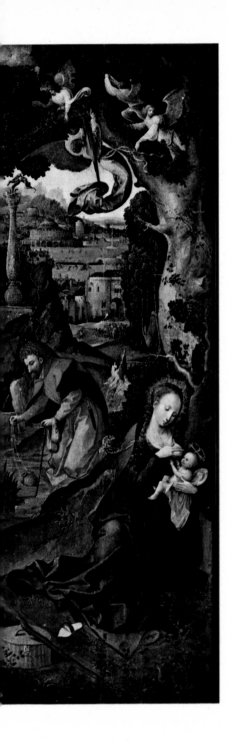

JAN DE BEER. *The Nativity* and *The Adoration of the Magi* and *Rest on the Flight into Egypt.*

These three paintings are by the most original of the so-called Antwerp Mannerists, Jan de Beer, the body of whose oeuvre has recently been reconstructed by scholars on the basis of a signed drawing in the British Museum. Although the artist was forgotten for three centuries, in his own lifetime he enjoyed considerable fame. Very likely it was Jan de Beer who caused the break in Antwerp with the stale repetitions of the fifteenth-century tradition through his bold innovations in form, style and decoration, and his "expressive eccentricity." In the feverish atmosphere of these three masterpieces some influence from contemporary German painting can be seen. Judging by the romantic inventions prodigally scattered throughout the works, the artist must have been in touch with Lucas van Leyden. The anxious excitement with which figures, landscape and architectural and decorative elements are heaped together abates at certain points to reveal a quiet rural view or a contemplative still life. The movement is slowed down by some elegant detail or dwells on a virtuoso passage, only to explode again in hallucinatory fantasies.

EL GRECO. *St. Francis and Brother Leo in Prayer.* *p. 156*

At least 128 paintings of St. Francis by El Greco or from his studio are known. Among them are twenty-eight compositions like the present painting, which has rightly been termed "a dialogue with death." The Brera version of the theme has been generally recognized as one of the best examples because of the freshness and immediacy of the handling. The rough habit, the almost geometrical form of the hoods, eyeballs, noses and hands seem almost to imprison the inhuman emaciation of the figures. The incredible slenderness of the lightly moving fingers on the skull stresses the weightlessness of the figures and the composition as a whole. There are no indications of depth or spatial relationships, nor is there any concern with compositional or narrative "normality." There is, however, an intense interior rapport between the saint in meditation and his devoted disciple, who is tense with dedication.

154

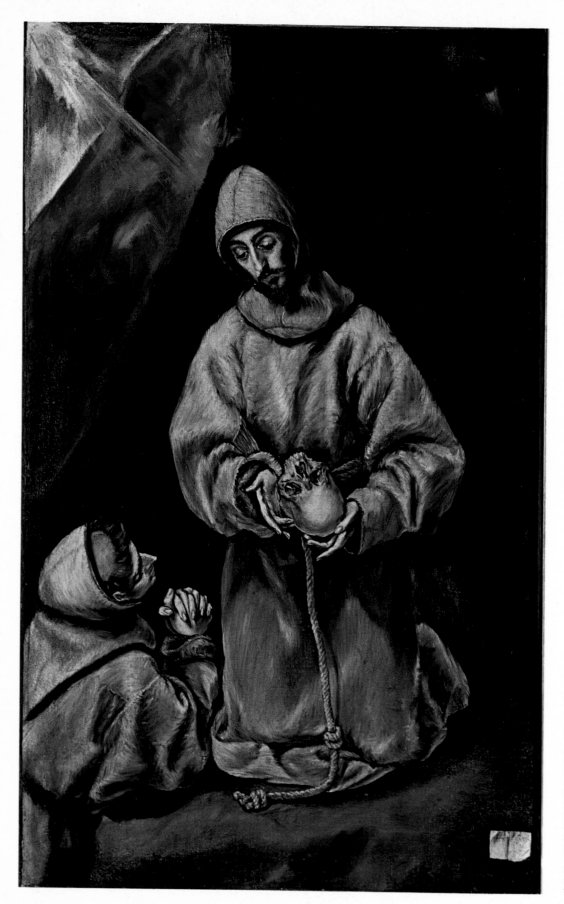

EL GRECO
(DOMENICO
THEOTOKOPOULOS)
Candia (Crete) 1541 —
Toledo 1614
*St. Francis and Brother Leo
in Prayer*
Oil on canvas;
42 1/2" × 26 1/4".
Signed in Greek letters:
DOMIN . . . TE . . .
OPOLIS EPOIEI. N. 945.
Formerly in private collections
in Paris and Milan, it was
acquired by the Gallery in
1931. The frame is a
sumptuous example of
seventeenth-century Spanish
wood carving.

PETER PAUL RUBENS. *The Last Supper.* *p. 158*

Although not one of Rubens' great masterpieces, this painting is an interesting document in the difficult and controversial question of shopwork in Rubens' production. As always, there are many small variations between the sketch and the finished painting. These are seen in details of the figures and the background, and in some inconspicuous changes in the overall proportions. In the sketch the mass of figures is broader and fuller, whereas in the painting it is tighter and more compressed. A noticeable heavy-handedness in this work suggests that assistants helped in the execution but Rubens must have worked on finishing it, and "retouched, with a fresh eye, quick intelligence and a ready hand," in the words of Roger de Piles.

ANTHONY VAN DYCK. *Portrait of a Lady.* *p. 159*

This painting is considered a portrait of Amelia of Solms, who became Regent of the Netherlands after the death of her husband, Frederick Henry of Orange. But her appearance is quite different in another presumed portrait in the Art History Museum in Vienna, and in a portrait in the Prado that certainly represents her. Less likely is her identification with Marie Claire, daughter of Duke Charles Alexander of Croy and wife of her cousin Charles Philip. This theory, which the Brera rejects, is based on the large standing portrait of the Duchess in the Fawkes collection at Fearnley Hall and on the engraving from Van Dyck by Konrad Waumans.

Executed during Van Dyck's second Antwerp period, the painting shows the hand of the master in such salient parts as the face, hands, veils, lace and jewels. But there is a notable decline in quality in the painting of the background. The inert, weightless dress is almost extraneous to the figure. On the right, indecisive geometrical forms suggest an architectural setting, as often seen in Van Dyck's earlier portraits. Another frequent motif (as in the portrait of Amelia in the Prado) is the reddish curtain on the left, but with its billowing twists and unresolved folds it is an incongruous element. There is a striking similarity in pose, expression, jewels and even the lace cuffs between this work and the *Portrait of Marie de Raet* (Wallace Collection, London), the wife of Philippe le Roy, which is datable around 1630. Thus there is some outside evidence for dating this much discussed and impressive portrait.

REMBRANDT VAN RIJN. *Portrait of a Young Woman.* *p. 160*

The identification of the young woman as Liesbeth van Rijn, who died after 1651, is generally accepted, though it is unsupported by documentation. Whether she was his sister or not, this full-faced young woman with her discontented mouth was very often portrayed by Rembrandt between

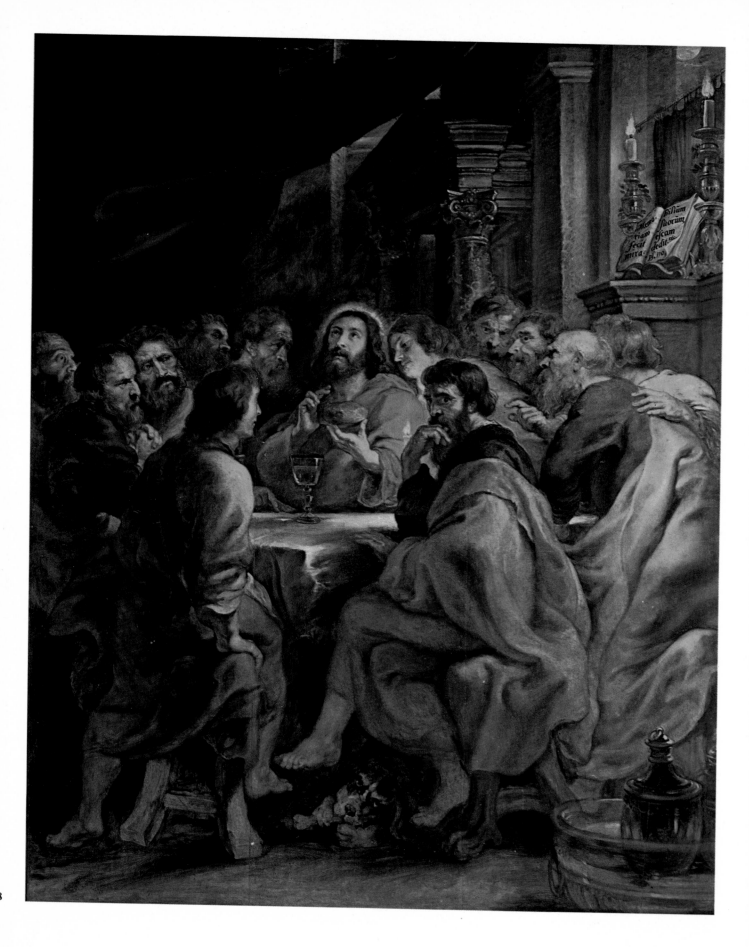

PETER PAUL RUBENS
Siegen 1577 — Antwerp 1640
The Last Supper
Oil on panel; 9'11 1/2" × 8'2 1/2".
Commissioned in 1632 by Catherine Lescuyer for the altar of the Holy Sacrament in the Cathedral of Saint-Rombaut at Malines. The model for this work (now in the Hermitage) was bought by Simon de Vos in 1662. Two panels from the predella are in the museum of Dijon. This painting went to the Louvre in 1794 and, in an exchange arranged in 1813, was sent to the Brera. The Louvre received, among other works, Boltraffio's *Casio Madonna* and Carpaccio's *St. Stephen Preaching.*

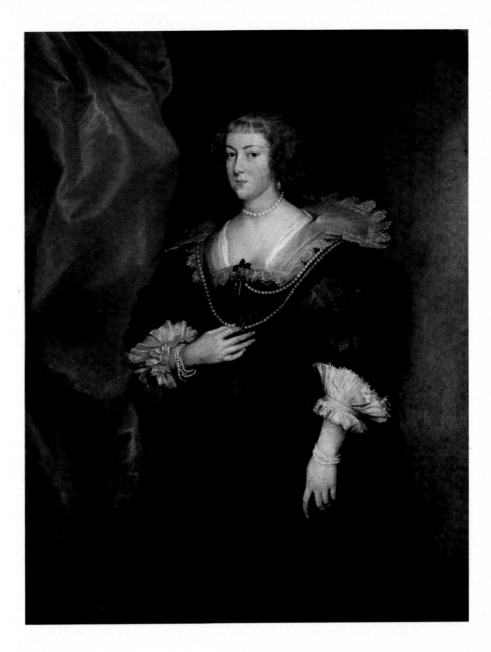

ANTHONY VAN DYCK
Antwerp 1599 — London 1641
Portrait of a Lady
Oil on canvas; 55" × 42 1/4".
Acquired in the 1813 exchange of paintings with the Louvre. The subject, with some variations, is also portrayed in the rectangular painting in Stockholm and in the oval painting in the Boston Museum of Fine Arts.

On page 160:
REMBRANDT VAN RIJN
Leyden 1606 — Rozengracht 1669
Portrait of a Young Woman
Oil on panel; 21 3/4" × 19".
Signed and dated: "R H L van Rijn 1632."
It came to the Brera from the Louvre in the exchange that took place in 1813.

1630 and 1633. The various first-hand versions and replicas provide excellent documentation of the infinite variety of approaches Rembrandt utilized for the same model, in a similar pose, the same format and often the identical costume. This was an exercise of fundamental importance in Rembrandt's early work and he repeated it with a similar abundance of examples with other members of his family or "types." The case of this "sister" is quite different from the others, however, as the artist did not utilize the simple device of changing costumes and accessories. He repeated the same image, with its limited possibilities for arranging and inventing. His technique is minutely descriptive, and the image, with its charge of vitality, emerges from its neutral ground without any forcing of the rather cool tones, which are harmoniously varied throughout the color range and have an exemplary balance.

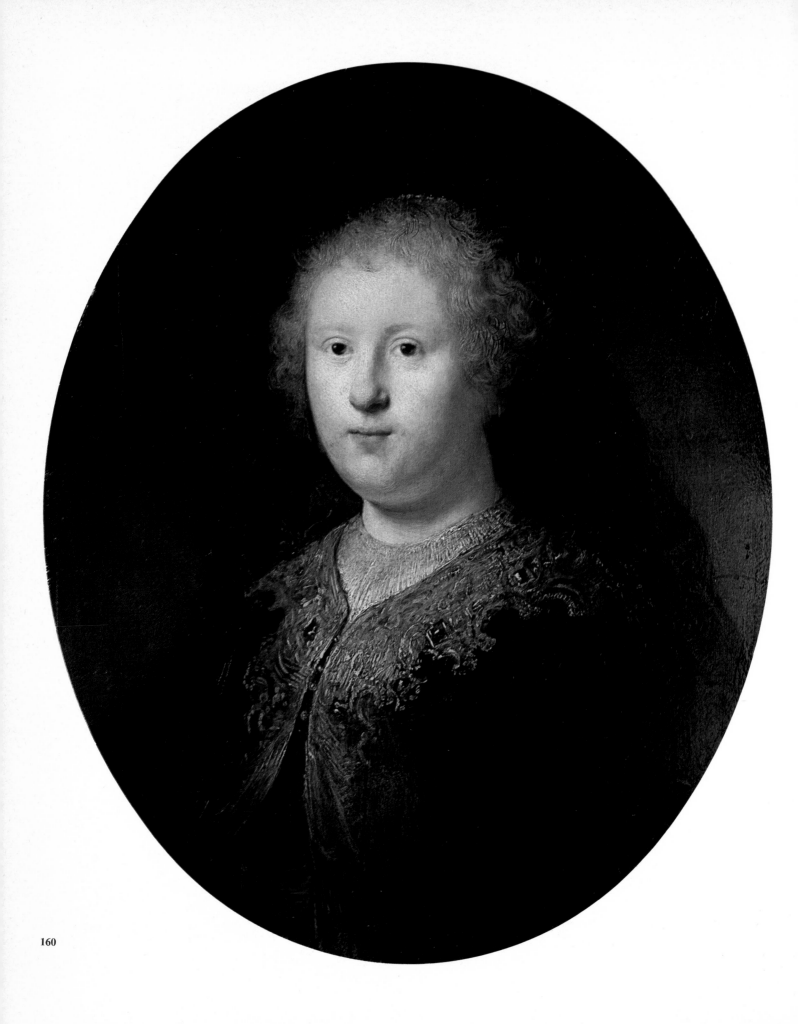

160

HISTORY OF THE MUSEUM
AND ITS BUILDING

HISTORY OF THE COLLECTIONS

The first secretary of the Academy, the Bolognese cleric Carlo Bianconi, drawing in part on his own possessions, collected the first group of paintings, sculptures and casts for the use of students in Milan. He took the initiative of asking that the works removed from the suppressed churches be consigned to him. Although he obtained few works of art, the principle he stated was to have far-reaching consequences. His successor, and the real founder of the Brera, was the painter Giuseppe Bossi, whose first step in 1803 was to stipulate in the Academy's regulations the need for an art gallery as a teaching aid and a public service, in keeping with Napoleonic ideas on the liberalization of cultural activities. The gallery was subsequently enlarged by the accession of works from suppressed churches and monasteries not only in Milan and the surrounding region, but throughout the kingdom. Ad hoc commissions of specialists scoured the country for works of art to send to the museums in Paris, the Galleria dell'Accademia of Venice and the Brera itself. The criteria of selection and destination were qualitative and cultural: masterpieces went to Paris, works documenting Venetian art over the centuries to Venice, and an anthology of all Italian painting to Milan.

Two of the Commissioners were Pietro Edwards and the painter Andrea Appiani, a friend of Bossi, who tried to save many works from going to Paris. They were very selective in their choices, choosing only a few canvases from among thousands for the Brera. The other works were distributed among public buildings and offices all over the kingdom. The peak of this dispersion activity was reached between 1808 and 1811. By 1806, however, Bossi had inaugurated a new arrangement of the paintings in the Brera and had published a booklet and inventory, which listed the works taken from religious establishments, those from the public domain, and others donated by the Viceroy Eugène de Beauharnais. Because of disagreements with Di Breme, the Minister of the Interior, Bossi resigned in 1807, but he left the Brera his own collection of portraits. Appiani succeeded him as curator and was very active in collecting pictures for the Gallery. It was at this time that many of the detached frescoes from Lombardy, which make the Brera unique, entered the collection. These included the frescoes by Luini from S. Marta, which was demolished in 1761; by Foppa from S. Maria di Brera, destroyed in 1808 to make more room for the Gallery; and by Bergognone and Bramantino.

The concept of bringing together works representing centuries of art activity, even at the price of losses and damage, was not only ambitious but was to have a major civic impact. Today we look with disapproval on this pillage, in which so many of the paintings' settings were damaged and destroyed. But we should not forget that

a more mature historical formation has resulted from this cultural policy, which in effect was a grandiose archaeological operation.

The Brera's original collection included Mantegna's *The Madonna of the Cherubim* (then attributed to Giovanni Bellini); the *Madonna and Child* that Bellini had executed for a Greek church; the huge, magnificent *St. Mark Preaching* by Gentile and Giovanni Bellini, from the Scuola di San Marco in Venice; and works by Vittore Carpaccio from the Scuola degli Albanesi and the church of S. Stefano. The great sixteenth-century Venetian artists were represented by the masterpiece of Titian's old age, *St. Jerome* (from the church of S. Maria Nuova in Venice); Paolo Veronese's *Baptism of Christ* (from S. Nicoletto dei Frari), *Christ in the Garden* (from S. Maria Maggiore) and *SS. Anthony Abbot, Cornelius and Cyprian* (from S. Antonio, Torcello); and Tintoretto's lunette showing *The Deposition* (from the Procurate of S. Marco, Venice). In addition, there were magnificent paintings by Paolo Veneziano (the *Coronation* that was returned to Venice only a few years ago), Paris Bordone, Cimo da Conegliano, Bonifazio de' Pitati, Bissolo and Bassano.

It is obvious that at its formation the Brera possessed a collection of Venetian masterpieces of exceptional importance. No less outstanding were the paintings from other departments of the territory, which included some of the highest examples of the art of the different Italian schools. From the church of S. Ambrogio ad Nemus in Milan came the *Sforza Altarpiece,* while paintings by Crespi, Marco d'Oggiono, Dosso Dossi, Boccaccino, Campi, Luini, Tiarini and Procaccini were gathered from various cities of Lombardy. From Forlì came works by Marco Palmezzano and Simone Cantarini's *Transfiguration;* from Bologna, Giotto's *Madonna and Child,* returned in 1894 so that it could rejoin the polyptych in the Bologna gallery, the predella of Lorenzo Costa's *Adoration of the Magi,* formerly in the church of the Misericordia, and pictures by Gessi and the Carracci, as well as Boltraffio's extraordinary *The Casio Madonna,* which went to the Louvre in an exchange in 1812. From the department of the Rubicon and from the Romagna, paintings by Niccolò Rondinelli and Giovanni Santi were sent to Milan for the Brera collection. Already on exhibition in the Gallery, just after its inauguration, were paintings by Federico Zuccari, Albani, Luca Giordano and Solimena, as well as works by such foreign artists as Jan de Beer's triptych and Poelenburg's *Women Bathing.* The detached frescoes from the Monastero Maggiore, the Villa della Pellucca and Broletto — the highly important work of Luini and Lanino — were also part of the original collection.

During the years immediately following the Brera's inauguration, the plundering

of the departments and the enrichment of the Gallery was intensified. Once again Appiani and his colleagues were sent to collect pictures; the year 1811 in particular saw a great deal of "rapine," as these operations were called by local art lovers. Among other paintings that then reached the Brera were Tintoretto's *The Discovery of St. Mark's Body,* from the Scuola Grande di S. Marco in Venice; Mantegna's *The San Luca Altarpiece,* from S. Giustina in Padua; Lorenzo Lotto's *Pietà,* from the Dominican Convent in Treviso; Foppa's altarpiece (without its predella), from the church of S. Maria delle Grazie in Bergamo; Giuseppe Maria Crespi's *Crucifixion,* from the Monastero di S. Maria Egiziaca in Bologna; Ercole de' Roberti's *Madonna Enthroned,* from S. Maria in Porto di Ravenna; Federico Barocci's *Martyrdom of St. Vitalis,* from S. Vitale in Ravenna; Gerolamo Savoldo's *Madonna and Child with Saints,* from the Dominican Church in Pesaro; Signorelli's *Scourging of Christ* and *Madonna,* from S. Maria del Mercato in Fabriano; Gentile da Fabriano's altarpiece (without its predella) from Valle Romita; the wonderful series by Carlo Crivelli, from the Dominican Church in Camerino; and finally, the work that many consider the greatest masterpiece in the gallery, Piero della Francesca's *Brera Altarpiece,* from the church of S. Bernardino near Urbino. Although many of these works were dispersed, several — including Tintoretto's *Miracle of St. Mark* — were recovered by Bertini and Carotti, while a systematic search for the others has gone on, currently under the direction of Angela Ottino della Chiesa.

Acquisitions by the Viceroy account for a number of pictures in the Brera, and in the course of his patronage he donated Giovanni Bellini's sublime *Pietà* and Raphael's *Marriage of the Virgin* to the Gallery. The government was also a patron of the Brera, buying en bloc the Sampieri collection of Bologna in 1811, which included works by Reni, Albani, Guercino and the Carracci. After the fall of Napoleon in 1815 and the Restoration, various works were returned to their places of origin. The most celebrated was the restitution of Paolo Veronese's *Supper of St. Gregory the Great* to the sanctuary of Monte Berico near Vicenza; in exchange the Brera received Veronese's *Feast in the House of Simon,* formerly in the church of S. Sebastiano in Venice. Exchanges were often arranged, with more or less favorable results, by the directors of the Gallery. Such arrangements were made with the Imperial Museum of Paris, from which several works by foreign artists were obtained (Rembrandt, Rubens, Van Dyck and Jordaens); with the gallery of the Archdiocese of Milan (paintings from the Monti Bequest in 1850); and with art dealers (Stefano da Verona's *Adoration of the Magi*).

164 Following Appiani's death in 1817 the accessions policy was carried on by his

successors, among whom were Francesco Hayez, Giuseppe Mongeri and Massimo d'Azeglio. Among their acquisitions were Mantegna's *Dead Christ* (from Bossi's heirs, 1824), Luini's *Madonna of the Rose Garden* (1825) and the two views by Bellotto (1832). In 1855 the Brera received Pietro Oggioni's bequest of hundreds of canvases, including works by Luini, Lotto, Crivelli, Garofalo, Reni, Tiepolo, and Guardi. In 1860, Victor Emmanuel II donated three portraits by Lotto on the occasion of his visit to Milan during the celebrations marking the unification of Italy. During Bertini's directorship, he was assisted by Giovanni Morelli, who gave his name to the most reliable nineteenth-century method of attribution, and by Luigi Cavenaghi, the famous restorer of Leonardo's *Last Supper*. In Bertini's time, a number of gaps in the collection were filled by the acquisition of paintings by Butinone, Bergognone, Torbido, Gaudenzio Ferrari, Paris Bordone, Sodoma, Bronzino, Bramantino, Procaccini and Ribera. His successor, Corrado Ricci, acquired Bramante's frescoes and the predella of Gentile da Fabriano's altarpiece, began the study of the Gallery's century-old history, and arranged the collection on a regional and chronological basis. Thus the Brera's prestige was maintained at the same high level by successive curators, from the time of its foundation to the curatorship of Ettore Modigliani and our own day.

The Gallery's operations were considerably aided in the post-World War I period by the association known as "The Friends of the Brera." When the association was dissolved in 1940, it made a final donation of the famous *Supper at Emmaus* by Caravaggio, from the Patrizi collection. In 1943 the Gallery's paintings were removed to storage for safekeeping, and the building was subsequently partially destroyed by air bombardment. The reconstruction of the Gallery was supervised by Modigliani, Fernanda Wittgens and the architect Pietro Portaluppi. To celebrate the restoration, Guido Cagnola presented the Brera with the beautiful *Madonna* by Ambrogio Lorenzetti. For the reopening, the frescoes from Mocchirolo were displayed in a room similar to their original setting. There were also new donations (Genovesino, Cagnacci, the Master of S. Colomba) and new acquisitions (Perin del Vaga, Cavallino, Ceresa, Pittoni). Finally, the rooms containing Lombard and Venetian paintings were reorganized by the architect Franco Albini.

Since 1951, the Gallery has had its own laboratory, which is equipped for photography, x-ray analysis and restoration. Like other Italian museums, in particular the Uffizi in Florence, the Brera has developed an active educational program, with guided tours, temporary exhibitions of drawings and restored works of art, and concerts of classical music. The concerts are held in rooms containing paintings contemporary with the music, so that a more complete idea of the taste of the period may be evoked.

THE BUILDING

The building that today houses the Brera is on the site on which, in the mid-thirteenth century, stood the church of S. Maria di Brera, occupied by the convent of the Humiliati, an order of nuns who devoted themselves to the processing of wool. The place-name "Brera" is actually a corruption of the Italian *Braida,* which means an open space or a city garden. By the sixteenth century, the order had become so powerful that it broke with Cardinal Carlo Borromeo; the nuns were even involved in an attempt on his life. As a result, Pope Gregory XIII abolished the order in 1571, expropriated its goods and gave it in commendam to Borromeo himself, stipulating that the grounds be made into a Jesuit university.

The plans for the new institution were designed by Martino Bassi, and the cornerstone of the building was laid in 1591. The work dragged on for so long that a new definitive plan was later prepared by Francesco Maria Richini. Construction was begun in 1615 but the plague of 1630 caused a halt. Further approval for continuation of the project was secured in 1651 but the architect died in 1658. The supervision of the construction was taken over by his son Domenico Richini, assisted by Gerolamo Quadrio and Pietro Giorgio Rossone. A hundred years later, when the Jesuits were suppressed, the work had still not been completed. At the time of the Austrian domination, the architect Piermarini made some Neoclassical additions, which blend with the classical severity of the building. In the façade, formerly on the Piazzetta di S. Maria but changed to the main street, he built the portal and the balcony above it.

The Empress Maria Theresa of Austria moved the Scuole Paoline, the famous non-clerical schools where Parini and Cesare Beccaria taught, into the finished building in 1773. Other institutions were also established there, including the Library, the Astronomical Observatory, the Patriotic Society (subsequently the Lombard Historical Institute), and finally the Academy of Fine Arts in 1776.

Angela Ottino della Chiesa has described the building: "The Baroque of the façade is severe. Rusticated pilasters divide it in three, and it is framed by the heavy cornice and the high basement, and scanned by the heavy contours of the windows. It is almost as if a swelling sound were made by the powerful Michelangelesque motif of the thirteen windows of alternating form repeated rhythmically across the red brick. And it prepares us for the flight, or rather the fugue, of coupled columns in the courtyard, which is the finest and most imposing example of Baroque architecture in Milan. The two-story portico, whose proportions are based on the Golden Section, is made up of the Tuscan Order below and the Ionic above. In this courtyard, which is derived from Pellegrini's in the Collegio Borromeo of Pavia, the membering is carefully profiled and harmonized throughout, and the movement of light and shadow is blended to make a calculated chiaroscuro effect . . ."

In the center of the main courtyard stands the colossal bronze statue of Napoleon I, modeled by Canova, which was cast in 1809 and placed there in 1859. Between the columns and on the walls of the porticoes are statues and busts of outstanding literary figures and scientists. In the rear, on an axis with the entrance, is the spectacular double-ramped staircase which connects the two loggias that open on the four sides of the courtyard.

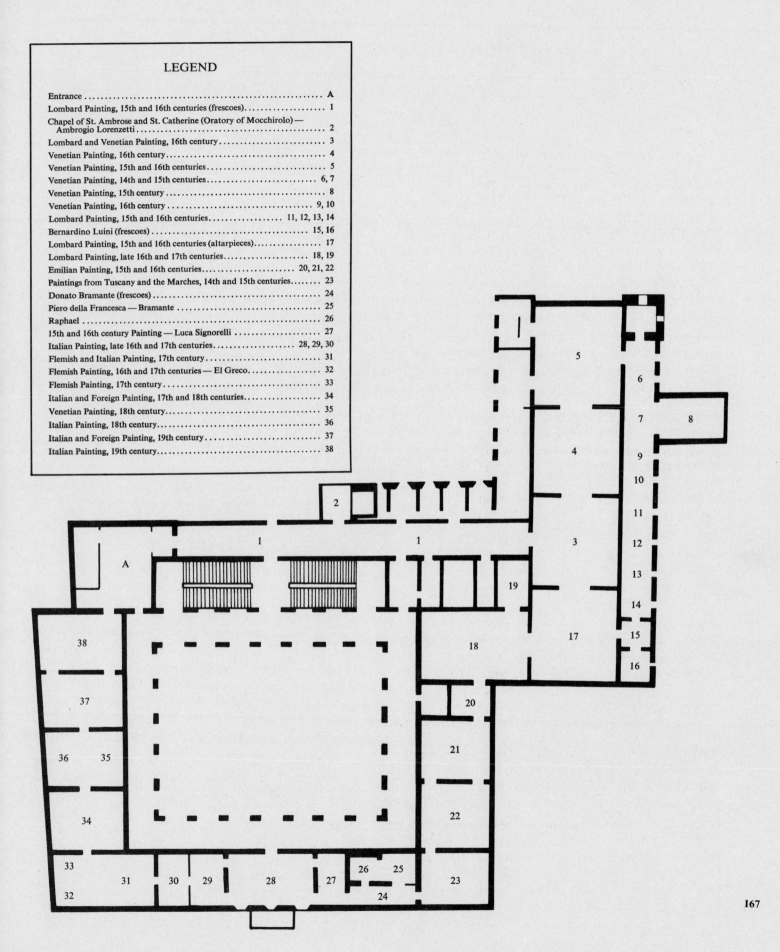

SELECTED BIBLIOGRAPHY

BERENSON, BERNARD. *Italian Painters of the Renaissance.* (Phaidon, London, rev. ed. 1957).

CHIESA, OTTINO DELLA. *Brera.* (Novara, 1962).

CLARK, SIR KENNETH. *Piero della Francesca.* (Phaidon, London, 1951).

DEWALD, ERNEST T. *Italian Painting, 1200–1600.* (Holt, Rinehart, Winston, New York, 1961).

FRIEDLAENDER, WALTER F. *Caravaggio Studies.* (Princeton University Press, Princeton, 1955).

GIBBONS, FELTON. *Dosso and Battista Dossi.* (Princeton University Press, Princeton, 1968).

GOULD, CECIL. *An Introduction to Italian Renaissance Painting.* (Phaidon, London, 1957).

HINKS, ROGER. *Caravaggio.* (The Beechhurst Press, New York, 1953).

LAUTS, JAN. *Carpaccio: Paintings and Drawings.* (Praeger, New York, 1962).

OERTEL, ROBERT. *Early Italian Painting to 1400.* (Praeger, New York, 1968).

ROBERTSON, GILES. *Giovanni Bellini.* (Clarendon Press, Oxford, 1968).

TIETZE, HANS. *Treasures of the Great National Galleries.* (Phaidon, London, 1954).

TIETZE-CONRAT, ERICA. *Mantegna.* (Phaidon, London, 1955).

VENTURI, LIONELLO. *Piero della Francesca.* (Skira, New York, 1954).

INDEX OF ILLUSTRATIONS

169

INDEX OF NAMES

GENERAL INDEX